GRAPHIC DESIGN NOW

Charlotte & Peter Fiell

Pages 4–5
Billboard for Adbusters. Jonathan Barnbrook, 2002.

Pages 10–11
Advertisement for Rote Fabrik (CH). François Chalet, 2001.

© 2005 TASCHEN GmbH
Hohenzollernring 53, D–50672 Köln
www.taschen.com

Original edition: © 2003 TASCHEN GmbH

Production: Ute Wachendorf, Cologne
Cover Design: Sense/Net, Andy Disl and Birgit Reber, Cologne
German translation: Annette Wiethüchter, Berlin
French translation: Philippe Safavi, Paris

Printed in Singapore
ISBN 3–8228–4778–X

To stay informed about upcoming TASCHEN titles, please request our magazine at www.taschen.com or write to TASCHEN, Hohenzollernring 53, D-50672 Cologne, Germany, Fax: +49-221-254919. We will be happy to send you a free copy of our magazine which is filled with information about all of our books.

Acknowledgements
We would like to express our immense gratitude to all those designers and design groups who agreed to take part in this project – there wouldn't have been a book without your participation. Additionally we offer our thanks to Anthony Oliver for his excellent new photography that was specially undertaken for this project. Lastly and by no means least we must give a very special mention to Eszter Karpati, our research assistant, whose good nature and formidable researching skills have driven the project from start to finish.

Danksagung
Als Herausgeber möchten wir allen Grafikern und Grafikdesignbüros von Herzen danken, dass sie sich an diesem Buchprojekt beteiligt haben. Ohne Ihre bereitwillige Mitwirkung hätte es diesen Band nicht gegeben. Wir bedanken uns auch bei Anthony Oliver für seine ausgezeichneten Neuaufnahmen, die er eigens für dieses Buch angefertigt hat. Last not least müssen wir unbedingt unsere Forschungsassistentin Eszter Karpati lobend erwähnen, deren Geduld und Findigkeit das ganze Vorhaben von Anfang bis Ende vorangetrieben haben.

Remerciements
Nous aimerions exprimer toute notre gratitude aux graphistes et groupes de graphistes qui ont accepté de participer à ce projet ; sans eux, ce livre n'existerait pas. Merci à Anthony Oliver pour ses excellentes photos prises spécialement pour cet ouvrage. Enfin, et non des moindres, une mention spéciale à Eszter Karpati, notre documentaliste, dont le bon caractère et les formidables talents de recherche ont guidé ce projet du début à la fin.

GRAPHIC
DESIGN
Charlotte & Peter Fiell
NOW

TASCHEN

KÖLN LONDON LOS ANGELES MADRID PARIS TOKYO

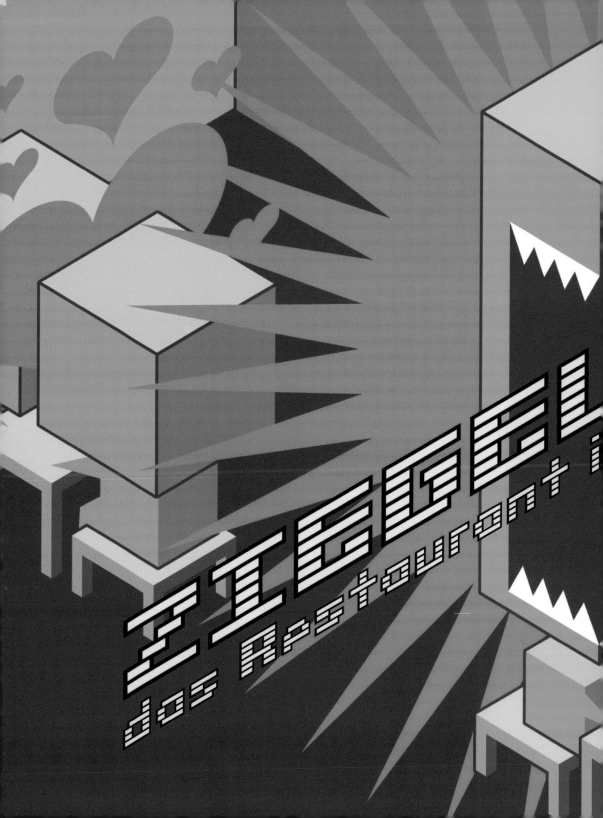

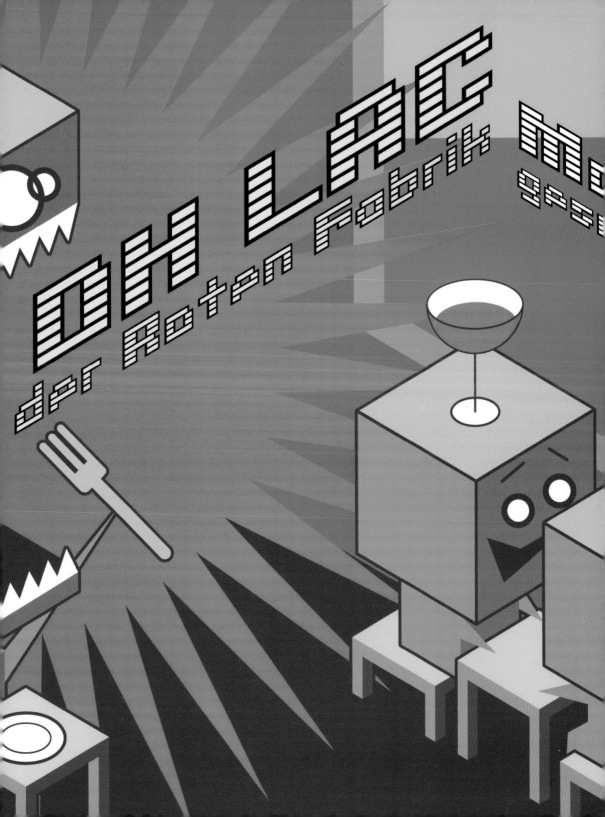

Graphic Design
for the 21st Century

Grafikdesign
im 21. Jahrhundert

Le design graphique
au 21e siècle

Over the last decade the practice of graphic design has undergone a momentous change as pixels have become a handy substitute for print and software has lessened the profession's reliance on its traditional tools of pen and paper. In no other discipline of design has computer technology had such a transforming impact, and this is why "Graphic Design for the 21st Century" has been dedicated to the thoughts and visions of designers working at today's graphic coalface. The one hundred designers included in this celebration of contemporary graphic design have been specifically selected for the forward-looking nature of their work. From the Netherlands and Switzerland to America and Iceland to Japan and Australia, this book features a truly international sampling of graphic design that reveals a shared desire to communicate ideas and values in the most visually compelling way possible.

Throughout our daily lives we are surrounded and peppered by graphic messages. Indeed they have become so much part of the fabric of every-day modern life – from breakfast cereal packaging and advertising billboards to logos on clothes and television company identities – that often we register their codes only on a subconscious level. Against an ever-present insidious backing track of visual Muzak, graphic designers vie for the viewer's attention by shaping communication that is not only visually arresting but also frequently intellectually contesting. To this end they can either grab attention in a bold and direct manner or slowly reel us in with visual ambiguity or double-coded meaning. In an ever-expanding sea of information and images the best attention "snaggers" are those who bait their hooks with meaningful content, quirkily intelligent humour and/or,

Im letzten Jahrzehnt hat sich im Bereich des Grafikdesigns ein revolutionärer Wandel vollzogen, da Pixel zum leicht verfügbaren Ersatz für Druckerzeugnisse geworden sind und Software dazu geführt hat, dass die Grafiker immer seltener auf ihre traditionellen Arbeitsmittel, nämlich Bleistift und Papier, zurückgreifen. In keinem anderen kreativen Fach hat die Computertechnik derart drastische Wirkungen gezeigt und deshalb widmet sich »Grafikdesign im 21. Jahrhundert« den Ideen und Visionen der Gestalter, die das Feld der zeitgenössischen Gebrauchsgrafik kultivieren. 100 Designer sind aufgrund des zukunftsträchtigen Charakters ihres Schaffens ausgewählt worden und haben Beiträge zu diesem Band geliefert. Die Beispiele reichen von den Niederlanden und der Schweiz über Island und Amerika bis nach Japan und Australien, so dass dieses Buch eine wahrhaft internationale Musterkollektion grafischer Arbeiten darstellt, denen der gemeinsame Wunsch zugrunde liegt, Ideen und Werte mit größtmöglicher Überzeugungskraft visuell umzusetzen.

Im täglichen Leben stürmen von allen Seiten unzählige grafische Botschaften auf uns ein – von der Packung der Frühstücksflocken und Werbeplakaten bis zu Markenzeichen auf Kleidungsstücken und den Logos der Fernsehsender. Sie alle sind so sehr Teil unseres modernen Alltagslebens geworden, dass wir ihre Codes schon gar nicht mehr bewusst wahrnehmen. Angesichts der allseits schleichend um sich greifenden »Hintergrund-Bildberieselung« wetteifern die Gebrauchsgrafiker um die Aufmerksamkeit des Publikums, indem sie ihre Botschaften so gestalten, dass sie nicht nur optisch attraktiv, sondern häufig auch intellektuell anspruchsvoll und pfiffig sind. Zu diesem Zweck nehmen sie

Au cours de la dernière décennie, les arts graphiques ont connu une véritable révolution, les pixels prenant le pas sur les caractères d'imprimerie et les logiciels diminuant la dépendance du secteur vis-à-vis de ses outils traditionnels tels que le crayon et le papier. Aucune autre discipline du design n'a été autant transformée par l'impact de l'informatique. C'est pourquoi « Le design graphique au 21e siècle » célèbre le design graphique contemporain en se consacrant aux idées et à la vision des tenants actuels de la profession. Les cents graphistes présentés ici ont été choisis tout particulièrement pour leur travail résolument orienté vers l'avenir. Des Pays-Bas à la Suisse, des Etats-Unis à l'Islande, du Japon à l'Australie, cet ouvrage propose un échantillonnage vraiment international des arts graphiques, reflétant un désir partagé de communiquer des idées et des valeurs de la manière la plus engageante qui soit.

Tout au long de la journée, nous sommes entourés et mitraillés de messages graphiques. Ils font désormais tellement partie du tissu quotidien de notre vie moderne – boîtes de céréales du petit-déjeuner, affiches publicitaires, logos de vêtements, sigles de chaînes de télévision etc. – que, le plus souvent, nous n'enregistrons leurs codes qu'à un niveau subconscient. Sur cette toile de fond omniprésente et insidieuse de gribouillis, les graphistes rivalisent pour attirer l'attention du public en élaborant une communication qui, non seulement accroche le regard, mais, souvent, interpelle l'intellect. Pour ce faire, ils peuvent capter notre attention d'une manière directe et frappante ou

Opposite Poster for "Sensation" exhibition. Why Not Associates, 1997.

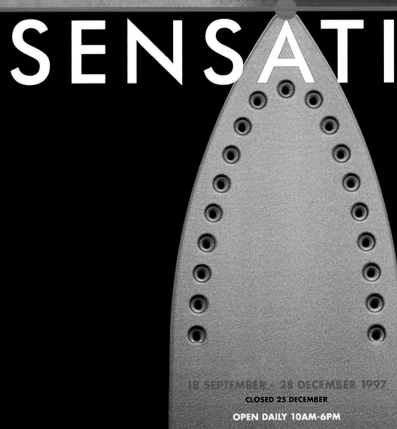

ROYAL ACADEMY OF ARTS
PICCADILLY LONDON W1

YOUNG BRITISH ARTISTS FROM THE SAATCHI COLLECTION

SENSATION

18 SEPTEMBER – 28 DECEMBER 1997

CLOSED 25 DECEMBER

OPEN DAILY 10AM–6PM

Right Flyer for Detroit Focus Gallery. Ed Fella, 1990.

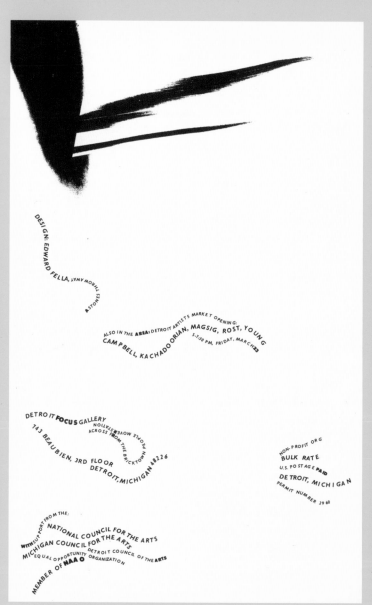

more rarely, genuinely new formal inventiveness. Because of the overwhelming bombardment of visual communications that we all experience on a daily basis, we have not only become more visually literate and culturally savvy in the deciphering of the intentions that lie at the root of the codes, but also our senses have become increasingly jaded by the stylistic sameness of much mainstream, "strategic," marketing-led communication. These days, for something to catch our attention for more than just a few seconds it has to be really thought-provoking or amusing. More than at any other time in the short but prolific history of graphic design, the current pressure on professional practitioners to produce distinctively authentic work that conveys a message in a uniquely captivating way is greater than ever. And that's not all; graphic design just got bigger. The profession has broadened as the boundaries between creative disciplines have become increasingly blurred through the application of – and opportunities presented by – new democratising digital technologies.

For the vast majority of designers in this survey the computer has become their primary tool, but given this, there is also a desire by many to break out of the constraining limitations imposed by off-the-shelf software programmes. The Internet and advanced computing power has delivered greater speed to graphic design practice, yet at the same time this technologically-driven acceleration has also increased the stylistic obsolescence of graphic design solutions – what appears cutting-edge one year will seem old hat the next as new ways of making graphic design provide novel possibilities of expression. Over the last decade graphic design has grown from a primarily static medium of encapsulated messages (books, posters, display ads, etc.) to one that is increasingly about movement and play, and is open to interaction since the advent of screen-based so-called graphic user interfaces (GUI). This

unsere Aufmerksamkeit entweder auf forsche, direkte Weise gefangen oder sie umgarnen uns langsam, nach und nach, mit bildlichen oder sprachlichen Doppeldeutigkeiten. In der heute unaufhörlich wachsenden Informations- und Bilderflut sind diejenigen am erfolgreichsten, die den Betrachter mit sinnvollen Inhalten, witzigen, geistreichen und/oder – was eher selten ist – wirklichen

chercher à nous embobiner lentement en créant une ambiguïté visuelle ou des doubles sens. Dans cet océan d'informations et d'images en expansion constante, ceux qui parviennent le mieux à nous «accrocher» sont ceux qui nous appâtent avec un contenu intelligent, original, humoristique et/ou, plus rare, une véritable inventivité dans la forme. Du fait du bombardement incessant

does not mean, however, that we should be writing obituaries for the printed page. New computer technologies have actually made the execution of books easier – leading to the proliferation of small print-run publications show-casing the work of individual graphic designers. Indeed, this type of publication, along with the numerous journals, exhibitions and award ceremonies dedicated to graphic design, help to raise the profile of this omnipresent yet often invisible profession, while also facilitating the cross-pollination of ideas amongst practitioners. The Internet has also had an enormous impact on the transference of ideas between graphic designers, and has helped to instigate an unprecedented level of collaboration between different design communities throughout the world. It is, however, printed publications such as this one that not only tangibly demonstrate through words and pictures the cultural flux of contemporary graphic design, but may well remain the most accessible record of work made from sprinklings of pixel dust as new media platforms perpetually render not-so-new ones obsolete. In comparison to print, New Media is in its infancy and today's pioneering generation of graphic designers are still grappling with how best to mine its communicative potential. The evolution of graphic design has been and will continue to be inextricably linked with the development of technological tools that enable designers to produce work with ever-greater efficiency.

Apart from illustrating the current output of one hundred leading graphic designers, this survey also includes "in-their-own-words" explanations of their personal approaches to the many challenges faced by anyone currently working in the contemporary visual communications field. The selected designers have also provided their own vision statements of what they think the future of graphic design will hold. Apart from illustrating some of the most interesting graphic design currently being produced, this book also offers insightful predictions on the course of graphic design in the future regarding its convergence with other

formalen Neuheiten ködern. Da täglich unzählige visuelle Botschaften und Informationen auf uns herniederprasseln, sind wir nicht nur beschlagener und gewitzter geworden, was unsere visuelle Wahrnehmung und das Entziffern der Absichten hinter den grafischen Codes angeht, sondern auch abgestumpft gegenüber dem stilistischen Einheitsbrei eines Großteils der gängigen »strategischen«, marktorientierten Werbung. Damit etwas heute unsere Aufmerksamkeit länger als nur einige Sekunden gefangen hält, muss es wirklich amüsant sein oder zum Nachdenken anregen. In der kurzen, aber höchst produktiven Entwicklungsgeschichte der Gebrauchsgrafik standen die Grafiker noch nie unter so großem Druck wie zurzeit, originelle, sich aus der Masse hervorhebende Entwürfe zu liefern, die Werbebotschaften auf unnachahmliche und fesselnde Weise transportieren. Das ist noch nicht alles: Die Welt der Gebrauchsgrafik ist in dem Maße größer geworden, in dem sich die Grenzen zwischen den verschiedenen künstlerisch-gestalterischen Berufen verwischt haben, und zwar durch die Nutzung der neuen, erweiterten Möglichkeiten, die von der allen verfügbaren modernen digitalen Technik geboten wird.

Die meisten der in diesem Band vorgestellten Grafiker benutzen den Computer als Hauptarbeitsmittel. Dennoch verspüren viele den Wunsch, die von der handelsüblichen Software gezogenen Grenzen zu überschreiten. Das Internet und die höhere Rechenleistung der Computer haben die Entwurfsarbeit zwar erheblich beschleunigt, diese von der Technologie erhöhte Geschwindigkeit hat aber auch zum raschen Veralten grafischer Lösungen und Stilmerkmale geführt: Was dieses Jahr hochmodern erscheint, ist schon nächstes Jahr ein alter Hut, wenn neue Techniken auch neue Ausdrucksmöglichkeiten eröffnen. In den letzten zehn Jahren hat sich die Gestaltungsarbeit des Grafikdesigners von einem überwiegend statischen Medium mit fixierten Botschaften (Bücher, Anzeigen, Plakate) zu einem Medium entwickelt, bei dem es zunehmend um Bewegung und Spiel geht, denn mit dem

de communications visuelles que nous subissons quotidiennement, nous avons développé inconsciemment une vaste culture de l'image et avons appris à déchiffrer les intentions qui se cachent derrière les codes. En outre, nos sens sont blasés par l'aspect répétitif des styles de communications «stratégiques» traditionnelles guidées par des intérêts commerciaux. De nos jours, pour qu'un message retienne notre attention pendant plus de quelques secondes, il doit vraiment faire réfléchir ou amuser. Plus qu'à n'importe quelle autre époque dans la courte mais prolifique histoire des arts graphiques, les professionnels subissent une pression sans précédent pour produire un travail authentique et original qui transmette un message d'une manière unique et captivante. Mais ce n'est pas tout. L'importance du graphisme ne cesse de croître. Le secteur s'est élargi à mesure que l'application et les possibilités offertes par les nouvelles technologies numériques ont démocratisé les disciplines créatives et ont rendu de plus en plus floues les frontières qui les séparaient autrefois.

L'ordinateur est devenu l'outil principal de la grande majorité des graphistes présentés ici, même si beaucoup d'entre eux expriment également le désir de se libérer des contraintes imposées par les logiciels proposés dans le commerce. L'internet et la puissance informatique permettent de travailler toujours plus rapidement mais accélèrent aussi le processus d'obsolescence stylistique des graphismes. Ce qui semble révolutionnaire cette année paraîtra désuet l'année prochaine quand de nouvelles manières de concevoir les projets graphiques offriront d'autres possibilités d'expression. Au cours de la dernière décennie, le graphisme est passé d'un média essentiellement statique servant à transmettre des messages fixes (livres, affiches, publicités, etc.) à un outil mobile et ludique, ouvert à l'interaction depuis l'avènement des «Interfaces Utilisateurs Graphiques» (IUG) sur écran d'ordinateur. Cela ne signifie pas pour autant la mort de la page imprimée. En effet, les nouvelles technologies informatiques ont rendu plus facile la réalisation des livres,

disciplines (such as fine art, film, illustration, music), its continuing love affair with advanced technology, its complicity with corporate globalisation, and its adoption of the poetic ambiguity of post-modern cultural interpretation over the direct clarity of modern universal communication. In an attempt to make sense of where graphic design might be heading, we have identified a number of the common concerns and themes raised by the selected designers. These are: the blurring of boundaries between disciplines; the importance of content; the impact of advanced technology; the desire for emotional connections; the creative constraints imposed by commercial software; the distrust of commercialism; the increasing quantity, com-

Aufkommen so genannter grafischer Benutzeroberflächen (graphic user interfaces, GUI) z. B. wird der bisher passive Betrachter zur Interaktion eingeladen. Das heißt allerdings nicht, dass wir nun Nachrufe auf das gedruckte Wort schreiben sollten, denn neue Computertechniken haben tatsächlich die Herstellung von Büchern erleichtert, was eine wachsende Zahl von Publikationen in kleinen Auflagen zur Folge hatte, mit denen sich einzelne Grafiker profilierten. Tatsächlich tragen solche Publikationen im Verbund mit den zahlreichen Zeitschriften und Ausstellungen sowie Preisverleihungen für hervorragendes Grafikdesign dazu bei, das Profil dieser allgegenwärtigen, oft jedoch unsichtbar und anonym wirkenden Berufsgruppe zu

entraînant la prolifération de petites publications sur papier présentant le travail de graphistes indépendants. De fait, ce genre de brochures, tout comme les nombreuses revues, expositions et remises de prix consacrées aux arts graphiques, contribuent à hausser le niveau de cette profession omniprésente mais souvent invisible, tout en facilitant la pollinisation croisée des idées parmi ses praticiens. L'internet a également eu une influence considérable sur la transmission des idées entre graphistes et favorisé la constitution d'un réseau de collaboration sans précédent entre différentes communautés de professionnels à travers le monde. Toutefois, ce sont des ouvrages imprimés tels que celui-ci qui, non seulement exposent de manière tangible avec des mots et des images les courants culturels des arts graphiques contemporains, mais demeureront l'archive la plus accessible de travaux réalisés à partir de poudre de pixels tandis que de nouvelles plates-formes médiatiques rendront perpétuellement obsolètes celles qui les ont précédées. Comparés à l'imprimerie, les médias numériques n'en sont qu'à leurs premiers balbutiements et la génération actuelle de graphistes avant-gardistes en sont encore à chercher à mieux comprendre leur potentiel communicatif. L'évolution des arts graphiques a toujours été et continuera d'être inextricablement liée au développement des outils technologiques qui permettront aux graphistes de travailler avec une efficacité toujours plus grande.

Cet ouvrage ne se contente pas de présenter la production actuelle de cent graphistes de premier plan mais leur permet également d'expliquer avec leurs propres termes leur démarche personnelle face aux nombreux défis auxquels sont confrontés tous ceux qui travaillent aujourd'hui dans le domaine de la communication visuelle. Les graphistes sélectionnés ont également exprimé leur vision de ce que l'avenir réserve aux arts graphiques. Outre le fait de présenter certaines des créations graphiques les plus intéressantes du moment, ce livre émet également des prédictions sur l'évolution du design graphique à la lumière de ses

plexity and acceleration of information; the need for simplification; and (last but by no means least) the necessity of ethical relevance.

To better understand how graphic design got to this stage of development, it is perhaps necessary to briefly outline the evolution of this relatively young profession. While the increasing cross-disciplinary aspect of graphic design practice may seem a new phenomenon, this is not really the case. In the late 19th century the graphic arts* most visibly manifested themselves in the design of large advertising posters in the Art Nouveau style – from the cabaret posters by Henri de Toulouse-Lautrec (1864–1901) to the advertisements for Job cigarette papers by Alphonse Mucha (1860–1939). This kind of commercial art was often undertaken by practicing artists and architect/designers and as such was highly influenced by contemporary developments in the fine and applied arts. The new profession of graphic design was, however, mainly confined to the creation of posters and books, and was closely related to the British Arts & Crafts Movement's promotion of "art" printing. At this stage, even when mechanised printing was used, the results often still appeared hand-printed. It was not until the early years of the 20th century that the so-called "graphic arts" were used to develop comprehensive and integrated corporate identities. In

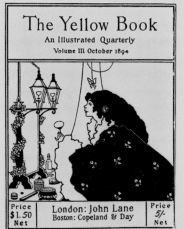

schärfen und zugleich die wechselseitige Anregung ihrer einzelnen Mitglieder untereinander zu fördern. Das Internet hat den Gedanken- und Erfahrungsaustausch unter den Grafikern entscheidend vorangetrieben und dazu beigetragen, ein in dieser Intensität und Ausdehnung noch nie da gewesenes Maß an Kooperation rund um den Globus zu schaffen. Es sind allerdings Druckerzeugnisse wie das vorliegende Buch, die den Gang des zeitgenössischen Grafikdesigns nicht nur in Texten und Bildern belegen, sondern auch die zugänglichste und dauerhafteste Informationsquelle aus bunten Rasterpunkten bleiben werden, denn die neuesten Internetportale werden kontinuierlich die weniger neuen ersetzen und überflüssig machen. Im Vergleich zum gedruckten Wort und Bild stecken die »neuen Medien« noch in den Kinderschuhen und die zeitgenössischen Pioniere der Computergrafik sind noch damit beschäftigt, das digitale Potenzial in all seinen Facetten zu erforschen und zu erschließen. Die Entwicklung des Grafikdesigns wird auch weiterhin unauflöslich mit der Entwicklung der dafür notwendigen Technologie – Hardware wie Software – verknüpft bleiben, die es den Grafikern erlaubt, mit immer größerer Effektivität zu arbeiten.

Das vorliegende Buch illustriert nicht nur das aktuelle Schaffen von 100 führenden Grafikdesignern bzw. Designbüros, sondern enthält auch deren Selbstdarstellungen und Erklärungen zu ihren persönlichen Auffassungen über die zahlreichen Herausforderungen, denen sich heute jeder, der im Bereich der visuellen Kommunikation arbeitet, stellen muss. Auch geben die ausgewählten Designer wunschgemäß Auskunft darüber, wie sie die Zukunft des Grafikdesigns sehen. In diesem Überblick findet der Leser nicht nur Abbildungen einiger der interessantesten Arbeiten aus jüngster Zeit, sondern auch fundierte Informationen über die Zukunft des Gewerbes,

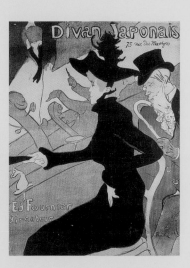

liens avec d'autres disciplines (telles que les beaux-arts, le cinéma, l'illustration, la musique), de sa longue histoire d'amour avec la technologie de pointe, de sa complicité avec la mondialisation, et de sa prédilection pour l'ambiguïté poétique de l'interprétation culturelle postmoderne par rapport à la clarté de la communication universelle moderniste. En cherchant à cerner les orientations futures du design graphique, nous avons identifié un certain nombre de préoccupations et de thèmes communs soulevés par les graphistes sélectionnés. Il en ressort les points suivants : l'effacement des frontières entre les disciplines ; l'importance du contenu ; l'impact de la technologie de pointe ; l'envie de retrouver des liens émotionnels ; les contraintes créatives imposées par les logiciels commerciaux ; la méfiance du mercantilisme ; la quantité, la complexité et l'accélération croissantes de l'information ; le besoin de simplification ; (enfin mais non des moindres) la nécessité d'une déontologie pertinente.

Pour mieux comprendre comment les arts graphiques en sont arrivés à ce stade de développement, il est sans doute utile de retracer l'évolution de cette profession relativement jeune. L'aspect multi-disciplinaire du design graphique peut paraître relativement nouveau mais ce n'est pourtant pas un phénomène récent. A la fin du 19e siècle, les arts graphiques* s'exprimaient de la manière la plus

Opposite Poster for Fuse, promoting new digital typeface. Research Studios, 2001.
Left Cover for the Yellow Book, volume III. Aubrey Beardsley, 1894.
Top Poster for Divan Japonais. Henri de Toulouse-Lautrec, 1892.

1907, for example, Peter Behrens (1868–1940) was appointed artistic adviser to the well-known German manufacturer AEG, and subsequently became the first designer to introduce such a programme. Designers were, however, still jacks-of-all-trades. One day they would be designing furniture and lighting, the next day textiles or ceramics, and because of this graphic design was seen as just another field in which artists or architect/designers could try their hand. The well-known logo of the Carlsberg brewery, for instance, was initially devised by the Danish ceramicist and furniture designer Thorvald Bindesbøll (1846–1908) in 1904.

The emergence of this new discipline during the early years of the 20th century led to the founding of the American Institute of Graphic Arts (AIGA) in New York in 1914 – the first organization to be specifically set up for the promotion of what was then termed "graphic arts". It was not until the First World War, however, that the importance of graphic design as a tool for propaganda was firmly established, most notably by James Montgomery Flagg (1877–1960), who created the famous "I Want You for US Army" recruiting poster showing Uncle Sam (based on a self-portrait). Following the war's end, the Art Directors Club was founded in New York in 1920 so as to raise the status of advertising – a growing area of the graphic arts that was distrusted by the general public because of the false claims and visual excesses that had become associated with it. The Art Directors Club subsequently staged exhibitions and produced publications that showcased the most creative advertising work, and in so doing helped to establish a greater professionalism within graphic design practice. Reflecting the discipline's move away from the subjectivity of fine art to the objectivity of design, the American typographer William Addison Dwiggins (1880–1956) reputedly first coined the term "graphic design" in 1922.

After the enormous upheavals of the First World War, many people put their faith in new technology and

seine Verflechtung mit anderen Disziplinen – bildende Kunst, Film, Illustration, Musik –, seine enge Beziehung zur neuesten Technik, seine Komplizenschaft mit der wirtschaftlichen Globalisierung und darüber, dass Grafiker heute vielfach der poetischen Vieldeutigkeit postmoderner kultureller Interpretationen den Vorzug vor der universellen Klarheit der Moderne geben. Im Bemühen um eine sinnvolle, begründete Aussage über den Weg, den das Grafikdesign einschlagen wird, haben wir zunächst einmal bei den ausgewählten Vertretern des Fachs eine Reihe von gemeinsamen Zielen und Themen identifiziert: den Wunsch nach Aufhebung des fachlichen Schubladendenkens, die vorrangige Bedeutung von Inhalten, den Einfluss modernster Technologie auf die Arbeitsergebnisse, den Wunsch nach emotionalen Verbindungen und nach Überwindung der von der handelsüblichen Software gezogenen Grenzen, das Misstrauen gegenüber dem Kommerz, die zunehmende Menge, Komplexität und Beschleunigung der Informationsflüsse, die Notwendigkeit der Vereinfachung und – last, but not least – die Notwendigkeit ethisch vertretbarer Entwürfe.

Zum besseren Verständnis der aktuellen Situation des Grafikdesigns muss man vielleicht zuerst einmal die Entwicklung dieses relativ jungen Berufszweigs zurückverfolgen. Der zunehmend interdisziplinäre Charakter der Berufspraxis mag als neues Phänomen erscheinen, ist es aber eigentlich nicht. Im späten 19. Jahrhundert hat sich die Kunst der Gebrauchsgrafik* am deutlichsten in großen, im Jugendstil bzw. im Stil des Art nouveau entworfenen Werbeplakaten niedergeschlagen – von denen, die Henri de Toulouse-Lautrec (1864–1901) für Pariser Cabarets schuf, bis zur Job-Zigarettenwerbung von Alphonse Mucha (1860–1939). Derartige »kommerzielle Kunstwerke« stammten häufig von ansonsten freischaffenden Künstlern sowie Architekten und kunsthandwerklichen Gestaltern und waren daher meist stark von den Entwicklungen in der bildenden und angewandten Kunst ihrer Zeit geprägt. Der neue Beruf des Gebrauchsgrafikers war eng

visible à travers les grands placards publicitaires de style Art nouveau, des affiches de cabaret d'Henri de Toulouse-Lautrec (1864–1901) aux publicités pour le papier à cigarette «Job» d'Alphonse Mucha (1860–1939). Cette forme d'art commercial étant souvent confiée à des artistes et des architectes / designers, elle était donc fortement influencée par les développements contemporains dans les beaux-arts et les arts appliqués. Le nouveau métier de graphiste, lui, se limitait principalement à la création d'affiches et de livres et était étroitement apparenté à la promotion de l'imprimerie «d'art» de l'Arts & Crafts Movement britannique. A cette époque, même avec l'impression mécanique, les résultats semblaient souvent imprimés à la main. Il fallut attendre le début du 20e siècle pour que les «arts graphiques» soient utilisés pour développer des identités d'entreprises complètes et intégrées. En 1907, l'architecte – designer Peter Behrens (1868–1940) fut nommé conseiller artistique de la célèbre firme allemande AEG, inaugurant un nouveau type de collaboration de ce genre. A l'époque, les créateurs étaient encore des hommes-orchestres, concevant tantôt des meubles et des luminaires, tantôt des tissus et des céramiques, etc. De ce fait, le graphisme n'était considéré que comme un domaine parmi tant d'autres dans lequel ils pouvaient exercer leurs talents. Le célèbre logo des brasseries Carlsberg, notamment, fut

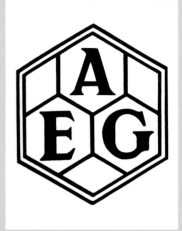

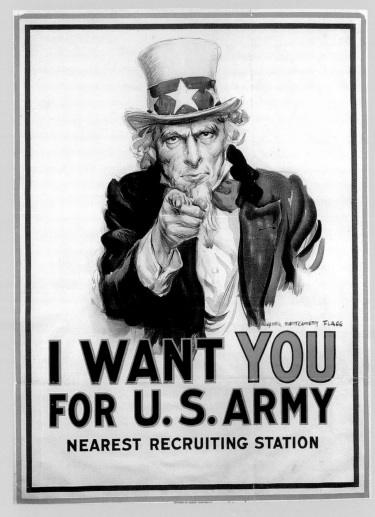

conçu à l'origine par le céramiste et créateur de meubles danois Thorvald Bindesbøll (1846–1908) en 1904.

Au cours des premières années du 20e siècle, l'émergence de cette nouvelle discipline entraîna en 1914 la création à New York de l'A.I.G.A. (American Institute of Graphic Arts), la première organisation fondée tout particulièrement pour la promotion des «Arts Graphiques». Toutefois, ce ne fut qu'après la Première Guerre mondiale que l'importance du design graphique comme outil de propagande fut fermement établie, notamment par James Montgomery Flagg (1877–1960), auteur de la célèbre affiche de recrutement «I Want You for US Army» montrant l'Oncle Sam (d'après un autoportrait). Après la fin de la guerre, l'Art Directors Club fut fondé à New York en 1920 pour promouvoir le statut de la publicité, un domaine des arts graphiques qui ne cessait de prendre de l'importance mais qui suscitait la méfiance du grand public en raison des annonces mensongères et des excès visuels qui lui étaient associés. L'Art Directors Club organisa des expositions et fit paraître des publications présentant les publicités plus créatives, favorisant ainsi un plus grand professionnalisme au sein du métier de graphiste. Reflétant le nouveau statut de cette discipline, qui s'éloignait de plus en plus de la subjectivité des beaux-arts pour se rapprocher de l'objectivité du design, le typographe américain William Addison Dwiggins (1880–1956) aurait été le premier à employer le terme de «design graphique» en 1922.

Après les grands bouleversements de la Première Guerre mondiale, nombreux furent ceux qui misèrent sur les nouvelles technologies et la production de masse, ces dernières ayant déjà donné au monde tout un assortiment de merveilles techniques allant du téléphone et de la T.S.F aux automobiles et aux avions. Balayant la tradition artistique par le progrès industriel, ils avaient une foi quasi religieuse en la standardisation et un désir de dépouillement qui s'appliquait à tout, des meubles aux luminaires en passant par les livres et les affiches, cherchant les formes les

mass-production, which had already given the world an array of technical marvels from telephones and wireless radios to automobiles and aeroplanes. Sweeping artistic tradition away with industrial progress, there was a quasi-religious belief in the benefits of standardisation and an overwhelming desire to strip everything from furniture and lighting to posters and books down to their purest and most elemental form. At the same time new movements in fine art – Futurism, Constructivism

verknüpft mit der Förderung der Druckgrafik durch die britische Arts-and-Crafts-Bewegung und konzentrierte sich auf die Gestaltung von Plakaten und Büchern. Damals sahen selbst maschinengedruckte Arbeiten vielfach immer noch wie Handdrucke aus. Erst in den ersten Jahren des 20. Jahrhunderts bediente man sich der so genannten grafischen Künste, um umfangreiche integrierte Firmenauftritte in Text und Bild zu entwickeln. Ein Beispiel: 1907 wurde Peter Behrens (1868–1940) Architekt und künstlerischer Berater der AEG in Berlin und in der Folge der erste »Designer«, der ein solches Programm einführte. Jeder irgendwie

Top Poster for the US Army. James Montgomery Flagg, 1917.
Opposite Trademark for AEG. Peter Behrens, c.1908.

and De Stijl – emerged that also had a profound impact on the evolution of graphic design. Strongly influenced by these avant-garde impulses, graphic designers associated with the Bauhaus developed a new rational approach to graphic design, which involved the use of bold geometric forms, lower-case lettering and simplified layouts. Often incorporating photomontages, this new kind of graphic design was not only visually dynamic but also had a communicative clarity. Graphic designers aligned to Modernism rejected individual creative expression in favour of what was described by Jan Tschichold (1902–1974) as "impersonal creativity." At the Bauhaus designers such as Lásló Moholy-Nagy (1895–1946), Herbert Bayer (1900–1985) and Joost Schmidt (1893–1948) sought to codify a set of rational principles for graphic design practice through their endorsement of sans-serif typography, asymmetrical compositions and rectangular fluid grids, a preference for photography over illustration, and the promotion of standardized paper sizes.

Prior to and during the Second World War, the Swiss School built on the Bauhaus' developments in order to create a Modern form of graphic design known as the International Graphic Style, which had a

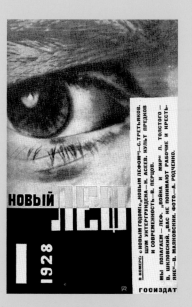

kreativ-künstlerisch tätige Mensch wurde damals noch als »Hans Dampf« in allen Gestaltungsgassen« angesehen, der heute vielleicht Möbel und Lampen und morgen Textilien oder Keramiken entwerfen konnte. Aus diesem Grund galt die Gebrauchsgrafik nur als eins von mehreren Betätigungsfeldern für Architekten und Künstler. Das bekannte Logo der Brauerei Carlsberg zum Beispiel wurde 1904 vom dänischen Töpfer und Möbeldesigner Thorvald Bindesbøll (1846–1908) entworfen.

Die Entwicklung des Grafikdesigns als separatem Berufszweig führte 1914 zur Gründung des New Yorker American Institute of Graphic Arts (AIGA), der ersten Institution, die gezielt zum Zweck der Förderung der »grafischen Künste« geschaffen wurde. Erst im Ersten Weltkrieg setzte sich jedoch das Grafikdesign als wichtiges Propagandamittel endgültig durch, vor allem durch die Arbeit von James Montgomery Flagg (1877–1960), Urheber des berühmten Rekrutierungsplakats mit der Überschrift »I Want You for US Army«, auf dem Onkel Sam (nach einem Selbstporträt Flaggs) als Anwerber erscheint. Nach dem Ersten Weltkrieg, im Jahr 1920, gründete sich in New York der Art Directors Club mit dem Ziel, der Gebrauchsgrafik mehr Anerkennung zu verschaffen, da dieses Gewerbe aufgrund falscher Behauptungen seiner Kritiker und eigener »darstellerischer Exzesse« beim breiten Publikum in Verruf geraten war. In der Folge veranstaltete der Art Directors Club Ausstellungen und gab Publikationen heraus, in denen die besten kreativen Werbegrafiken gezeigt wurden. Dadurch trug der Club zur Professionalisierung des Grafikdesigns bei. Der amerikanische Typograf William Addison Dwiggins (1880–1956) prägte 1922 den Begriff »graphic design«, der die Abkehr des neuen Berufszweigs von der Subjektivität der schönen Künste und seine Hinwendung zur Objektivität der

plus pures et élémentaires. Parallèlement, de nouveaux mouvements artistiques – le futurisme, le constructivisme, De Stijl – devaient marquer profondément l'évolution du design graphique. Très influencés par ces impulsions avant-gardistes, les graphistes associés au Bauhaus développèrent une nouvelle méthodologie rationnelle basée sur un recours à des formes géométriques simples, des lettres en bas de casse et des mises en pages épurées. Incorporant souvent des montages photographiques, ce nouveau type de graphisme était non seulement visuellement dynamique mais savait également communiquer avec clarté. Les graphistes associés au modernisme rejetèrent l'expression créative individuelle à la faveur de ce que Jan Tschichold (1902–1974) avait décrit comme de «la créativité impersonnelle». Au sein du Bauhaus, des créateurs tels que Lásló Moholy-Nagy (1895–1946), Herbert Bayer (1900–1985) et Joost Schmidt (1893–1948) cherchèrent à codifier une série de principes rationnels pour la pratique du design graphique, caractérisés par une typographie aux caractères sans empattement, des compositions asymétriques, des quadrillages rectangulaires et fluides, une préférence pour la photographie plutôt que pour l'illustration, ainsi que la pro-

DAS BAUHAUS IN DESSAU

Dessau, Mauerstraße 36　Fernruf 2896　Dichantgesellschaft Filiale Dessau

KATALOG DER MUSTER

VERTRIEB durch die

BAUHAUS GmbH

1929

**ᴀᴇᴛ A A
B ·N· A· B·
K· ᴠ·
ᴠᴀᴋ**

25 ᴊᴀᴀʀ

TENTOONSTELLING

ᴠᴀɴ **HEDENDAAGSCHE
KUNSTNYVERHEID
KLEINPLASTIEK
ARCHITECTUUR**

**STEDELYK MUSEUM
| AMSTERDAM**
29·JUNI — 28·JULI
GEOPEND ᴠᴀɴ 10-5
INGERICHT ᴅᴏᴏʀ ᴅᴇɴ **TENTOONSTELLINGS**
RAAD ᴠᴏᴏʀ **BOUWKUNST** ᴇɴ **VERWANTE KUNSTEN**

V. HUSZAR

39 univers

45 univers	46 *univers*	47 univers	48 *univers*	49 univers

53 univers	55 univers	56 *univers*	57 univers	58 *univers*	59 univers

63 univers	65 univers	66 *univers*	67 **univers**	68 ***univers***

73 **univers**	75 **univers**	76 ***univers***

83 **univers**

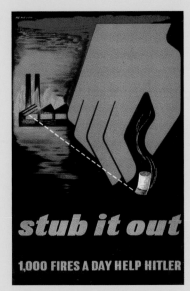

strong reductivist aesthetic that incorporated lots of "white space" and "objective photography" (i.e. realistic images). Precise, direct, and clinical, Swiss School graphic design was centred on the Modernist precept that "Form Follows Function."

During the Second World War, graphic designers, especially in Britain and America, produced bold propaganda posters that similarly displayed the formal purity and aesthetic economy of Modernism. Wartime designers such as Abraham Games (1914–1996), F.H.K. Henrion (1914–1990), and Jean Carlu (1900–1997), fused bold images with short yet powerful slogans, such as "Talk Kills," "We're in it together," and "America's Answer! Production," so as to produce a kind of non-narrative visual shorthand that conveyed the given public information message in the most direct manner possible. This type of high-impact visual communication that sought universal perception was later used for commercial purposes.

Opposite "Univers" typeface for Deberny & Peignot. Adrian Frutiger, 1954–57.
Top Poster for the British Ministry of Information. Frederick Henri Kay Henrion, 1943.
Right Poster for the Kunstgewerbemuseum, Zurich. Joseph Müller-Brockmann, 1960.

präzisen zeichnerischen Gestaltung reflektierte.

Nach den gewaltigen Umwälzungen, die der Erste Weltkrieg mit sich gebracht hatte, setzten viele Menschen ihre Hoffnung in neue Techniken und die Massenproduktion, die der Welt bereits eine Reihe technischer Wunderwerke von Telefonen und Radios bis zu Automobilen und Flugzeugen beschert hatten. Indem sie die kunsthandwerkliche Überlieferung zugunsten des industriellen Fortschritts aufgaben, glaubten sie mit nahezu religiöser Inbrunst an die Wohltaten der Standardisierung und gaben dem überwältigenden Drang nach, alles und jedes – von Möbeln und Beleuchtungskörpern über Plakate bis hin zu Büchern – auf die reinsten, elementarsten Formen zu reduzieren. Gleichzeitig gab es andere, neue Strömungen in der bildenden Kunst – Futurismus, Konstruktivismus, De Stijl –, welche die Entwicklung des Grafikdesigns ebenfalls entscheidend prägten. Unter dem Einfluss dieser avantgardistischen Impulse entwickelten die mit dem Bauhaus verbundenen Grafiker einen neuen rationalen Ansatz für ihre Kunst mit vorzugsweise geometrischen Formen, Kleinbuchstaben, vereinfachten Layouts und vielfach auch Fotomontagen. Diese neue Gestaltungsweise wirkte nicht nur dynamisch, sondern besaß auch große Klarheit in der Aussage. Die der Moderne verpflichteten Grafiker verwarfen den individuellen schöpferischen Ausdruck zugunsten dessen, was Jan Tschichold (1902–1974) als »unpersönliche Kreativität« bezeichnete. Künstler wie Làsló Moholy-Nagy (1895–1946), Herbert Bayer (1900–1985) und Joost Schmidt (1893–1948), die am Bauhaus lehrten, schufen einen Kodex rationaler, sachlicher Prinzipien des Grafikdesigns, zu denen serifenlose Schrifttypen, asymmetrische Kompositionen und fließende rechtwinklige Raster ebenso zählten wie genormte Papiermaße und der Vorrang der Fotografie vor der gezeichneten Illustration.

Vor und während des Zweiten Weltkriegs baute die Schweizer Schule des Grafikdesigns auf den Bauhausprinzipien auf, um eine

motion de formats de papier standardisés.

Avant et pendant la Seconde Guerre mondiale, l'Ecole suisse s'inspira des apports du Bauhaus afin de créer une forme moderniste de graphisme connue comme le « style graphique international ». Sa forte esthétique réductionniste intégrait beaucoup « d'espaces blancs » et de « photographie objective » (à savoir des images réalistes). Précis, direct et clinique, le graphisme de l'Ecole suisse était centré sur le principe moderniste : « la forme suit la fonction ».

Pendant la Seconde Guerre mondiale, les graphistes, notamment en Grande-Bretagne et aux Etats-Unis, produisirent des affiches de propagande stylisées très influencées par la pureté formelle et l'économie esthétique du modernisme. Les créateurs travaillant pendant la guerre, tels qu'Abraham Games (1914–1996), F. H. K. Henrion (1914–1990) ou Jean Carlu (1900–1997), conjuguèrent des images fortes avec des slogans brefs mais puissants tels que Talk Kills (« La parole tue ») ; We're in it together (« Serrons-nous les coudes ») et America's Answer : Production ! (« La réponse de l'Amérique : la production ! »), réalisant une sorte de raccourci visuel non narratif qui transmettait au public ciblé l'in-

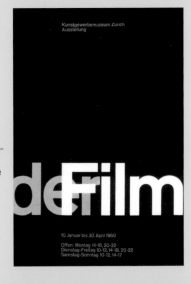

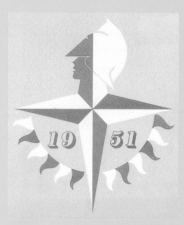

After the Second World War, graphic designers working in the United States, such as Herbert Matter (1907–1984) and Paul Rand (1914–1996), utilized the European avant-garde approach of dynamically combining typography and imagery in order to produce eye-catching, expressive and at times humorous graphic design work for high profile corporate clients, such as IBM and Knoll International. From the immediate postwar years to the late 1950s, there was a dramatic increase in the use of design as a marketing tool, which led to greater specialisation in design practice. By now, graphic design was recognised as a distinct profession rather than just a branch of a general design vocation. During this period the Swiss School's influence spread internationally through the success of Modern typefaces such as Helvetica designed by Max Miedinger (1910–1980) and Edouard Hoffmann in 1957, and Univers designed by Adrien Frutiger (b.1928) that same year, and also through the launch of the journal "New Graphic Design" in 1959. Large corporations increasingly employed graphic designers to help them differentiate their products in an ever-more competitive marketplace. At this time Modern graphic design became almost completely detached from its social foundations and instead became inextricably linked to the consuming desires of corporate advertising. In 1958 the Canadian-born communications theorist Marshall McLuhan (1911–1980) began undertaking an in-depth

moderne Form der Gestaltung zu entwickeln, die als Internationaler Grafikstil bekannt wurde und geprägt war von einer stark reduktionistischen Ästhetik mit vielen »weißen Flächen« und »objektiven Fotos« (d. h. realitätsgetreuen Bildern). Präzise, direkt und mit klinischem Blick stützte sich die Schweizer Schule auf das Motto der Moderne: »form follows function« – die Form folgt dem Zweck.

Im Zweiten Weltkrieg schufen besonders britische und amerikanische Grafiker gewagte Propagandaplakate, die in ähnlicher Manier die Reinheit und Ökonomie der Gestaltungsmittel der Moderne belegen. Amerikanische Grafiker wie etwa Abraham Games (1914–1996), F. H. K. Henrion (1914–1990) und Jean Carlu (1900–1997) verbanden in den Kriegsjahren starke Bilder mit kurzen, schlagkräftigen Slogans wie »Talk kills«, »We're in it together« oder »America's answer! Production«, um mit einer Art Bildstenografie die vorgegebene Botschaft so unmittelbar wie möglich auszudrücken. Diese hoch wirksame visuelle Kommunikationsmethode zielte darauf ab, von allen Bürgern wahrgenommen zu werden, und wurde später auch für kommerzielle Zwecke eingesetzt.

Nach dem Zweiten Weltkrieg folgten viele in den USA tätige Grafiker wie Herbert Matter (1907–1984) und Paul Rand (1914–1996) dem Ansatz der europäischen Avantgarde, indem sie typografische und bildliche Elemente mischten und so augenfällige, ausdrucksstarke und mitunter humorvolle Arbeiten für bedeutende Unternehmen wie IBM und Knoll International schufen. Von der unmittelbaren Nachkriegszeit bis Ende der 50er Jahre des 20. Jahrhunderts kamen grafische Werbemittel zunehmend im Marketing zum Einsatz, was zur größeren Spezialisierung der Grafikdesigner führte. Inzwischen wurde der Beruf des Werbegrafikers als eine spezifische Profession innerhalb der größeren Gruppe grafisch-

formation de la manière la plus directe possible. Ce type de communication à fort impact visuel visant à être universellement déchiffrable fut ensuite repris à des fins commerciales.

Après la Seconde Guerre mondiale, les graphistes travaillant aux Etats-Unis, dont Herbert Matter (1907–1984) et Paul Rand (1914–1996), utilisèrent la démarche européenne avant-gardiste en combinant de façon dynamique la typographie et l'iconographie pour produire des affiches accrocheuses, expressives et parfois humoristiques pour de grandes compagnies telles qu'IBM ou Knoll International. Entre les années de l'immédiate après-guerre et la fin des années 1950, on assista à l'essor considérable du design en tant qu'outil de commercialisation, ce qui entraîna une plus grande spécialisation. Le graphisme était désormais reconnu comme une profession à part entière et non plus comme une simple branche du design. Au cours de cette période, l'influence de l'Ecole suisse se fit sentir à l'échelle internationale grâce au succès de nouveaux types de caractères modernistes tels que Helvetica, créé par Max Miedinger (1910–1980) et Edouard Hoffmann en 1957, et Univers, conçu par Adrien Frutiger (né en 1928) la

Top Identity emblem for the Festival of Britain. Abraham Games, 1951.
Right Logo for IBM. Paul Rand, 1956.
Opposite Cover for "Art and Architecture" magazine. Herbert Matter, 1946.

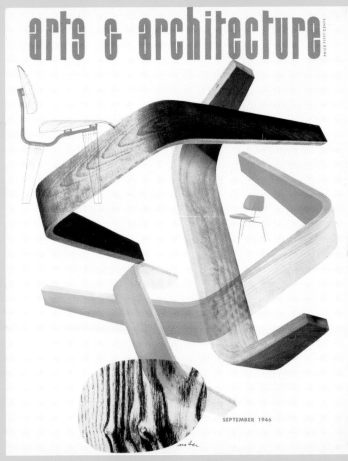

arts & architecture

PRICE FIFTY CENTS

SEPTEMBER 1946

analysis of contemporary advertising and subsequently concluded, "the Medium is the Massage" (a pun on the term "Mass Age" and an allusion to the media's soft pummelling of culture). What this "Oracle of the Electronic Age" had identified was that image had become more important than content. Of perhaps even greater significance, however, was McLuhan's questioning of where electronic media were ultimately taking society – a subject for debate that has certainy more pertinence now than when it was first raised.

By the late 1960s there was a fundamental questioning of Modernism and its de-humanizing aesthetic blandness. A new generation of graphic designers, including Wolfgang Weingart (b.1941) began ex-

gestalterischer Tätigkeiten anerkannt. In dieser Zeit wurde die Schweizer Schule weltweit bekannt und einflussreich, und zwar aufgrund des Erfolgs der von Schweizern entwickelten neuen Druckschriften: der Helvetica (1957) von Max Miedinger (1910–1980) und Edouard Hoffmann und der Univers (ebenfalls 1957 entstanden) von Adrien Frutiger (*1928) sowie infolge der Gründung der Zeitschrift »New Graphic Design« im Jahr 1959. Große Unternehmen stellten immer mehr Grafiker ein, um ihre Produkte in einem hart umkämpften Markt durch auffällige Werbung aus der Masse der Konkurrenzprodukte herauszuheben. In dieser Zeit erfolgte die fast völlige Loslösung der Gebrauchsgrafik von ihren gesellschaftlich-kulturellen Wurzeln, so dass sie seither als Werbegrafik untrennbar mit den

même année, ainsi que par le lancement en 1959 de la revue « New Graphic Design ». Un nombre croissant de grandes compagnies engagèrent des graphistes pour les aider à différentier leurs produits sur des marchés de plus en plus compétitifs. A cette époque, le design graphique moderniste se détacha presque entièrement de ses racines sociales pour devenir inextricablement lié aux exigences impérieuses de la publicité. En 1958, Marshall McLuhan (1911–1980), célèbre théoricien canadien spécialisé dans la communication, entama une analyse approfondie de la publicité de son temps et en conclut : « The Media is the Massage » (« Le média constitue le message en soi » ; jeu de mots sur le terme « Mass Age », l'âge des masses, et référence à l'aplanissement de la culture par les médias). Cet « oracle de l'ère électronique » avait déjà compris que l'image primait désormais sur le contenu. Plus important encore, McLuhan s'interrogeait sur la direction dans laquelle les médias électroniques entraînaient la société, un sujet à controverse qui est encore plus pertinent aujourd'hui qu'il ne l'était alors.

Vers la fin des années 1960, on assista à une profonde remise en cause du modernisme et de sa neutralité esthétique déshumanisante. Une nouvelle génération de graphistes, dont Wolfgang Weingart (né en 1941), expérimentèrent des compositions plus expressives tout en continuant à suivre la démarche moderniste de l'Ecole suisse. D'autres, tels que Milton Glaser (né en 1929), furent très influencés par le pop art, lui-même fortement inspiré par la publicité. Des artistes comme Andy Warhol (1928–1987), Richard Hamilton (né en 1922) et Peter Blake (né en 1932) puisaient leur inspiration dans le langage visuel de la culture populaire, brouillant encore un peu plus les distinctions entre les beaux-arts et l'art commercial. A la fin des années 1960, une pléthore d'affiches de protestation contre la guerre du Viêt Nam démontrèrent que les graphistes n'avaient pas besoin de recourir à une approche moderniste pour créer des travaux transmettant un message avec force. Tout au long de la décennie, le gra-

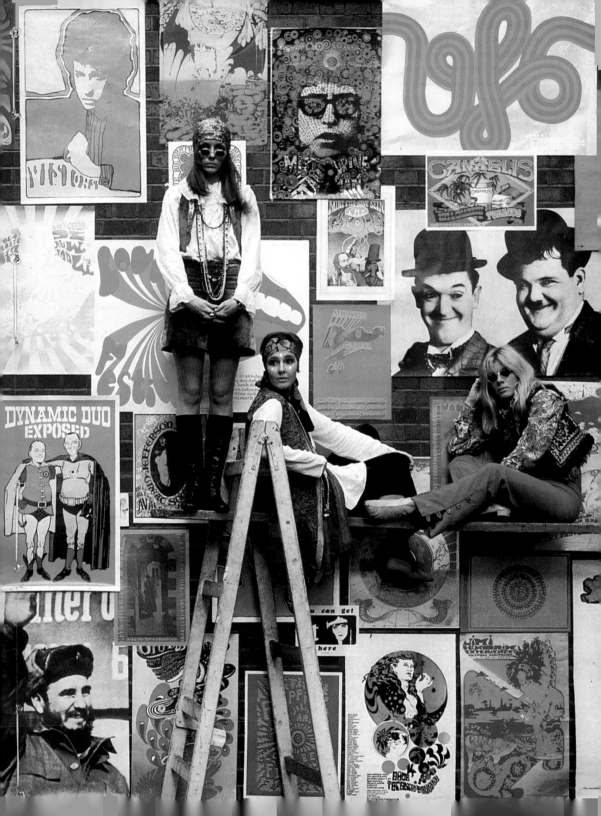

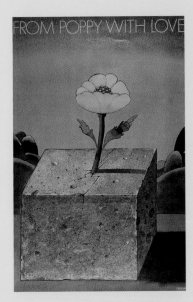

perimenting with more expressive compositions while continuing to follow the Modern approach of the Swiss School. Other graphic designers such as Milton Glaser (b.1929) were highly influenced by Pop Art, which had itself been influenced by commercial art. With artists such as Andy Warhol (1928–1987), Richard Hamilton (b.1922) and Peter Blake (b.1932) looking to the visual language of popular culture for inspiration, the distinctions between fine and commercial art became hazier. In the late 1960s, a plethora of anti-Vietnam War protest posters showed that designers did not have to use a Modernist approach in order to produce work that powerfully conveyed a message. Throughout the 1960s, graphic design expanded into new areas of visual communication such as television and film title sequences. The discipline was now also playing an increasing role in the dissemination of cultural publicity and public information as well as commercial advertising. By the late 1960s graphic designers were also beginning to ex-

Opposite Photograph by Patric Ward for the Observer magazine showing a hoarding of psychedelic posters, 1967.
Top Poster for Poppy Records. Milton Glaser, 1967.
Right Poster for Staatlicher Kunstkredit. Wolfgang Weingart,1978/79.

Zielen der konsum- und absatzorientierten Wirtschaft assoziiert wird. 1958 begann der kanadische Kommunikationswissenschaftler Marshall McLuhan (1911–1980) mit der Arbeit an seiner gründlichen Untersuchung der aktuellen Situation im Bereich der Werbegrafik und folgerte: »The medium is the massage,« (Wortspiel mit dem Begriff »Mass Age« – Massenzeitalter – und der sanften Bearbeitung der Gesellschaft durch das Medium). Mit seinem »Orakel des Elektronikzeitalters« stellte McLuhan fest, dass das Bild wichtiger geworden war als der Inhalt. Von noch größerer Bedeutung war möglicherweise die von McLuhan gestellte Frage, wohin die elektronischen Medien die Menschheit letzten Endes führen würden – ein Diskussionsthema, das mit Sicherheit heute noch wichtiger ist als damals.

Ende der 60er Jahre wurden die Konzeptionen der Moderne und ihre menschenfeindliche ästhetische Fadheit grundlegend in Frage gestellt. Eine neue Grafikergeneration, zu der auch Wolfgang Weingart (* 1941) zählte, begann mit expressiveren Kompositionen zu experimentieren, während sie andererseits dem modernen Ansatz der Schweizer Grafikschule treu blieb. Andere Grafiker wie Milton Glaser (* 1929) waren stark von der Pop Art geprägt, die ihrerseits Einflüsse aus der Werbegrafik aufgenommen hatte. Durch das Schaffen von Künstlern wie Andy Warhol (1928–1987), Richard Hamilton (* 1922) und Peter Blake (* 1932), die ihre Inspiration aus der Bildsprache der Alltagskultur bezogen, verwischten sich die Grenzen zwischen der bildenden Kunst und freien Grafik einerseits und dem zweckbestimmten Grafikdesign (Gebrauchs-/Werbegrafik) andererseits. Eine Fülle von Anti-Vietnamkrieg-Plakaten der späten 60er Jahre belegen, dass ihre Urheber keinen klassisch-modernen Ansatz benötigten, um Grafiken mit starker Aussagekraft zu schaffen. In den 60er Jahren eroberte das Grafikdesign neue Gebiete der visuellen Kommunikation, unter anderem das Fernsehen und die Vor- und Abspannsequenzen von Spielfilmen. Grafiker spielten nun außer im Bereich der

phisme s'étendit à de nouveaux domaines de la communication visuelle tels que la télévision et le cinéma. La discipline jouait désormais un rôle croissant dans la diffusion de la culture et de l'information publique tout comme dans la publicité. Vers la fin de cette période, les graphistes commencèrent également à exploiter les grandes avancées technologiques survenues dans le tirage photographique, qui leur offraient une liberté créative bien plus grande ainsi qu'une impression couleur moins chère et de meilleure qualité.

A la fin des années 1960 et au cours des années 1970, le graphisme devint encore plus étroitement associé au marketing, de nombreuses sociétés commandant de nouveaux logos – langage universel du capitalisme d'entreprise – afin d'être toujours plus compétitives sur un marché de plus en plus planétaire et basé sur l'image. En réaction à la banalité et à l'uniformité du langage visuel de l'entreprise, l'ère du verseau fut marquée par l'apparition tonitruante et kaléidoscopique du poster psychédélique, soit l'antithèse même de l'affiche inspirée de l'Ecole suisse. Devant le désenchantement croissant face au modernisme et sa récupération par les multinationales, de nombreux graphistes cherchèrent des alternatives. En Grande-Bretagne à la fin des années 1970, le mouvement punk servit de catalyseur à la naissance d'une nouvelle approche,

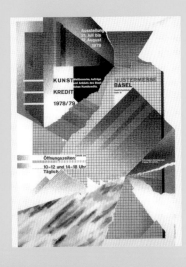

ploit the enormous changes taking place in photographic print technology, which allowed them a far greater degree of creative control and provided them with cheaper and better quality colour printing.

Graphic design became even more closely tied to marketing during the late 1960s and the 1970s with many companies commissioning new logos – the universal language of corporate capitalism – in an effort to compete more effectively in an increasingly global and image-based world. As a reaction against the ascendancy of the banal uniformity of corporate visual language, the Age of Aquarius saw the lurid kaleidoscopic dawn of the psychedelic poster, which was the very antithesis of the Swiss School. In response to growing disenchantment with Modernism and its perceived complicity with big business, many other designers began seeking alternative approaches to graphic design. In the late 1970s, the Punk movement acted as a catalyst for the birth of a new approach to graphics in Britain, which was exemplified by the Sex Pistols' God Save the Queen record sleeve (1977) designed by Jamie Reid (b.1940). This brash rough-and-ready-made anarchic style not only captured the energy and frustrated anger of contemporary youth-culture, but also intentionally mocked the staid aesthetic refinement of Modernism.

Around the same time a New Wave of post-modern graphic design swept Holland and America. Although retaining certain Swiss School elements, New Wave graphic design subverted the holy grid of Modernism and playfully incorporated eclectic cultural references from art, photography, film, advertising and iconic graphic designs from the past. New Wave designers such as Jan van Toorn (b.1932) and April Greiman (b.1948) replaced Modern objectivity with a post-modern subjectivity that evoked viewer response through a new kind of visual poetry. Inspired by the emergence of new forms of electronic media, Californian New Wave work incorporated deconstructed compositions so as to produce a sense of messages being

kommerziellen Werbung auch eine wichtige Rolle in der Verbreitung sozio-kultureller Inhalte und Informationen von öffentlichem Interesse. Ab Ende der 60er Jahre nutzten Grafikdesigner außerdem die revolutionäre neue Offset-Drucktechnik, die mit Druckfilmen arbeitet. Sie erlaubte ihnen ein größeres Maß an kreativer Steuerung des Herstellungsprozesses und lieferte billigere Farbdrucke von besserer Qualität.

Ende der 60er und in den 70er Jahren rückte die angewandte Grafik in noch größere Nähe – und Abhängigkeit – vom Marketing, als viele Unternehmen neue Firmenlogos – Universalvokabeln des privatwirtschaftlichen Kapitalismus – in Auftrag gaben. Damit sollte ihre Wettbewerbsfähigkeit in einem globalen und imageabhängigen Markt gesteigert werden. Als Reaktion auf den Vormarsch banaler Uniformität in der öffentlichen Selbstdarstellung der Industrieunternehmen erlebte das Zeitalter des Wassermanns die grelle kaleidoskopische Geburt des psychedelischen Plakats – der exakten Antithese des rationalen Designs der Schweizer Schule. Infolge ihrer wachsenden Unzufriedenheit mit der Nüchternheit des klassischen Moderne und dem Gefühl, zu Komplizen des Big Business geworden zu sein, suchten viele Grafiker nach alternativen Gestaltungsarten und -mitteln. Die Punk-Bewegung der späten 70er Jahre gab in Großbritannien den Anstoß zu einer neuen grafischen Kunstrichtung, für die das Plattencover der LP »God Save the Queen« (1977) der Sex Pistols beispielhaft ist. Der Entwurf stammte von Jamie Reid (* 1940). Dieser grellbunte, krude, anarchische Stil hielt nicht nur die Energie und frustrierte Wut der damaligen Jugendkultur im Bild fest, sondern nahm auch ganz bewusst die konservativ-seriösen ästhetischen Raffinessen der Moderne auf die Schippe.

Etwa zur gleichen Zeit kam in den Niederlanden und den USA die New

illustrée par la pochette du disque des Sex Pistols «God Save the Queen» (1977), réalisée par Jamie Reid (née en 1940). Ce style anarchique, agressif et fruste traduisait l'énergie et la colère frustrée de la jeunesse tout en parodiant intentionnellement le raffinement esthétique et guindé du modernisme.

Vers la même époque, un nouvelle vague de graphismes postmodernes déferla sur la Hollande et les Etats-Unis. Tout en conservant certains des éléments de l'Ecole suisse, ils détournaient le sacro-saint quadrillage moderniste en introduisant de manière ludique des références éclectiques à l'art, à la photographie, au cinéma, à la publicité et aux motifs graphiques emblématiques du passé. Des graphistes new wave tels que Jan van Toorn (né en 1932) ou April Greiman (née en 1948) remplacèrent l'objectivité moderniste par une subjectivité postmoderne qui

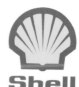

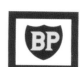

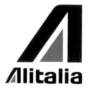

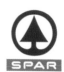

Right Logos for Shell and BP. Raymond Loewy Associates, 1967 & 1968. Logos for Alitalia and Spar. Landor Associates, 1969 & 1970.
Opposite Cover for the Sex Pistols'"God Save the Queen" single. Jamie Reid, 1977.

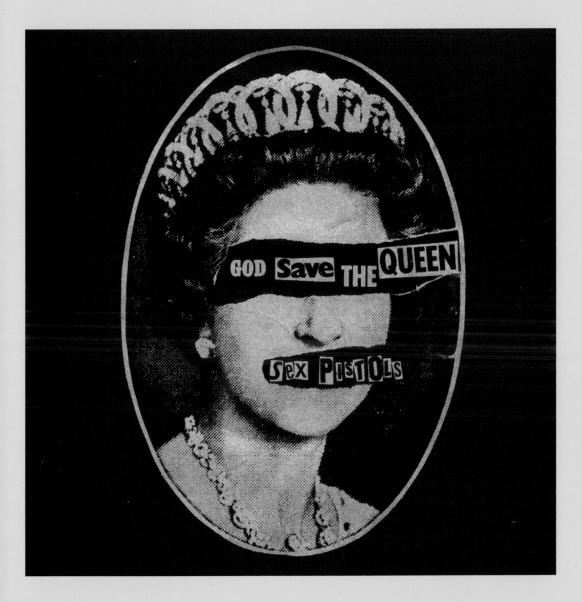

filtered through layers, which in turn affected a strong three-dimensional quality or visual depth. Using Apple Macintosh software, designers created a language of hybrid imagery with encoded messages, while the seemingly random placement of collage-like images provided their work with a refreshing vitality. In 1982, the launch of the large-format graphic magazine Emigre by Rudy Vander-Lans (b.1955) and Zuzana Licko (b.1961) disseminated the ideas be-

Wave des postmodernen Grafik-designs auf. Obwohl sie bestimmte Elemente der Schweizer Schule beibehielten, warfen die New-Wave-Grafiker doch insgesamt das gehei-ligte Paradigma der Moderne über den Haufen und bauten spielerisch Versatzstücke aus Malerei und Plas-tik, Fotografie und Film, Werbung und historischen Grafik-»Ikonen« in ihre Entwürfe ein. Grafiker wie Jan van Toorn (* 1932) und April Greiman (* 1948) ersetzten klassisch-moderne

évoquait la réaction du spectateur à travers une forme de poésie visuelle. Inspirée par l'émergence de nou-veaux médias électroniques, la nou-velle vague californienne proposait des compositions déconstruites qui créaient l'impression de messages filtrés par des couches superposées, ce qui apportait en retour une forte qualité tridimensionnelle ou de la profondeur visuelle. A l'aide des logi-ciels d'Apple Macintosh, les gra-phistes inventèrent un langage ico-

hind this new movement in graphic design to a much wider international audience. Eventually, post-modernism came to mean a multiplicity of graphic styles (often appropriated), which were characterised by visually arresting, layered compositions of frequently indecipherable meaning.

During the 1980s the increasing emphasis on image over content led to the meteoric rise of "the brand", which, with the right help from graphic designers, transcended national preferences to become a globally understood seal of approval. Companies such as Levi's and Nike were quick to understand that "cutting-edge" graphic design could give their products a distinct competitive advantage. At a time when the social glue of traditional institutions,

Objektivität durch postmoderne Subjektivität und ihre neue Art visueller Poesie fand bei den Betrachtern Anklang. Inspiriert von den neuen elektronischen Medien schufen kalifornische New-Wave-Grafiker auch dekonstruierte Kompositionen, um den Eindruck zu erwecken, dass die grafisch umgesetzten Inhalte durch mehrere Schichten gefiltert waren, was eine deutlich dreidimensionale Qualität bzw. optische Tiefe erzeugte. Unter Einsatz von Apple-Macintosh-Software entwickelten Designer in Kalifornien eine Art hybride Bildsprache mit verschlüsselten Botschaften, während die scheinbar zufällige Platzierung von collagenhaften Bildern ihren Arbeiten eine erfrischende Vitalität verliehen. 1982 gründeten Rudy van der Lans (* 1955) und Zuzana Licko (* 1961) die Zeitschrift

nographique hybride contenant des messages codés, tandis que l'insertion apparemment aléatoire d'images rappelant des collages donnait à leurs travaux une vitalité rafraîchissante. En 1982, le lancement de la revue de typographie grand format « Emigre » par Rudy VanderLans (né en 1955) et Zuzana Licko (née en 1961), propagea les idées de ce nouveau mouvement à un public international beaucoup plus vaste. Au bout du compte, le postmodernisme en vint à signifier une multiplicité de styles graphiques (souvent récupérés) caractérisés par des compositions multicouches, visuellement frappantes et au sens fréquemment indéchiffrable.

Au cours des années 1980, la primauté croissante de l'image sur le contenu entraîna l'essor météorique de la « marque » qui, avec l'aide avisée des graphistes, transcendait les préférences nationales pour devenir un label d'approbation compris partout dans le monde. Des compagnies telles que Levi's et Nike comprirent rapidement qu'un design graphique « dans le vent » pouvait donner à leurs produits un net avantage sur la concurrence. A une époque où se fragmentait la cohésion sociale des institutions traditionnelles, de la famille nucléaire à la religion organisée, les marques offraient aux consommateurs un sentiment d'appartenance à un groupe, « sans les responsabilités », qui les aidaient à définir leur propre image. Façonner une marque consiste avant tout à projeter des aspirations et à créer des désirs. C'est l'emballage (le style) plutôt que le produit (le contenu) qui nous séduit à un niveau affectif, d'où le fait que certains logos commerciaux soient vénérés comme de véritables idoles. Toutefois, le facteur de « bien-être » s'émousse rapidement quand on sait que ces baskets ou ces vêtements aux prix exorbitants ont été fabriqués par des ouvriers du Tiers Monde payés une misère. Un sentiment de culpabilité peut alors rapidement venir ternir les ors de la marque. Tout au long des années 1980 et jusqu'au début des années 1990, les graphistes se sont fait les complices de l'essor fulgurant de ce culte du logo, au point de paraître presque totalement insen-

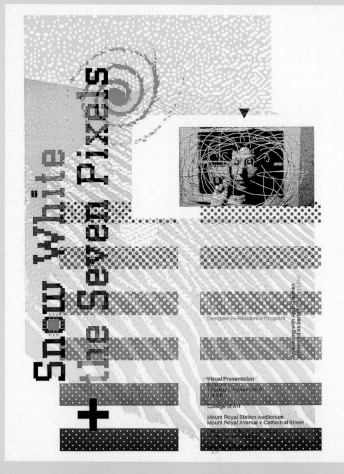

Snow White + the Seven Pixels

Designer-in-Residence Program

An evening with April Greiman
presented as part of the

Visual Presentation
8:00 pm
Thursday, November 6
1986
Maryland Institute
College of Art

Mount Royal Station Auditorium
Mount Royal Avenue + Cathedral Street

from the nuclear family to organized religion, was becoming unstuck, brands offered the consumer a no-strings-attached sense of belonging while helping them define their self-image. Branding is essentially all about the projection of aspirations and the creation of desires. It is the package (style) rather than the product (content) that appeals to us on an emotional level, and this is the reason why certain commercial logos are worshipped like religious idols. The feel-good factor of a brand, however, can be quickly eroded with the knowledge that those ludicrously expensive trainers, clothes, etc. have been made by wage-slaves in the Third World – quite simply the gilt can turn to guilt. Throughout the 1980s and early 1990s the graphic design profession aided and abetted the meteoric rise of "the brand" and appeared almost completely blinkered to the ills of rampant consumerism.

By the early 1990s, post-modernism had escaped from the confines of design institutions and the music and art scenes and became widely embraced by corporate marketeers desperately searching for the elusive elixir of cool – the very life blood of branding. At long last the gulf between progressive educational theory and mainstream professional practice appeared to have been bridged. There was, however, a growing realisation among a new generation of Late Modern designers – many of whom are included in this survey – that style and content are equally important in the creation of Good Design solutions. Today's New Pluralism in graphic design must be seen on the one hand as a response to the greater multiculturalism of today's global society, and on the other as being prompted by the strong desire of designers to develop their own unique style, which enables them to stand out from the crowd. Many designers are challenging traditional notions of beauty with provocative work that expresses radical ideas. The majority of image-makers working today have been strongly inspired by developments in art and film and have incorporated aspects of these disciplines into their work, which has in turn led to a

Opposite Poster for "Snow White + Seven Pixels" presentation. April Greiman, 1986.
Right Calendar for Mart. Jan van Toorn, 1972.

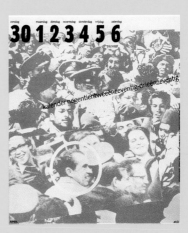

»Emigre«, die einem breiteren internationalen Publikum das Gedankengut der neuen Strömung in der Gebrauchsgrafik vermittelte. In diesem kreativen Bereich bedeutete Postmoderne schließlich eine Fülle unterschiedlicher Stile (häufig auch übernommener Formen), die sich durch optisch reizvolle, geschichtete Kompositionen mit häufig unentzifferbarer Bedeutung auszeichneten.

In den 80er Jahren führte die wachsende Bevorzugung von Bild und Piktogramm gegenüber dem Text zum kometenhaften Aufstieg der »Marke«, die mit kongenialer Unterstützung des Grafikers nationale Vorlieben hinwegfegte, um zum weltweit akzeptierten Gütesiegel zu werden. Firmen wie Levi's und Nike begriffen sehr schnell, dass eine treffsichere Werbung ihren Produkten entscheidende Wettbewerbsvorteile verschaffen konnte. In einer Zeit, in der der gesellschaftliche Leim in Form überlieferter Institutionen – von der Kleinfamilie bis zur kirchlich organisierten Religion – seine bindende Kraft zu verlieren begann, boten Marken den Konsumenten das Gefühl der Zusammen- und Zugehörigkeit ohne Verpflichtungen und halfen ihnen, ihr Selbstbild zu definieren, denn bei der Markenbildung geht es im Wesentlichen um die Projektion von Hoffnungen und Zielsetzungen und um die Erzeugung von Wünschen. Es ist die Verpackung (Stil) und nicht das Produkt (Inhalt), die uns emotional anspricht, und das ist auch der Grund dafür, dass bestimmte Markenzeichen buchstäblich vergöttert werden. Der Wohlfühlfaktor einer Marke kann sich jedoch schnell verflüchtigen, wenn man erfährt, dass diese oder jene wahnsinnig teuren Sportschuhe, Pullover usw. von Lohnsklaven in der Dritten Welt angefertigt worden sind – aus dem Wohl- kann schnell ein Schuldgefühl werden. In den 80er und frühen 90er Jahren unterstützte und förderte die gesamte Grafikdesignbranche den Aufstieg der »Marke« und es schien fast, als sei sie angesichts der Übel eines ungebremsten Konsumdenkens mit Blindheit geschlagen.

sibles aux maux du consumérisme galopant.

Au début des années 1990, le post-modernisme s'était échappé des confins des institutions du design, de la musique et de l'art pour être largement récupéré par les départements de marketing dans leur quête désespérée de l'élixir volatil du « cool », le nerf de la stratégie de marque. Finalement, le gouffre entre la théorie pédagogique progressiste et la pratique professionnelle au sens large semblait avoir été comblé. Toutefois, parmi la nouvelle génération de graphistes du « modernisme tardif », dont bon nombre figurent dans cet ouvrage, on a pu observer une prise de conscience croissante du fait que le style et le contenu sont aussi importants l'un que l'autre dans la création de solutions pour un « Bon Design ». Le nouveau pluralisme d'aujourd'hui doit s'interpréter, d'une part, comme une réaction au multiculturalisme accru de notre société planétaire et, de l'autre, comme l'expression du puissant désir des graphistes de développer leur propre style afin de se démarquer du lot. Bon nombre d'entre eux remettent en question les critères traditionnels de beauté en réalisant des projets provoquants qui expriment des idées radicales. La majorité de ceux qui fabriquent des images aujourd'hui ont été fortement inspirés par les nouveaux courants de l'art et du cinéma et ont intégré des aspects de ces disciplines dans leurs travaux, ce qui, en retour, a élargi l'interprétation de

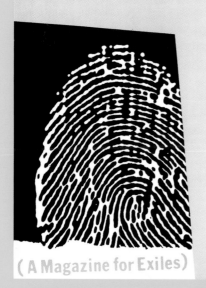

(A Magazine for Exiles)

ce que constitue exactement le graphisme. Des graphistes tels que M/M (Paris), Devis & van Deursen ou Jonathan Barnbrook ont tissé des liens étroits avec le monde de l'art. Toutefois, dans la plupart des cas, leur travail demeure assujetti au projet de leur client et, à ce titre, ne peut prétendre à la liberté créative d'un art à part entière, à moins d'être entrepris par eux-mêmes pour eux-mêmes. Afin de laisser parler leur propre créativité et d'exprimer leurs idées personnelles, un nombre croissant de graphistes financent donc leurs travaux exploratoires et expérimentaux avec les revenus de commandes commerciales bien rémunérées (c'est notamment le cas de Jonathan Barnbrook). Beaucoup ont compris que l'ambiguïté peut créer une impression de mystère, ce qui aide à capter puis à retenir l'attention du spectateur. De par ce phénomène, le graphisme est souvent utilisé non plus pour résoudre des problèmes de communication mais pour soumettre des énigmes au public. On remarque également un nombre croissant de graphistes produisant des travaux qui reposent davantage sur le texte, avec un message unique direct et puissant qui n'est plus ouvert à une multitude d'interprétations. La forme directe des messages vient souvent du fait que l'annonceur incarne un idéal et veut promouvoir sa cause avec la plus grande clarté possible. Depuis le début des années 1990, le « subvertising » (jeu de mots entre subvert, « ébranler, faire échouer » et advertising, « publicité ») avec son carambolage de messages commerciaux fait preuve d'une grande efficacité communicative dans sa tentative de mener une révolution antimondialiste. En effet, on paraît aujourd'hui de plus en plus convaincu que la simplification est souvent le meilleur moyen de filtrer l'information dans un océan sans fond de futilités. Il semble qu'à l'avenir, les graphistes auront l'obligation de devenir des « architectes de l'information » afin de créer des outils qui aideront l'utilisateur à mieux naviguer sur les eaux complexes de l'ère numérique.

La longue complicité entre le métier de graphiste et les grandes entre-

broader interpretation of what actually constitutes graphic design. Designers such as M/M (Paris), Mevis & van Deursen and Jonathan Barnbrook have developed close associations with the art world; however, their work in most cases remains constrained by the client's brief and as such can never match the complete creative freedom of art unless it is undertaken by themselves, for themselves. Increasingly designers are therefore subsidizing self-initiated exploratory and experimental work that allows them to express their

Anfang der 90er Dekade war die Postmoderne aus den Beschränkungen der Designinstitutionen, der Musik- und Kunstszene ausgebrochen und eroberte die Welt der Marketingfachleute, die verzweifelt auf der Suche waren nach dem schwer zu fassenden Elixier, dem Herzblut der Markenbildung, dem man den Namen »Cool« gegeben hatte. Endlich war die Kluft zwischen progressiver Bildungstheorie und gängiger Berufspraxis überwunden, so schien es. Allerdings machte sich unter den jüngeren Grafikern der

own creative individuality and personal ideas with revenues from well-paid commercial work (Jonathan Barnbrook for instance). Many have realised that uncertain meaning can evoke a sense of mystery, which can help to capture and hold the viewer's attention. This phenomenon has led graphic design to be used not as a means to solve a communication problem, but as a way of posing the viewer with a communicative riddle. There are also, however, a growing number of designers who are producing more text-based work, which has a single, powerfully direct message that is not open to a multitude of interpretations. Often the directness of messages comes about because the communicator stands for an ideal and wants to promote his/her cause with the utmost clarity. Since the early 1990s, "Subvertising" with its jamming of corporate messages has displayed a strong communicative directness in its attempt to help spearhead an anti-globalisation revolution. Certainly there is now a growing realisation that simplification is often the best way to filter information from an endless ocean of trivia, and that in the future the onus will be on graphic designers to become "information architects" so that they can create

Spätmoderne – von denen viele in diesem Buch vertreten sind – die Erkenntnis breit, dass Stil und Inhalt für gute Designlösungen gleichermaßen erforderlich sind. Der aktuell herrschende neue Pluralismus im Grafikdesign muss einerseits als Folge der größeren Multikulturalität unserer Weltgemeinschaft gesehen werden und andererseits als Ergebnis des ausgeprägten Bemühens vieler Designer um ihren ureigenen Stil, der sie von der Masse abhebt. Viele Grafiker stellen die herkömmlichen Schönheitsbegriffe in Frage, und zwar mittels provokanter Arbeiten, in denen sie radikale Konzepte ausdrücken. Die meisten heute tätigen Bildermacher lassen sich stark von Kunst und Film inspirieren und verarbeiten diese Anregungen, was dazu geführt hat, dass der Begriff Grafikdesign derzeit weiter gefasst und interpretiert wird als früher. Designer wie M/M (Paris), Mevis & van Deursen und Jonathan Barnbrook pflegen enge Beziehungen zur Kunstszene. Ein Großteil ihrer Arbeitsleistung ist jedoch den Vorgaben der Kunden unterworfen und sie können daher niemals die völlige schöpferische Freiheit des bildenden Künstlers erlangen, es sei denn, in ihrer Freizeit zum eigenen Vergnügen. Daher subventionieren Grafikdesigner (zum Beispiel Jonathan Barnbrook) in zunehmendem Maße eigene experimentelle Initiativen aus den Erlösen gut bezahlter Aufträge aus der Wirtschaft. Diese Projekte erlauben es ihnen, künstlerische Individualität zu entwickeln und eigene Ideen umzusetzen. Viele haben erkannt, dass unbestimmte Inhalte etwas Geheimnisvolles haben, das geeignet ist, die Aufmerksamkeit des Betrachters auf sich zu ziehen und gefangen zu halten. Aufgrund dieses Phänomens werden grafische Entwürfe nicht länger als Mittel zur Lösung einer Kommunikationsaufgabe gesehen, sondern als Chance, den Betrachter in das kommunikative Rätsel einzubeziehen. Andererseits gibt es eine

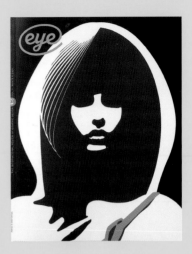

prises a conduit à l'expansion rapide et à la mondialisation d'une culture commerciale. Il est peut-être temps pour ces professionnels de s'interroger sur les fondements éthiques du travail qu'ils produisent. Le graphisme a été trop longtemps utilisé cyniquement comme un moyen d'inciter les consommateurs des pays industrialisés à acheter plus de produits dont ils avaient besoin alors que, dans les pays en voie de développement, des millions de gens n'ont toujours pas accès à l'eau potable, à suffisamment de nourriture, à des médicaments de base et à une éducation même rudimentaire. Pire encore, ces produits superflus sont souvent réalisés dans des ateliers clandestins par des ouvriers exploités et appartenant aux couches les plus démunies de notre société planétaire. Les graphistes ont trop souvent aidé les entreprises à mettre leurs marques en valeur, masquant ces détails sous des campagnes bien léchées. Plutôt qu'aider à vendre des produits discutables – des boissons alcoolisées pour adolescents, des cigarettes, des mauvais produits alimentaires, des voitures polluantes et autres produits pétrochimiques nuisant à l'environnement, ils pourraient mettre leur ingéniosité communicative au service de préoccupations sociales et écologiques vitales. De fait, c'est ce qui est en train de se produire au niveau populaire comme on peut le constater en feuilletant le magazine « Adbusters ».

Opposite Emigre magazine, issue 1. Rudy Vanderlands, 1984.
Left Wall-painted title sequence for the Biennale di Venezia. M/M (Paris) in collaboration with Philippe Parreno, Pierre Huyghe and Dominique Gonzalez-Foerster, 1999.
Top Eye magazine. UNA (London) designers, illustration Jasper Goodall, 2001.

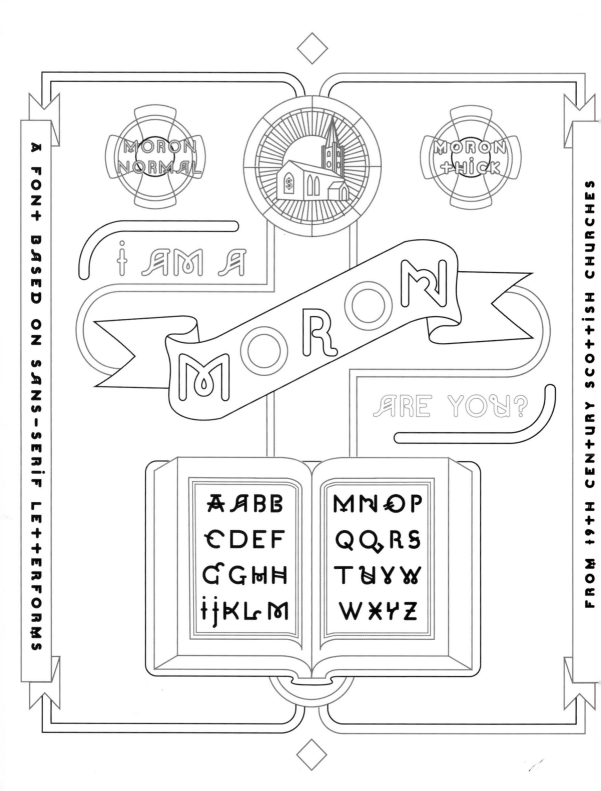

tools that help the user to better navigate the complex seas of the digital age.

The long-standing complicity of the graphic design profession with big business has led to the rapid expansion and globalisation of commercial culture, and perhaps it is now time for practitioners to question the ethical basis of the work they produce. For too long, graphic design has been cynically used as a means to induce people in the developed world to buy more products they don't really need, when in developing nations literally millions still do not have access to clean water, sufficient food, basic medicines or rudimentary education. To make matters worse, these superfluous marketing-driven products are often made in exploitative sweatshops by the most deprived members of our global society. Yet all too frequently, graphic designers have helped corporations gloss over such brand-depreciating details with slick ad campaigns. Rather than helping to sell questionable products – from alcopops, cigarettes and junk food to gas-guzzling cars and environmentally damaging petrochemicals – graphic designers could use their

Opposite Specimen sheet for the typeface 'Moron'. Jonathan Barnbrook, 2001.
Top "Los Amorales" book for Artimo. Mevis & van Deursen, 2001.
Right Corporate flag for Adbusters. Shi Zhe Yung, 2000.

wachsende Anzahl von Grafikern, die stärker auf Text basierende Arbeiten mit einer einzigen, eindrucksvoll direkten Botschaft entwickeln, die eben nicht eine Vielzahl von Interpretationen zulässt. Die Unmittelbarkeit entsteht in diesen Fällen, weil der Mitteilende ein Idealist ist, der seinen »Fall« mit äußerster Deutlichkeit und Klarheit vorbringen will. Seit Anfang der 90er Jahre hat die Praxis des »Subvertising« (subverting und advertising = Subversion und Werbung) mit ihrer Verballhornung von Firmenwerbungen eine ausgeprägte Direktheit des Kommunikationsstils an den Tag gelegt, die dazu dienen soll, den Kampf gegen die Globalisierung anzuführen. Auf jeden Fall wächst heute die Erkenntnis, dass Vereinfachung in vielen Fällen die beste Methode ist, um wichtige Informationen aus einer endlosen Flut von Trivialitäten herauszufiltern, und dass Grafiker in Zukunft die Pflicht haben, sich zu »Informationsarchitekten« auszubilden, damit sie Werkzeuge schaffen, die dem Benutzer dabei helfen, die vielfältigen Klippen des Computerzeitalters mit mehr Geschick und Effizienz zu umschiffen.

Die lange während Allianz der Gebrauchsgrafiker mit dem Big Business hatte die rasche Expansion und Internationalisierung der Konsum- und Werbekultur zur Folge und es ist daher vielleicht für die in diesem Bereich arbeitenden kreativen Köpfe an der Zeit, die ethischen Grundlagen ihrer Arbeit zu überprüfen. Allzu lange ist die grafische Kunst auf zynische Weise dazu missbraucht worden, die Menschen in den hoch entwickelten Ländern zum Kauf von Produkten zu verleiten, die sie nicht wirklich brauchen, während buchstäblich Millionen in den unterentwickelten Ländern noch nicht einmal sauberes Trinkwasser, ausreichend Nahrungsmittel und die nötigsten Medikamente haben oder eine rudimentäre Schulbildung genießen. Die Situation wird noch dadurch verschlimmert, dass die von den Marketingabteilungen im Westen georderten überflüssigen Waren häufig unter unmenschlichen Bedingungen von den ärmsten Mitgliedern der globalen Gesellschaft zu Hungerlöhnen hergestellt werden.

Par-dessus tout, les graphistes d'aujourd'hui doivent reconnaître qu'ils sont investis d'une responsabilité particulière (et la capacité d'y faire face) non seulement vis-à-vis de leurs clients mais face à la société dans son ensemble. Le pouvoir persuasif phénoménal du design graphique pourrait être maîtrisé et orienté de manière à modifier radicalement la façon dont nous réfléchissons aux questions importantes de l'avenir, du réchauffement de la planète à la dette du Tiers Monde. Bien que tous les travaux réalisés par les graphistes ne relèvent pas du domaine de la prise de décision éthique, la profession doit encore faire basculer la balance du commercial au social si elle veut rester une force culturelle pertinente et vitale.

*Note des auteurs : dans cet essai, nous examinons le design graphique en termes de combinaison de textes et d'images. Naturellement, la typographie en tant que spécialisation des arts graphiques a une histoire beaucoup plus longue.

communicative ingenuity to highlight vital social and environmental concerns. In fact this is already happening at a grassroots level, as can be gleaned from a casual perusal of Adbusters magazine.

Above all else, graphic designers working today need to acknowledge that they have a special responsibility (and ability to respond) not just to the needs of their clients, but also to those of society as a whole. The phenomenal persuasive power of graphic design could be harnessed and directed in such a way that it radically alters the way people think about the important issues of the future, from global warming to third world debt. Although not all the work done by graphic designers falls into the realm of ethical decision-making, the profession still needs to tip the balance from the commercial to the social if it is to remain a relevant and vital cultural force.

Please note: for the purpose of this essay we are viewing graphic design in terms of the combination of text and image. Typography as a specialisation of graphic design has, of course, a much longer history.

Allzu oft haben Werbegrafiker den westlichen Firmen noch geholfen, derartige »markenschädigende« Informationen mittels Hochglanz-Werbekampagnen zu vertuschen. Anstatt Beihilfe zum Absatz fragwürdiger Produkte zu leisten – von Alcopops (alkoholhaltigen Limonaden), Zigaretten und ungesundem Fastfood bis zu bleispuckenden Autos und umweltschädlichen Chemikalien –, könnten Grafiker ihr kommunikatives Talent dazu benutzen, lebenswichtige soziale und ökologische Belange ans Licht der Öffentlichkeit zu bringen. Tatsächlich passiert das schon jetzt – und zwar an der Basis –, wie man schon beim flüchtigen Durchblättern der Zeitschrift »Adbusters« (Anzeigensprenger) bemerkt.

Vor allem anderen aber müssen Grafiker einräumen, dass sie eine besondere Verantwortung dafür tragen (und auch dazu fähig sind), nicht nur die Bedürfnisse ihrer Auftraggeber zu erfüllen, sondern auch die der Gesellschaft als Ganzes. Die phänomenale Überzeugungskraft des Grafikdesigns könnte so mobilisiert und eingesetzt werden, dass sie eine radikale Umkehr im Denken der Menschen über wichtige Zukunftsfragen herbeiführt – von der Erwärmung der Erdatmosphäre bis zum Schuldenberg der Entwicklungsländer. Obwohl nicht alle Arbeiten von Grafikdesignern den Bereich ethischer Entscheidungsfindungen berühren, müssen die Mitglieder der Profession noch den Schritt vom überwiegend kommerziellen zum überwiegend sozialen Engagement vollziehen, wenn sie eine relevante und lebendige kulturtreibende Kraft bleiben wollen.

Anmerkung: In diesem Essay beschreiben die Begriffe Gebrauchsgrafik oder Grafikdesign die Zusammenstellung von Text und Bild. Die Typografie als spezielle Form der Gebrauchsgrafik blickt natürlich auf eine viel längere Geschichte zurück.

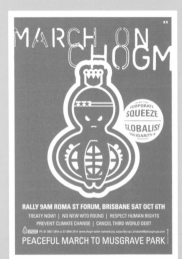

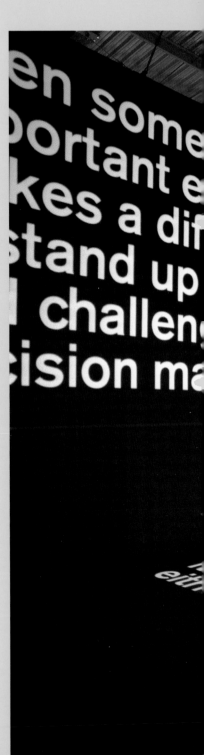

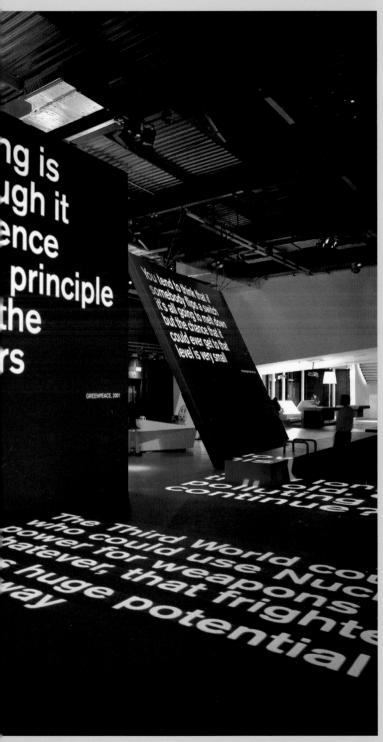

GREENPEACE, 2001

Opposite Poster for Commonwealth Heads of
Government Meeting protest march. Inkahoots, 2001.
Left Exhibition graphics and projected typo-animated
audio-visual installation debating the issues relating to
nuclear power for the Science Museum at BNFL
Visitors Centre, Sellafield, UK. UNA (London)
designers, 2002.
Top Adbusters magazine. Cover design Banksy, Art
Director Paul Shoebridge, 2002.

Aboud Sodano

"It's only a job, but a good job."

Opposite page:

Project
Paul Smith Spring /
Summer 2002 advertising
print campaign
Photography: Sandro
Sodano

Title
Irreverence

Client
Paul Smith, London

Year
2002

PAUL
SMITH

WESTBOURNE HOUSE, 122 KENSINGTON PARK ROAD, LONDON W11 •
120 KENSINGTON PARK ROAD, LONDON W11 • 40-43 FLORAL STREET,
LONDON WC2 • 84-86 SLOANE AVENUE, LONDON SW3 • 7 THE COURTYARD,
THE ROYAL EXCHANGE, CORNHILL, LONDON EC3 • 22 BOULEVARD RASPAIL,
75007 PARIS • 108 FIFTH AVENUE, NEW YORK, NY 10011 • PALAZZO
GALLARATI SCOTTI, VIA MANZONI 30, 20121 MILANO • www.paulsmith.co.uk

"I really don't think that my vision of the future of graphic design is that relevant or indeed important. Every aspiring designer should stick to his or her beliefs. What I do care about in my work is that it is original, appropriate, and never patronising. My long-term goal is to achieve a healthy and equal balance between design that works strategically but doesn't pollute the environment, and design that creatively pushes boundaries, whether they be aesthetic or about choice of medium. I would ideally like to use the skills that I have as a designer to take on board some social responsibility, as I am actually aware that it is designers of my generation and the one previous that are responsible for the saturation of the High Street with ubiquitous and meaningless design."

» Ich glaube wirklich nicht, dass meine Vision des Grafikdesigns der Zukunft so relevant oder gar bedeutungsvoll ist. Alle aufstrebenden Grafiker und Grafikerinnen sollten ihren Überzeugungen treu bleiben. Mir ist bei meinen Arbeiten wichtig, dass sie originell und passend sind und niemals gönnerhaft wirken. Langfristig verfolge ich das Ziel, eine gesunde Ausgewogenheit zwischen strategisch wirksamen – dabei aber nicht zur Umweltverschmutzung beitragenden – Entwürfen und einem Design herzustellen, das kreativ Grenzen überschreitet, egal ob diese im Bereich von Stil und Ästhetik liegen oder in der Wahl des Mediums. Am liebsten würde ich meine Fähigkeiten und mein erworbenes Wissen als Grafiker dafür einsetzen, soziale Verantwortung zu übernehmen, weil mir bewusst ist, dass die Designer meiner Generation und der Generation meiner Eltern für die allgegenwärtige, sinnlose Grafik unserer Einkaufsstraßen verantwortlich sind.«

«Je ne pense pas que ma vision de l'avenir de la création graphique soit pertinente ni ait la moindre importance. Tout aspirant graphiste devrait s'en tenir à ce qu'il croit. Ce qui m'importe dans mon travail, c'est qu'il soit original, approprié et jamais condescendant. Mon objectif à long terme est de parvenir à un équilibre sain entre un graphisme stratégiquement efficace mais respectueux de l'environnement et un stylisme qui repousse de manière créative les frontières tant esthétiques que celles liées au choix du média. Dans l'idéal, j'aimerais me servir de mon savoir-faire pour assumer une forme de responsabilité sociale, car je me rends compte que les graphistes de ma génération et de celle qui nous a précédés ont saturé les rues de nos villes d'images omniprésentes et insignifiantes.»

Aboud Sodano
Studio 26
Pall Mall Deposit
124–128 Barlby Road
London W10 6BL
UK

T +44 20 8968 6142
F +44 20 8968 6143

E mail@
 aboud-sodano.com

www.aboud-sodano.com

Design group history
1989 Co-founders Alan Aboud and Sandro Sodano graduated from Saint Martin's School of Art, London
1990 Established partnership and formed Aboud Sodano
Alan Aboud appointed worldwide Art Director for Paul Smith
Responsible for the image of all Paul Smith lines
1992 Working with The Terrence Higgins Trust, Aboud Sodano created charity's first non-gender specific HIV-AIDS information cards
1993 Produced the promotion and advertising for The Whitney Museum of American Art's retrospective exhibition of the works of Nan Goldin
1995 Designed and art directed "The Lady is a Tramp", by David Bailey
1998 Commenced moving image work; completed 'Paul's Shorts', a ten-minute set of short

stories for Paul Smith's accessories range, co-directed with Rory Hanrahan
1999 Commenced working with Levi Strauss Europe, integral part of the creation of Levi's Engineered Jeans; working closely with Caroline Parent, Creative Director of Levi Strauss, established the concept and brand values for the reinvention of the Levi's Brand Creative consultants on the Levi Strauss advertising account at BBH, London
2001 In conjunction with Hasan & Partners, Helsinki, Alan Aboud executed the concept and art direction of Hennes and Mauritz advertising campaigns; "You can find inspiration in anything*", a book about the life of Paul Smith, a project that Aboud Sodano conceived with publisher Robert Violette and designed for Violette Editions

Founders' biographies
Alan Aboud
1966 Born in Dublin
1989 BA (Hons) Graphic Design, Saint Martin's School of Art, London
1995 Birth of twin boys, Victor Sylvester and Milo Van
Sandro Sodano
1966 Born in Newport, Wales
1989 BA (Hons) Graphic Design, Saint Martin's School of Art, London
2001 Birth of daughter Constanza Velvet

Recent awards
2002 Silver Award, British D&AD; Silver Cube Award, New York Art Directors Club; Gold Award, Art Directors Club of Europe

Clients
Citizen Watches
Inter Parfums
Joi'x
Paul Smith
Peters and Beach
Purple Public Relations
Violette Editions
Visionary Living
Yoshinaga

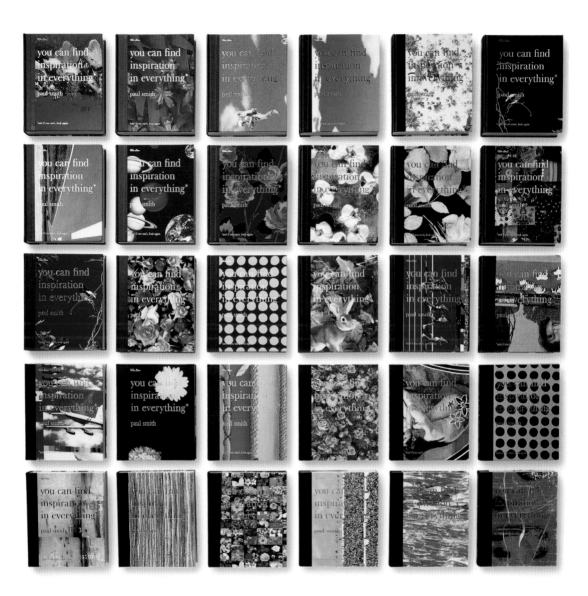

Project
A book about the life
of Paul Smith (image
featuring thirty different
covers available)

Title
You can find inspiration in
anything, and if you can't,
look again

Client
Violette Editions, London

Year
2001

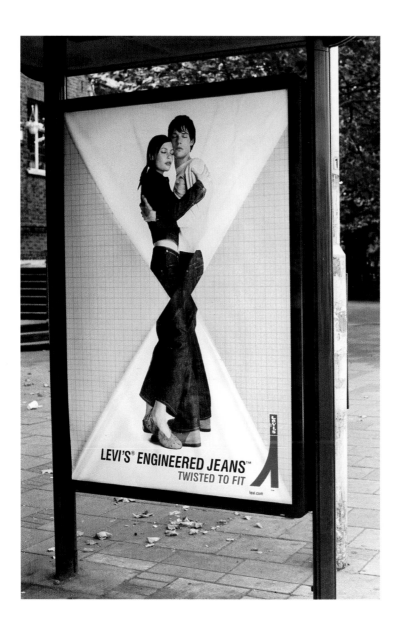

Project
Levi's Engineered Jeans
outdoor print campaign
Photography: Rankin

Title
Twisted to fit

Client
Bartle Bogle Hegarty,
London

Year
2000

Opposite page:

Project
Paul Smith Autumn
Winter 2002 advertising
print campaign
Photography: Sandro
Sodano

Title
Opposites

Client
Paul Smith, London

Year
2002

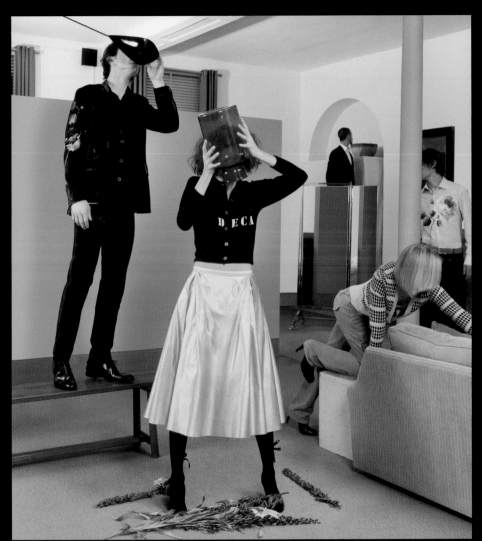

Paul Smith

PAUL SMITH

WESTBOURNE HOUSE, 122 KENSINGTON PARK ROAD, LONDON W11 •
120 KENSINGTON PARK ROAD, LONDON W11 • 40-44 FLORAL STREET,
LONDON WC2 • 84-86 SLOANE AVENUE, LONDON SW3 • 7 THE COURTYARD,
THE ROYAL EXCHANGE, LONDON EC3 • 22-24 BOULEVARD RASPAIL,
75007 PARIS • 108 FIFTH AVENUE, NEW YORK, NY 10011 • PALAZZO
GALLARATI SCOTTI, VIA MANZONI 30, 20121 MILANO • www.paulsmith.co.uk

Acne

"Work hard. Have fun."

Opposite page:

Project
Art project: Ärliga blå
ögon

Title
Ärliga blå ögon / Honest
blue eyes

Client
Peter Geschwind / Johan
Zetterquist / Roger
Andersson

Year
2001

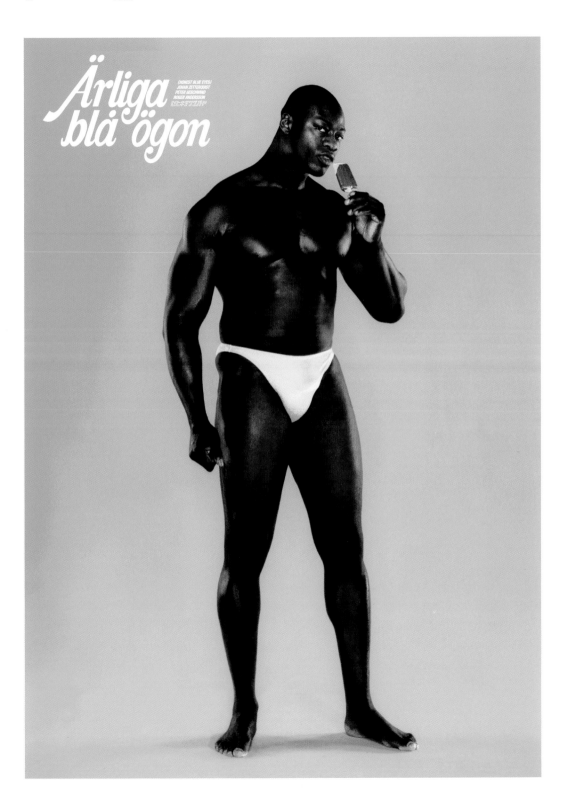

(HONEST BLUE EYES)
JOHAN ZETTERKVIST
PETER JÄSCHWIND
ROGER ANDERSSON

Ärliga
blå ögon

"We live in a 24hr design-driven society where nothing is left un-designed. A need for more graphic design is nowhere to be found in this image infrastructure. Instead, we are in search of great ideas. Design is only a translation of great ideas. Great ideas are what we remember from history and what will make a difference in the future."

» Wir leben heute in einer Welt, die rund um die Uhr von Design getrieben ist, in der es nichts Ungestaltetes mehr gibt. In dieser piktografischen Infrastruktur lässt sich nirgends ein Bedarf für mehr Grafikdesign entdecken. Statt dessen suchen wir nach herausragenden Ideen, denn Grafik ist immer nur die Übersetzung großer Ideen. Aus der Geschichte bleiben immer die großen Visionen in Erinnerung und die werden auch in Zukunft etwas bewegen und verändern.«

« Nous vivons dans une société où tout passe en permanence par le design. Dans cette infrastructure de l'image, nous n'avons pas besoin de plus de graphisme. En revanche, nous sommes en quête de bonnes idées. La création graphique n'est que la traduction de bonnes idées. Elles sont ce que nous retenons de l'histoire et ce qui fera la différence à l'avenir. »

Acne
Majorsgatan 11
114 47 Stockholm
Sweden

T +46 8 555 799 00
F +46 8 555 799 99

E contact@acne.se

Design group history
1996 Co-founded by Tomas Skoging, Jonny Johansson, Jesper Kouthoofd and Mats Johansson in Stockholm
1998 founded ACNE Action Jeans company
1999 founded Netbaby World Online entertainment company
2000 founded ACNE Film production company; ACNE set up its own advertising agency

Founders' biographies
Tomas Skoging
1967 Born in Uppsala, Sweden
1995 Berghs Advertising School, Stockholm
Jonny Johansson
1969 Born in Karlskrona, Sweden
Self-taught
Jesper Kouthoofd
1970 Born in Gothenburg, Sweden
1995 Berghs Advertising School, Stockholm
Mats Johansson
1968 Born in Stockholm
1993–1995 Berghs Advertising School, Stockholm
Pontus Frankenstein (Acne Creative)
1970 Born in Jönkoping, Sweden
1996 Beckmans School of Design, Stockholm
David Olsson (Acne Film)
1975 Born in Stockholm
Self-taught

Recent awards
2000 Shortlisted, Cannes Lions (x 4); Winner, EPICA; Jury's Special Prize, Utmärkt svensk form (Excellent Swedish Design); Best Music Video, Grammy (Sweden); Advertising Effectiveness Award (Film); Shortlisted, Swedish Golden Egg (Film)
2001 Advertising Effectiveness Awards (Film); Fashion Designer of the Year, Elle Magazine, Stockholm; shortlisted, Cannes Lions (x 1); Winner, EPICA; Finalist, EPICA; Winner, Eurobest Länsförsäkringar; shortlisted, Swedish Golden Egg, (Graphic Design); Silver (x 2), Swedish Golden Egg (Film & Print)
2002 Shortlisted, Swedish Golden Egg (x 2 Film & x 1 Radio); Bronze Award, Clio (Graphic design & product design)

Clients
Diesel
Ericsson
Harvey Nichols
H&M
JC
Microsoft
Nissan
Nokia
OLW
SAS
Telia
TV4
Whyred

Project
Scandinavian Airlines / children concept

Title
Ole

Client
SAS / Scandinavian Airlines

Year
2000

Opposite page:

Project
Zoovillage

Title
Spring campaign

Client
Zoovillage.com

Year
2000

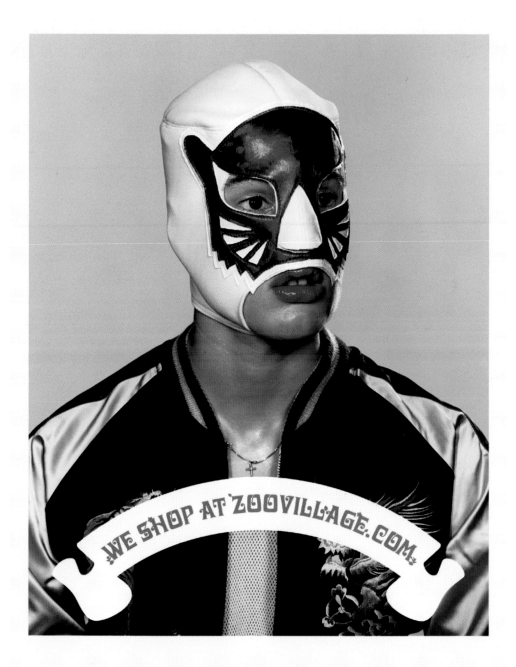

Your local streetwear store. Open 24hrs.

Project
Book – cover and inlay
design

Title
Media så funkar det /
Media – How it works

Client
Mattias Hansson /
Bokförlaget DN

Year
2000

Project
Digibird / packaging

Title
Sparrow

Client
Wunderkind / Acne

Year
2001

Alexander Boxill

"Appropriate, creative, structured."

Opposite page:

Project
Company Brochure

Title
Company brochure

Client
Self-published

Year
2001

"If this question is about us, then we find it very difficult to answer as the future is one thing we try not to think about … graphic design doesn't exist in isolation and our interests do not lie in just graphic design. Our vision, our design and our needs change as we respond to the changes around us. However, if this question is a more generic probe, then the 'future' would seem to equal an education system which continually increases the amount of graphic design students while decreasing the amount of tutors … and therefore the 'vision' would seem to predict bad news for us all."

»Wenn es bei dieser Frage um unsere eigene berufliche Zukunft geht, haben wir Schwierigkeiten, sie zu beantworten, denn wir versuchen, überhaupt nicht an die Zukunft zu denken … Der Grafiker lebt und arbeitet ja nicht abgeschieden von der Welt und wir interessieren uns auch nicht nur für Grafik. Unsere Vision, unsere Entwürfe und Bedürfnisse wechseln je nachdem, wie wir auf die Veränderungen in unserer Umgebung reagieren. Wenn sich die Frage jedoch auf die Fachdisziplin bezieht, denken wir bei ›die Zukunft‹ an das Bildungssystem, das immer mehr Grafikstudenten hervorbringt, während es zugleich die Anzahl der Lehrer verringert … dann würde unsere Zukunftsvision wohl eher düster aussehen.«

«Si la question porte sur nous, il nous est très difficile de répondre dans la mesure où nous essayons de ne pas penser à l'avenir… Le graphisme seul n'existe pas et nous ne nous intéressons pas au graphisme en soi. Notre vision, notre objectif et nos besoins changent à mesure que nous réagissons aux changements autour de nous. Si la question est d'ordre générique, l'avenir semble nous réserver un système éducatif où il y aurait toujours plus d'étudiants en design graphique et de moins en moins de professeurs… donc une ‹vision› plutôt pessimiste pour tous.»

Alexander Boxill
Unit 1
Providence Yard
Ezra Street
London E2 7RJ
UK

T/F +44 20 7729 0875

E info@
 alexanderboxill.com

Design group history
1994 Co-founded by
Jayne Alexander-Closs
and Violetta Boxill in
London

Founders' biographies
Jayne Alexander-Closs
1969 Born in Niath, Wales
1989–1992 BA (Hons)
Graphic Design, Central
St Martins College of Art
and Design, London
1992–1994 MA Graphic
Design, Royal College
of Art, London
1994+ Lectured at Central
St Martins College of Art
and Design, London;
Middlesex University;
Portsmouth Polytechnic;
Colchester University
Violetta Boxill
1970 Born in London
1989–1992 BA (Hons)
Graphic Design,
Middlesex University
1992–1994 MA Graphic
Design, Royal College
of Art, London
1994+ Lectured at Central
St Martins College of Art
and Design, London;
Middlesex University;
Portsmouth Polytechnic;
Colchester University

Clients
British Council
Business Design Centre
Converse
Design Council
Habitat
Hayward Gallery
Laurence King Publishing
NAM
Royal College of Art
Somerset House Trust
Thames and Hudson

Project
Product style guide

Title
Converse Fall 2001

Client
Converse Europe

Year
2001

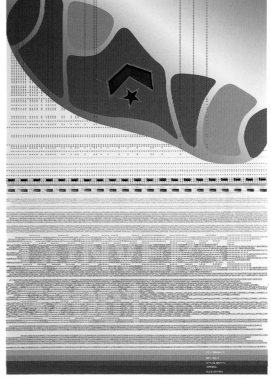

Project
Product style guide

Title
Converse Summer 2001

Client
Converse Europe

Year
2001

Opposite page:

Project
Part of the creative
package + identity for a
new art fair

Title
Fresh Art Fair

Client
Business Design Centre

Year
2001

FRESH ART IS A NEW ART FAIR
THAT WILL PROVIDE A RARE PLATFORM
FOR INDIVIDUAL INDEPENDENT
ARTISTS TO SHOW AND SELL THEIR
WORK DIRECTLY TO AN ENTHUSIASTIC
BUYING AUDIENCE

**THE CONCEPT FOR
A NEW ART FAIR**

Artists will be allocated stands
within specific zones including:
• Painting
• Sculpture
• Print
• Photography
• Drawing
• New Media

There will also be a provision
for Fine Art Studio groups
to participate within these
specified zones.

In addition fresh art will provide
a vibrant and competitive
atmosphere for fine art
college graduates to launch
their careers. These graduate
artists will exhibit within a
dedicated zone.

A selection panel will be put
in place to ensure the quality
of the artists selected to
exhibit within these zones.
Potential exhibitors will be
approached through current
partnerships with organisations
such as Britart.com and AXIS
in addition to our current lists
of artists as well as through
advertisements in key and
highly supportive media such
as Art Review magazine.

Ames Design

"Amidst all of the hype of modern design and computers, we have remained true by generating the majority of our designs by hand, viewing the computer as a tool and not letting it dictate our designs."

Opposite page:

Project
Rock poster

Title
East Block

Client
Pearl Jam

Year
2000

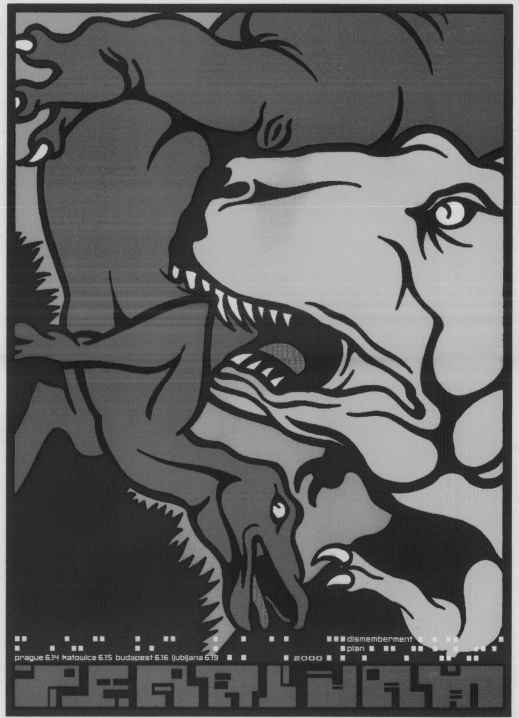

Ames Design / Scribellum Press

"Rage against the machine. The almighty computer has made every housewife and hobbyist a 'designer', bringing mediocrity to the masses. We predict a backlash sparking a throwback era of design in which designers are craftsmen performing a craft. The phrases 'Make it pop' and 'It's got to be more sexy' will be dead to us."

»Wüten gegen die Maschine. Der all-mächtige Computer hat aus jeder Hausfrau und jedem Hobbykünstler einen ›Designer‹ gemacht und damit massenhaft Mittelmaß verbreitet. Wir prognostizieren, dass eine Gegen-reaktion einsetzen und eine rück-wärtsgewandte Design-Epoche einlei-ten wird, in der Designer wieder als Kunsthandwerker ihr Handwerk und ihre Kunst ausüben werden. Phrasen wie ›es muss poppig sein‹ oder ›es muss sexier sein‹ werden dann nichts mehr bedeuten.«

«Sus à la machine! L'ordinateur tout-puissant a fait de toutes les ména-gères et de tous les amateurs des ‹créateurs›, apportant la médiocrité aux masses. Nous prédisons un retour de bâton, suscitant un renou-veau de l'époque où le graphiste était un vrai artisan. Les expressions ‹Rends-le popu› ou ‹Faut que ça soit plus sexy› n'auront plus aucun sens pour nous.»

Ames Design
1735 Westlake Ave N.
#201
Seattle
WA 98109
USA

T +1 206 516 3020
F +1 206 633 2057

E ames@speakeasy.net

www.amesbros.com

Design group history
1996 Co-founded by Coby Schultz and Barry Ament in Seattle, Washington

Founders' biographies
Coby Schultz
1971 Born in Helena, Michigan
1993 Graphic Design, Montana State University
1994–1995 Freelance designer, Seattle
1996+ Co-founder, Ames Design, Seattle

Barry Ament
1972 Born in Big Sandy, Michigan
1992 Graphic Design, Montana State University Dropout
1993–1996 Graphic Designer, Pearl Jam Inc., Seattle
1996+ Co-founder, Ames Design, Seattle

Recent exhibitions
2002 "Paper, Scissors, ROCK!: 25 years of Northwest Punk Poster Design", USA travelling exhibition

Recent awards
1999 Grammy Nomination
2001 Bronze, One Show

Clients
Amazon.com
Bates USA
Bozell
EMP
Epic Records
Fallon McElligott
Foote, Cone & Belding
Geffen Records
Giro Helmets
Got Milk?
House of Blues
K2 Snowboards
Kompan Playgrounds
MTV
Morrow Snowboards
Neil Young
Nike
Nissan
Pearl Jam
Phish
PowerBar
Red Bull
Ride Snowboards
Sony Music
TBWA/Chiat/Day
Virgin Records
Warner Bros.
Weiden & Kennedy

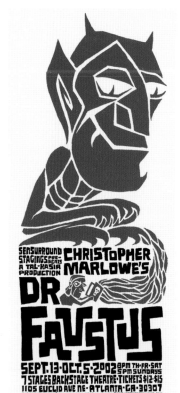

Project
Play poster

Title
Dr. Faustus

Client
Sensurround Stagings

Year
2002

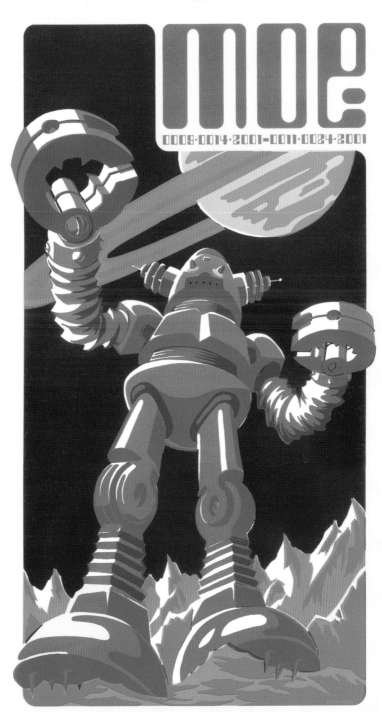

Project
Rock poster

Title
10th Anniversary

Client
Moe.

Year
2001

Project
Snowboard

Title
Fuse Series

Client
K2 Snowboards

Year
2000

Opposite page:

Project
Play Poster

Title
The Clive Barker Project

Client
Sensurround Stagings

Year
2002

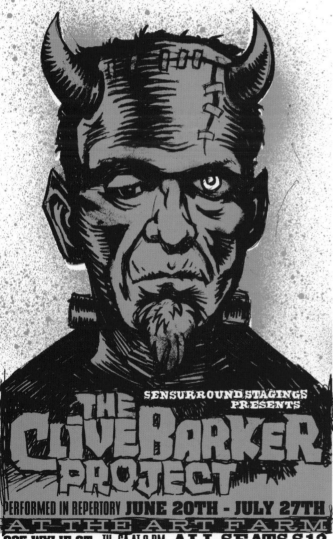

Philippe Apeloig

"Graphic design is the intersection point between art and communication."

Opposite page:

Project
Poster for a group
exhibition

Title
Celebrating the Poster

Client
Eastern Kentucky
University, Richmond,
USA

Year
2000

"Having come of age at a time when the computer was introduced and subsequently embraced as a radical new design tool and solution, I and other designers of my generation are seeing it now dominate almost every aspect of design. Design is fundamentally idea-oriented, and designers carry profound influence in their power to shape and communicate cultural concepts. The future of design lies as much in this active and critical role within society as it does in the further development of technology. Graphic design is the art of visualizing ideas, activating space, intuiting proportion. It is the result of meticulous attention to detail. Good graphic design prompts the viewer to meditate, often unconsciously, on potent word/image combinations. Good graphic design is always memorable."

» Da ich in einer Zeit groß geworden bin, in der der Computer aufkam und als radikal neues Gestaltungswerkzeug angewendet wurde, erlebe ich wie andere Grafiker meiner Generation, dass er fast das ganze grafische Gestalten beherrscht. Unsere Arbeit beruht auf Ideen und wir Grafiker üben mit unserer Vermittlung kultureller Konzepte tief greifenden Einfluss aus. Die Zukunft unserer Zunft liegt ebenso in dieser kritischen Rolle wie in der technischen Weiterentwicklung. Grafikdesign ist die Kunst, Gedanken zu visualisieren, Flächen und Räume zu aktivieren und Proportionen zu erspüren. Sie ist das Ergebnis minutiöser Detailarbeit. Gutes Grafikdesign lässt den Betrachter – oft unbewusst – über eindringliche Text-Bild-Kompositionen nachdenken. Gutes Grafikdesign bleibt immer im Gedächtnis haften.«

« Les graphistes semblent se libérer de l'utilisation systématique de l'ordinateur, qui a été considéré comme l'outil miracle capable de résoudre tous les problèmes graphiques. Le design est une question de concept et de communication. Notre avenir sera guidé par le développement des nouvelles technologies et par le rôle actif et critique des designers dans la société. Certes il ne s'agit pas de négliger les aspects techniques : la composition d'une page, le souci des proportions, la qualité de la typographie et l'usage des couleurs ; mais le graphisme est avant tout l'art de visualiser des idées. J'aime qu'une affiche donne l'idée de mouvement, de spontanéité, et cela résulte d'un contrôle minutieux de chaque détail. Je veux interpeller le public, le pousser à méditer sur la combinaison entre mot(s) et image(s). Le résultat doit se fixer dans la mémoire. »

Philippe Apeloig
41, rue Lafayette
75009 Paris
France

T +33 1 43 55 34 29
F +33 1 43 55 44 80

E apeloigphilippe@
wanadoo.fr

www.apeloig.com

Biography
1962 Born in Paris, France
1981–1985 Art and Applied Arts, École Nationale Supérieure des Arts Appliqués/École Nationale Supérieure des Arts Décoratifs, Paris
1984 Diplôme of the École Nationale Supérieure des Arts Appliqués BTS Visual Arts (Brevet de Technicien Supérieur), Paris

Professional experience
1983 Internship, Total Design, Amsterdam
1985 Internship, Total Design, Amsterdam
1985–1987 Graphic designer, Musée d'Orsay, Paris
1988 Internship, April Greiman's studio, Los Angeles
1989 Founded Philippe Apeloig Design in Paris
1992–1998 Taught typography, École Nationale Supérieure des Arts Décoratifs, Paris
1993 Art Director, Le Jardin des Modes, Paris
1993–1994 Grant from the French Ministry of Culture to research typography at the French Academy of Art, Villa Medici, Rome
1997+ Design consultant, Musée du Louvre, Paris
1999+ Full-time faculty member, Cooper Union for the Advancement of Science and Art, New York
2001+ Curator, Herb Lubalin Study Center of Design and Typography, Cooper Union for the Advancement of Science and Art, New York

Recent exhibitions
1998 Solo exhibition, DDD Gallery, Dai Nippon Printing, Osaka
1999 Solo exhibition, GGG Gallery, Dai Nippon Printing, Tokyo
2000 International Poster Exhibition in Tokushima, Japan; Eastern Kentucky University, Richmond, Kentucky; "Graphic Design, Philippe Apeloig Graphic Design / Posters, Imaging and Multimedia", The Cooper Union School of Art, New York City; "The Lingering Memory": Philippe Apeloig Posters, solo exhibition, Maryland Institute College of Art
2000–2001 Coexistence, Museum on the Seam, Jerusalem, world touring exhibition
2001 "Inside the Word", solo exhibition, Galerie Anatome, Paris; "Le Musée s'affiche – Posters for Museums", solo exhibition, Maison Française of NYU; Graphismes, exhibition at the French National Library for the 50th anniversary of the AGI, Paris; "Nouveau Salon des Cent", exhibition for the centenary of Toulouse-Lautrec's death, touring exhibition; "Typo-Janchi", Seoul typography biennale, Korea
2003 Solo exhibition, University of the Arts, Philadelphia USA

Recent awards
1998 Certificate of Excellence, STD, International TypoGraphic Awards 98, England
1999 Special Jury Award, Tokyo Type Directors Club
2000 Certificate of Typographic Excellence, New York Type Directors Club
2001 Red Dot Award for High Design Quality, Germany

Clients
Achim Moeller Fine Art, New York
American Jewish Historical Society
Arc en rêve, Centre d'Architecture, de Design et d'Urbanisme
Association Française d'Action Artistique
Carré d'Art, Contemporary Museum of Art and Library
Cité du Livre in Aix en Provence
École Nationale Supérieure des Arts Décoratifs, Paris
Éditions Odile Jacob, Paris
Fnac
Imprimerie Nationale, France
Institut National d'Histoire de l'Art, Paris
Knoll
Linotype Library, Germany
Maison Française de New York University
Musée d'Art et d'Histoire du Judaïsme, Paris
Musée des Beaux-Arts de Montréal
Musée du Louvre
Musée d'Orsay
Octobre en Normandie Festival
Réunion des Musées Nationaux, Paris

Opposite page:

Project
Project for the French National Board of Education

Title
Liberté / Egalité / Fraternité

Client
French Ministry of National Education

Year
2001

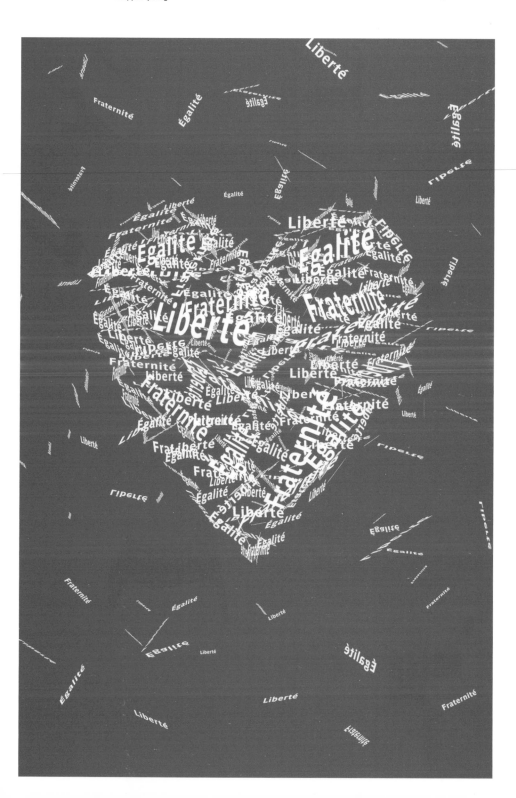

Project
New Year's Eve Card

Title
New Year's Eve Card

Client
Philippe Apeloig Studio

Year
2001

Opposite page:

Project
Poster for Linotype,
Essen, Germany

Title
3rd Design Type Contest
Linotype

Client
Linotype

Year
1999

■ Call for entries

3. Type

Design Contest

3ʳᵈ International
Digital Type
Design Contest.
Deadline:
October, 31, 1999

Put your own creations
to the test!
Send us your best
digital font(s).
An international jury
will choose the winners
in four font categories.

Categories:
1. Text Fonts
2. Headline Fonts
3. Experimental Fonts
4. Symbols

Jury:
Andrew Boag (UK)
Irma Boom (NL)
Adrian Frutiger (CH)
Gabriele Günder (D)
Bernd Möllenstädt (D)
Jean François Porchez (F)
Wolfgang Weingart (CH)

Winning awards
total of 40,000 DM
For detailed contest
conditions see reverse

Jonathan Barnbrook

"Language is a virus, money is a nasty disease."

Opposite page:

Project
Why2K? A book
published for the
Millennium featuring
excerpts of British
writing from the past 150
years

Title
Cover for 'Why2K?'

Client
Booth-Clibborn Editions

Year
2000

"There was a time when it was thought that design had an important role in society. It could tell people meaningful information or try to improve our ways of living. Today we seem to have forgotten that design has this possibility. The kind of work that designers seek are the ones for the coolest sports companies, not the ones that will have the most effect on society or add most to culture. It is time for designers to realise that design is not just something 'cool' and that design is also not just about money. We need to take our profession seriously and engage in cultural and critical discussion about what we are doing and aiming for. The modernist idea that designers are transparent messengers with no opinions of their own is no longer valid. We cannot just do our design and say issues such as unethical work practices are not our problem. We cannot say that a lack of meaningful content is not a problem. If we want the respect and attention we think we deserve, then we need to think about what happens to our work when it is seen in society and about the kind of work we want to participate in. Design STILL has the potential to change society and we should start remembering this once more."

» Es gab einmal eine Zeit, in der man Design eine bedeutende gesellschaftliche Rolle zuschrieb. Es konnte sinnvolle Informationen übermitteln oder versuchen, unsere Lebensart zu verbessern. Heute scheinen wir das vergessen zu haben. Grafiker bemühen sich um Aufträge von den coolsten Sportartikelherstellern und nicht von denen, die am meisten für Gesellschaft und Kultur tun. Es ist an der Zeit, dass sich Grafikdesigner bewusst machen, dass es nicht nur darum geht, cool zu sein und Geld zu verdienen. Wir müssen unseren Beruf ernst nehmen und uns an der kritischen Kulturdebatte über unser Tun und unsere Ziele beteiligen. Das Bild vom Gestalter als bloßem Vermittler ohne eigene Ansichten ist längst überholt. Wir können nicht nur an unseren Entwürfen arbeiten und behaupten, Fragen wie unwürdige Produktionspraktiken gingen uns nichts an, das Fehlen sinnvoller Inhalte sei nicht unser Problem. Wenn wir uns die Anerkennung verschaffen wollen, die wir unserer Meinung nach verdienen, müssen wir uns gut überlegen, was unsere Arbeit bewirkt und uns nach Auftraggebern umschauen, die wir unterstützen möchten. Das Grafikdesign hat immer noch das Potenzial, die Gesellschaft zu verändern, und das sollten wir uns wieder ins Gedächtnis rufen.«

« Il fut un temps où l'on pensait que le graphisme jouait un rôle important dans la société. Il pouvait transmettre aux gens des informations utiles ou tenter d'améliorer nos conditions de vie. Aujourd'hui, on semble avoir oublié ces fonctions. Les créateurs cherchent avant tout à travailler pour les compagnies de sport les plus branchées plutôt que sur des projets susceptibles d'avoir un effet sur la société ou d'enrichir la culture. Il serait temps qu'ils se rendent compte que le design n'est pas qu'une affaire ‹branchée› de gros sous. Nous devons prendre notre profession au sérieux et engager un débat culturel et critique sur ce que nous faisons et ce que nous recherchons. L'idée moderniste selon laquelle le graphiste serait un messager transparent sans opinion personnelle n'est plus valable. Nous ne pouvons plus nous contenter de livrer nos travaux en déclarant que des questions telles que le respect de l'éthique professionnelle ne nous concernent pas. Nous ne pouvons plus dire que l'absence d'un contenu qui ait un sens n'est pas un problème. Si nous voulons le respect et l'attention que nous pensons mériter, nous devons réfléchir à ce que devient notre travail une fois lancé dans la société et sur le type de projets auxquels nous avons envie de participer. Le design a ENCORE le potentiel de changer la société. Ne l'oublions plus. »

Jonathan Barnbrook
Barnbrook Studios
Studio 12
10–11 Archer Street
London W1D 7AZ
UK

T +44 20 7287 3848
F +44 20 7287 3601

E virus@easynet.co.uk

Biography
1966 Born in Luton, England
1988 BA (Hons) Graphic Design, Central St Martins College of Art and Design, London
1989 MA Graphic Design, Royal College of Art, London

Professional experience
1990 Founded Barnbrook Design, London

Recent exhibitions
1999 "Lost and Found", worldwide touring exhibition by British Council of Contemporary British Design
2001 "Contemporary Graphic Design", Bibliothèque Nationale de France, Paris

Recent awards
1998 Gold Prize, The Tokyo Type Directors Club; Gold Award, New York Type Directors Club; Gold Award and Best of Show, Art Directors Club of New York

Clients
Adbusters
Barbican Gallery
Beams
Damien Hirst
Institute of Contemporary Arts, London
Museum of Contemporary Art, Los Angeles
Saatchi Gallery
White Cube Gallery

Project
Letterform from the typeface "Moron"

Title
Moron Font

Client
Virus Fonts

Year
2001

Opposite page:

Project
A series of works that appeared in a South Korean magazine about the North Korean regime

Title
North Korea: building the brand

Client
Self-published

Year
2001

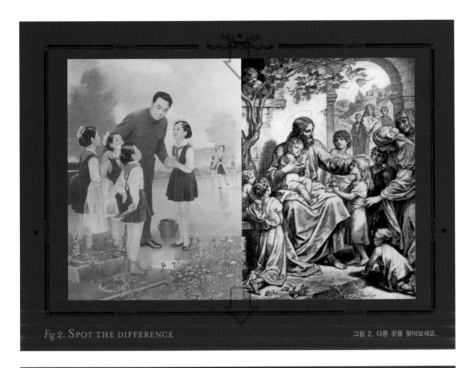

Fig 2. SPOT THE DIFFERENCE 그림 2. 다른 곳을 찾아보세요.

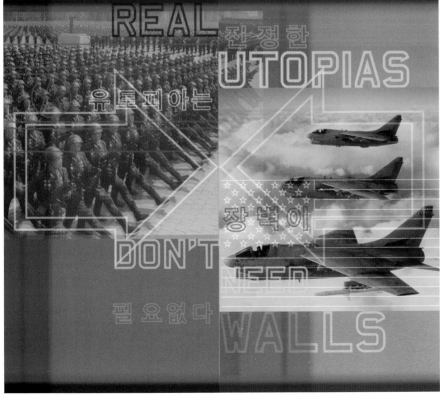

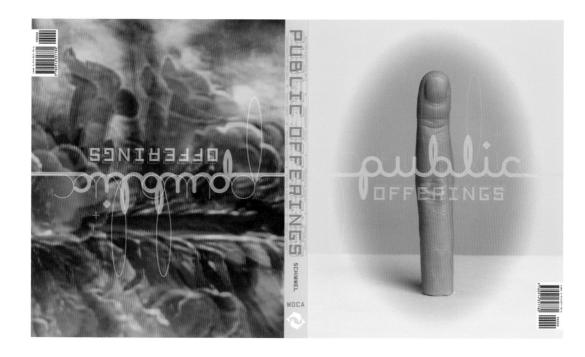

Project
Exhibition catalogue for
Museum of
Contemporary Art,
Los Angeles

Title
Public Offerings cover

Client
Museum of
Contemporary Art,
Los Angeles

Year
2001

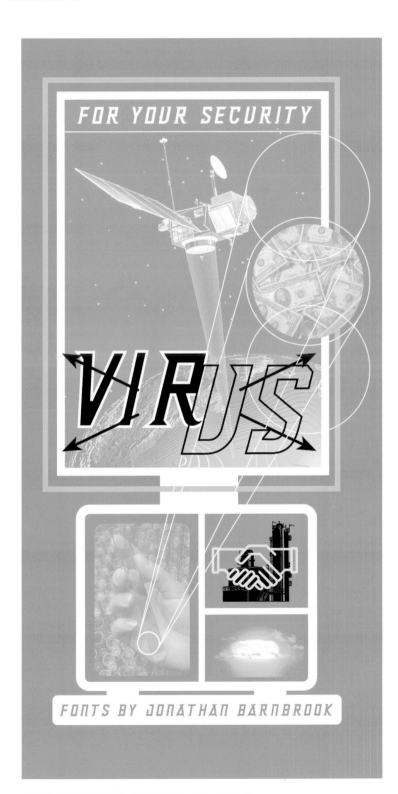

Project
A leaflet for the font
company Virus set up to
release the fonts of
Jonathan Barnbrook

Title
For Your Security, Virus
leaflet cover

Client
Self-published

Year
1999

Ruedi Baur

"The questions that concern me are not simply those of graphic design but issues of orientation, identification and information."

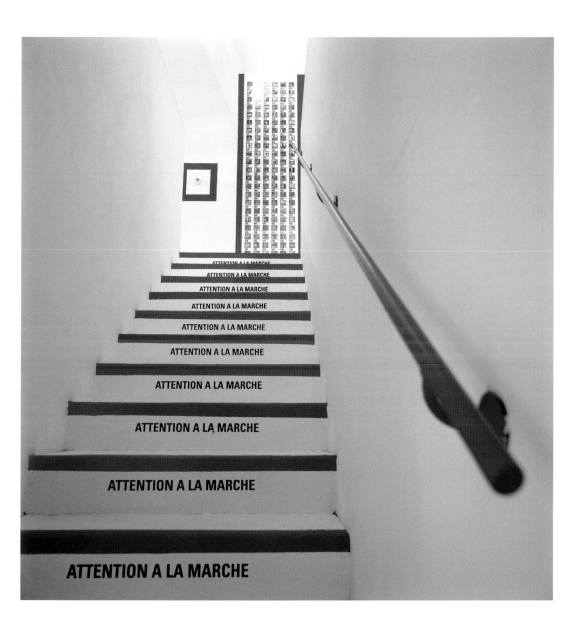

Project
Personal exhibition

Title
Installation U. Eur. + CH
ou other nationalities,
Strasbourg

Client
La Chaufferie

Year
1999

"Graphic design is merely one tool among many intended to resolve questions related to orientation, identification and information. In the future we must further enhance our teamwork, and realise in more effective fashion our interdisciplinary approach; respond even better to questions of sense and message, given today's superabundance of ambient information; attempt to break down the barriers between art and design, and between self-initiated and commissioned work; further transcend the limitations of graphic design."

» Die angewandte Grafik ist nur ein Medium von vielen, die in der Lage sind, die mit Orientierung, Identifikation und Information einhergehenden Fragen zu lösen. In Zukunft müssen wir noch besser im Team zusammenarbeiten und unsere Projekte in noch stärkerem Maße interdisziplinär entwickeln, und zwar im Hinblick auf die Überfülle der von allen Seiten auf uns einstürmenden Informationen. Künftig müssen wir versuchen, die Barrieren zwischen Kunst und Gebrauchsgrafik zu durchbrechen, zwischen dem freien Schaffen und Auftragsarbeiten. In Zukunft müssen wir die Grenzen des Grafikdesigns noch weiter als bisher überschreiten.«

« Le graphisme n'est qu'un outil parmi d'autres susceptible de résoudre les questions liées à l'orientation, l'identification et l'information. Il nous faut à l'avenir encore mieux travailler en équipe, encore mieux aborder nos projets avec une approche transdisciplinaire. Il nous faut à l'avenir encore mieux répondre aux questions de sens, de message, dans le contexte de surabondance d'informations qui nous entoure. Il nous faut à l'avenir tenter de briser les limites entre l'art et le design, entre le travail d'auteur et le travail de commande. Il nous faut à l'avenir encore mieux dépasser les limites du graphic design. »

Ruedi Baur
Intégral
Ruedi Baur et Associés
5, rue Jules Vallès
75011 Paris
France

T +33 1 55 25 81 10
F +33 1 43 48 08 07

E atelier@
 integral.ruedi-baur.com

Biography
1956 Born in Paris
1975–1980 Graphic Design, Zurich School of Applied Arts
Apprenticeship with Michael Baviera, Zurich and Theo Ballmer, Basel

Professional experience
1980 Co-founded Plus Design Studio with Sereina Feuerste, Zurich
1981 Co-founded BBV Studio with Michael Baviera and Peter Vetter, Lyon, Milan and Zurich
1982 Established own studio in Lyon
1984–1988 Founded and directed the design gallery Projects, Villeurbanne, France
1988 Transferred activities to Paris, working with Denis Coueignoux and Chantal Grossen
1989 Partnership with Pippo Lionni; founded the Intégral Concept Studio and subsequently created the studio Intégral Ruedi Baur et Associés, Paris
1989–1994 Managed the design department at the École des Beaux-Arts de Lyon in collaboration with Philippe Délis
1990–1992 Curated the Design à la Maison du livre exhibition space in Villeurbanne in collaboration with Blandine Bardonnet
1991 Member of the Alliance Graphique Internationale (AGI); Philippe Délis became the third partner in Intégral Concept
1993 Guest Professor at the Hochschule für Gestaltung, Offenbach, Germany

1994–1996 Organized a postgraduate course on the theme Civic Spaces and Design, École des Beaux-Arts de Lyon
1995 Appointed Professor and Head of System Design, Leipzig Academy of Visual Arts (Hochschule für Graphik und Buchkunst, HfGB)
1997–2000 Rector, Leipzig Academy of Visual Arts
1998–1999 Intégral Concept is expanded to include three new studios: Lars Müller (Baden), Studio Vinaccia (Milan), Lipsky et Rollet (Paris) and two designers: Christine Breton (Marseille) and Pierre-Yves Chays (Chamonix)
1999 Founded the Leipzig Institute of Interdisciplinary Design

Exhibitions
1989 "Ruedi Baur, conception sur papier" (solo exhibition), Maison du Livre, de l'Image et du Son, Villeurbanne
1991 "Design: Ruedi Baur, Pippo Lionni", Institut für Neue Technische Form, Darmstadt
1994 "Ruedi Baur, intégral concept" (solo exhibition), DDD Gallery, Osaka; GGG Gallery, Tokyo; "Processes in process" (solo exhibition), Design Horizonte, Frankfurt/Main
1995 "Meine Augen schmerzen" (solo exhibition), Museum für Kunst und Gewerbe, Hamburg
1998 "Pixel compressions" (solo exhibition), Central Academy of Arts & Design, Beijing
1999 "U. Eur. + CH ou other nationalities" (solo exhibition), La Chaufferie, Strasbourg

Clients
Archaeological Museum Kalkriese
Biennale de l'environnement, Seine-Saint-Denis
Centre culturel Tjibaou, Nouméa
Centre national de documentation pédagogique
Centre Georges Pompidou
Cité des sciences et de l'industrie
Cité internationale de Lyon
Cité internationale universitaire de Paris
City of Lyon
City of Nancy
City of Saumur
City of Tourcoing
Domaine national de Chambord
Expo 02 (Swiss national exhibition)
French Ministry of Education
International exhibition Lisbon 1998
Inselspital Berne
Landesmuseum Zurich
Le Cargo, Grenoble
L'Expo 2004 (international exhibition Seine-Saint-Denis)
Mission 2000 en France
Musée d'art moderne et contemporain de Genève
Pôle universitaire européen de Strasbourg
Suermondt Ludwig Museum, Aachen
Union centrale des arts décoratifs

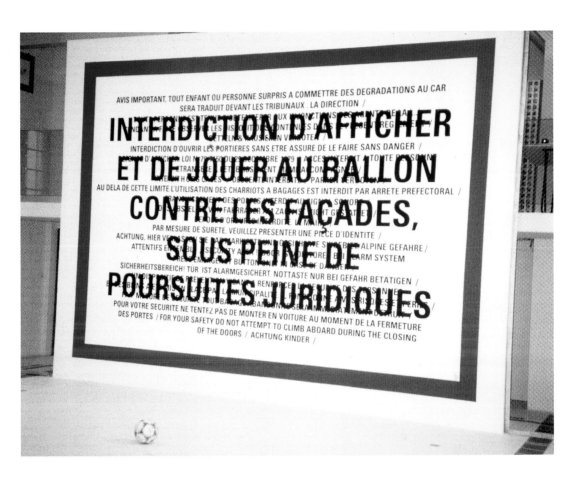

Project
Personal exhibition

Title
Installation U. Eur. + CH
ou other nationalities,
Strasbourg

Client
La Chaufferie

Year
1999

Project
Design of the façade and
signage for the Ésisar
school

Title
Ésisar Valence

Client
DDE de la Drôme,
rectorat de l'académie de
Grenoble, Drac Rhône-
Alpes

Year
1997

Opposite page:

Project
Design of the façade and
signage for the Ésisar
school

Title
Ésisar Valence

Client
DDE de la Drôme,
rectorat de l'académie de
Grenoble, Drac Rhône-
Alpes

Year
1997

Irma Boom

"I try to answer the commissioner's request by raising a new question."

Opposite page:

Project
Book on the 50th
anniversary of the
company

Title
Light Years 2000–1950

Client
Zumtobel Staff, Austria

Year
2000

"Graphic design is an interesting profession when one is asked to be a participating developer on a project. Graphic design is not interesting when a designer is asked to make things on demand. The making process is a mutual 'journey' in which both the commissioner and the designer have to be open to the unknown and unexpected. Because you cannot always describe things in words, meetings are important in the search for a direction. When graphic design is a developing process, there is no guarantee of success. My experience in this matter is that it is very interesting and necessary to have a long relationship with a few clients to establish a working method that is valuable for both parties. If there is no time to invest in this, I have no time."

» Der Beruf des Designers ist interessant, wenn man sich an der Entwicklung eines Projekts beteiligen soll. Er ist uninteressant, wenn man nur der Erfüllungsgehilfe des Auftraggebers ist. Der Entstehungsprozess ist eine gemeinsame ›Reise‹, auf der sowohl Auftraggeber als auch Grafiker offen sein müssen für das Unerwartete. Weil man nicht alles nur durch Reden klären kann, muss man sich persönlich treffen. Wenn grafisches Gestalten ein Entwicklungsprozess ist, gibt es keine Erfolgsgarantie. Ich habe erfahren, dass es interessant und notwendig ist, eine gute Beziehung mit wenigen Kunden aufzubauen und eine Arbeitsmethode zu entwickeln, die von beiden Parteien geschätzt wird. Wenn sie keine Zeit dafür investieren wollen, habe ich auch keine Zeit für sie.«

« Le graphisme est un métier intéressant quand on nous demande de participer à l'élaboration d'un projet. Il cesse de l'être quand on doit travailler sur commande. Le processus de réalisation est un ‹voyage› à plusieurs où le commanditaire et le graphiste doivent être ouverts sur l'inconnu et l'inattendu. Comme on ne peut pas tout décrire avec des mots, les réunions servent à chercher une direction. Lorsque le graphisme est un processus de développement, la réussite n'est pas garantie. Je sais d'expérience qu'il est très intéressant et nécessaire d'entretenir une longue relation avec quelques clients afin d'établir une méthode de travail précieuse pour tout le monde. Je n'ai pas de temps pour ceux qui n'ont pas le temps de s'investir dans ce genre de rapports. »

Irma Boom
Irma Boom Office
Kerkstraat 104
1017 GP Amsterdam
The Netherlands

T +31 20 627 1895
F +31 20 623 9884

E irmaboom@xs4all.nl

Biography
1960 Born in Lochem,
The Netherlands
1979–1985 AKI, School
of Fine Art, Enschede,
The Netherlands

Professional experience
1985–1990 Senior
designer, Government
Publishing, Printing Office,
The Hague
1991+ Founded own
studio, Irma Boom Office,
Amsterdam
1992+ Lecturer, Yale
University, New Haven,
Connecticut
1998–2000 Tutor, Jan
van Eyck Akademie,
Maastricht

Recent exhibitions
1998 "Do Normal", San
Francisco Museum of
Modern Art; "Irma Boom
on her Books" (solo exhibition), Stroom Center for
Visual Arts, The Hague
2000 "19th International
Biennale of Graphic
Design", Brno, Czech
Republic
2001 "Typojanchi", Seoul,
Korea; "Graphisme(s)",
Bibliothèque National de
France, Paris; "Boom
Beyond Books" (solo
exhibition), Gutenberg
Prize Leipzig, Leipziger
Stadtbibliothek, Germany
2002 "Double Dutch",
Totem Gallery, New York;
"Road Show" (touring
exhibition), New York
(AIGA), Paris (Institut
Néerlandais), Mulhouse
(Musée des Beaux-Arts/
Villa Steinbeck), Valencia
(Musée des Beaux-Arts),
Baltimore (Maryland
Institute College of Art),
Barcelona (ADGFAD/
Laus 01), Erasmushuis,
Djakarta, Stuttgart (Design
Center)

Recent awards
1998 Overall Winner, Lutki
& Smit Annual Report
Competition, Culemborg
1999 Award (x4), Collectieve Propaganda van het
Nederlandse Boek (CPNB)
2000 Gold Medal,
Schönste Bücher aller
Welt, Leipzig
2001 Award (x3), Collectieve Propaganda van het
Nederlandse Boek (CPNB)
2002 Silver Medal,
Schönste Bücher aller
Welt, Leipzig

For total oeuvre
Gutenberg Preis 2001

Clients
Architectural Association,
London
AVL/Joep van Lieshout
Berlin Biennale
Birkhäuser Verlag
Centraal Museum Utrecht
De Appel
Ferrari
Forum for African Arts
(Cornell University)
Foundation De Appel
Het Financieele Dagblad
KPN/Royal PTT Nederlands
Mondriaan Foundation
NAi publishers
Oeuvre AKZO Coatings
Office for Metropolitan
Architecture (OMA)
Oktagon Verlag
Paul Fentener van Vlissingen
Paul Kasmin Gallery
Prince Claus Fund
Prins Bernhard Foundation
Royal Ahrend NV
Royal Library
Rijksmuseum
SHV Holdings NV
Slewe Galerie
Stedelijk Museum
Stichting CPNB
Stichting De Roos
Stroom
Thoth publishers
United Nations New York
Vitra International
World Wide Video Festival
Zumtobel

Project
Postage stamps

Title
Dutch Butterflies

Client
Royal Dutch PTT,
The Netherlands

Year
1993

Project
Poster for Holland Festival
on Dance and Opera
(top right: the basic
poster)

Client
Holland Festival,
The Netherlands

Year
1990

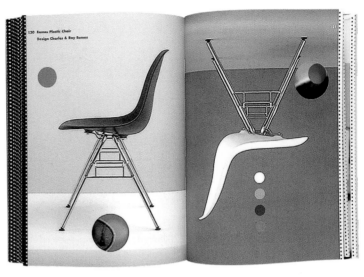

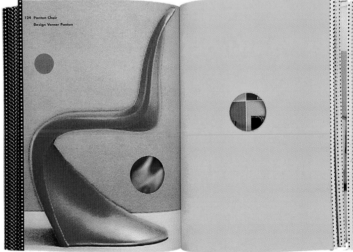

Project
Book as inspiration source

Title
Workspirit

Client
Vitra, Birsfelden,
Switzerland

Year
1998

Opposite page:

Project
Book focusing on the
most salient examples of
the SHV mentality over
the past 200 years

Title
Think Book

Client
SHV NV, The Netherlands

Year
1996

büro für form

"Good graphic design is the result of the endless search for beauty in things."

Project
Demented Forever Series
Part 03
60 x 60 cm lightbox
images

Title
Demented Forever Series

Client
Erste Liga Gastronomie
GmbH

Year
2001

"While the boundaries within the possibilities of design are changing day by day, the creators are becoming more responsible for the messages hidden in every piece of their work. Graphic design will spread a lot more than simple matter, beauty, emotions or style. It could even be a vision for life. The only thing missing so far is a bit more pathos …"

» Weil sich die Grenzen innerhalb der Möglichkeiten des Grafikdesigns ständig verschieben, tragen die Gestalter immer mehr Verantwortung für die Botschaften, die in jeder ihrer Arbeiten versteckt sind. Grafikdesign wird viel mehr verbreiten als nur Dinge, Schönheit, Gefühle oder Stil. Es könnte sogar zur Lebensart werden. Das Einzige, was noch fehlt, ist ein bisschen mehr Pathos …«

« Si les frontières au sein des possibilités graphiques reculent sans cesse, les créateurs sont de plus en plus responsables des messages cachés dans tous les éléments de leur travail. Le graphisme s'étendra bien au-delà de la simple matière, beauté, émotion et style. Il pourrait devenir une vision de la vie. Il ne lui manque à présent qu'un petit peu plus de pathos… »

büro für form
Hopf & Wortmann
Hans-Sachs-Strasse 12
80469 Munich
Germany

T +49 89 26 949 000
F +49 89 26 949 002

E info@buerofuerform.de

www.buerofuerform.de

Design group history
1998 Co-founded by Benjamin Hopf and Constantin Wortmann in Munich
2000 Alexander Aczél joined the team as Head of Graphics

Founders' biographies
Benjamin Hopf
1971 Born in Hamburg
1993–1998 MA Industrial Design, University of Design, Munich
1996 Department of Advanced Studies, Siemens Design, Munich
Constantin Wortmann
1970 Born in Munich
Self-taught
1996–1997 Freelance Designer, Ingo Maurer, Munich
Alexander Aczél
1974 Born in Munich
1995–1996 Media Designer, Mediadesign Akademie, Munich
1996–2002 Freelance work for various clients
1999+ Member of the Institution of Unstable Thoughts, Kiev
2000+ Head of Graphics, büro für form, Munich

Exhibitions
2000 "Don't walk with strangers", Fashion Show for TAK2, Praterinsel, Munich; "Amdamdes" (Projections & Installation), Praterinsel, Munich
2002 "Demented Forever" (Backlight exhibition), Erste Liga, Munich; "Slut Machine" (Backlight exhibition), Erste Liga, Munich

Recent awards
2000 IF-Award, Best of Category, Hanover; Design for Europe, Kortijk, Belgium

Clients
Bajazzo Verlag
Beast Media
BMG Ariola
Burda Verlag
Cedon Museumshops
Chili Entertainment
Classicon
Condé Nast Verlag
Cream 01
D-Code
Fingermax
Häberlein & Maurer
Habitat
Kundalini
Mu Meubles
Next Home Collection
Osram Lighting
Piranha Media
Publications Verlag
Serien Lighting
Serviceplan
Siemens
Start
SZ Magazin
TAK2

Project
Decorative Patterns

Title
Patterns02: (Artist Logo)

Client
BMG Ariola, Germany

Year
2000

Opposite page:

Project
Decorative patterns

Title
Patterns04: (T-Shirt-Logo)

Client
Tak2 Clothing Company

Year
2000

Project
Demented Forever Series
Part 01
60 x 60 cm lightbox
images

Title
Demented Forever Series

Client
Erste Liga Gastronomie

Year
2001

Project
Demented Forever Series
Part 04
60 x 60 cm lightbox
images

Title
Demented Forever Series

Client
Erste Liga Gastronomie

Year
2001

Delaware

"Simple & Effective."

Project
2nd album "SURFIN'
USSR"

Title
Fireman

Client
Self-published

Year
1997

"Graphic design is all about plain living and high thinking. We are a Japanese supersonic group that rocks design and believes that design rocks. The Delaware style is a mixture of music, visual images & texts that is both minimal and pop."

» Beim Grafikdesign geht es um einfaches Leben und komplexes Denken. Wir sind eine japanische Überschallgruppe, die die Designwelt beben lässt und davon überzeugt ist, dass das Grafikdesign die Welt bewegt. Der Delaware-Stil ist eine Mischung aus Musik, Bildern und Texten, die Minimalismus und Pop vereint.«

« Le graphisme est avant tout une affaire de vie dépouillée et de pensée évoluée. Nous sommes un groupe supersonique japonais qui balance du design et qui pense que le design, ça balance. Le style Delaware est un mélange à la fois minimaliste et pop de musique, d'images et de textes. ».

Delaware
2C Tokiwamatsu
1–20–6 Higashi
Shibuya-ku
Tokyo 150–0011
Japan

T +81 3 3409 4944
F +81 3 3409 4944

E mail@delaware.gr.jp

www.delaware.gr.jp

Design group history
1993 Founded by Masato Samata in Tokyo

Founder's biography
Masato Samata
1959 Born in Gumma, Japan
Self-taught

Recent exhibitions
2000–2001 "Mobile Gallery", i-mode online show
2001 "Artoon at PS-1", PS-1, New York; "JaPan Graphics", RAS Gallery, FAD, and Convent dels Angels, Barcelona

Clients
DoCoMo
Fukoku-Seimei
Iwata-Ya
Yutaka-Shoji

Project
i-mode official site
"MOBILE ART"

Title
Disc of We Are Alone
(left)
Flower Life (center)
Flower (right)

Client
NIPPON Enterprise ltd. &
DICE ltd.

Year
2002

Project
4th album "ARTOON"

Title
Livin' Dinin'
Kitchen (top left)
Take A Walk (top right)
We Are Alone
(bottom left)
Yeah Yeah Yeah
(bottom right)

Client
Self-published

Year
2001

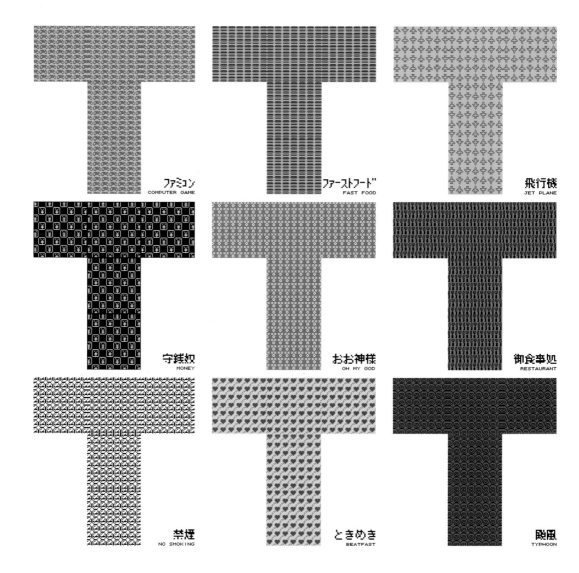

Project
Homepage "FREEware/
DELAware" issue 62

Title
Kimono Dress

Client
Self-published

Year
2001

Project
"MOBILE GALLERY" on
i-mode

Title
Graphic DUB

Client
Self-published

Year
2001

Dextro

"Access to the subconscious by the use of cannabis."

Project
dextro.org

Title
/

Client
Self-published

Year
1993

"Peace by rehabilitating the right
hemisphere of the brain."

» Frieden durch rehabilitierung der
rechten gehirnhälfte.«

« La paix par la réhabilitation de
l'hémisphère droit du cerveau. »

Dextro
E dextro@dextro.org

Biography
Born in Austria
Self-taught
Freelance designer in
Vienna, Tokyo and Berlin
1994+
www.dextro.org
1997+
www.turux.org

Project
dextro.org

Title
/

Client
Self-published

Year
2000

Project
dextro.org

Title
/

Client
Self-published

Year
2000

Project
dextro.org

Title
/

Client
Self-published

Year
1999

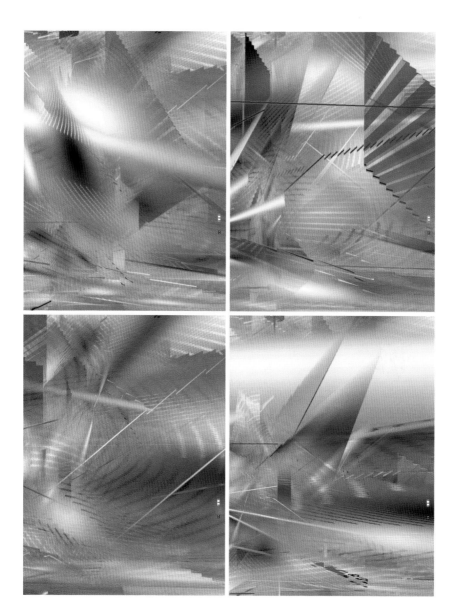

Project
dextro.org

Title
/

Client
Self-published

Year
1993

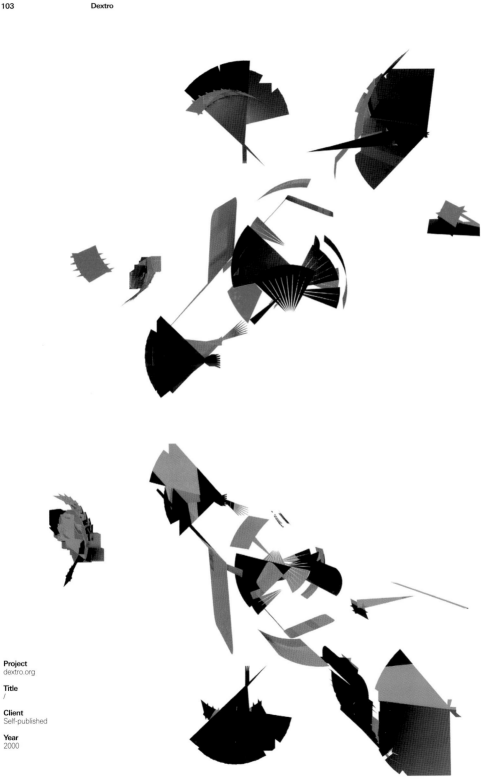

Project
dextro.org

Title
/

Client
Self-published

Year
2000

Extra Design

"Make it as simple as it can be."

Opposite page:

Project
Illustration

Title
Kitty Building

Client
IdN

Year
2000

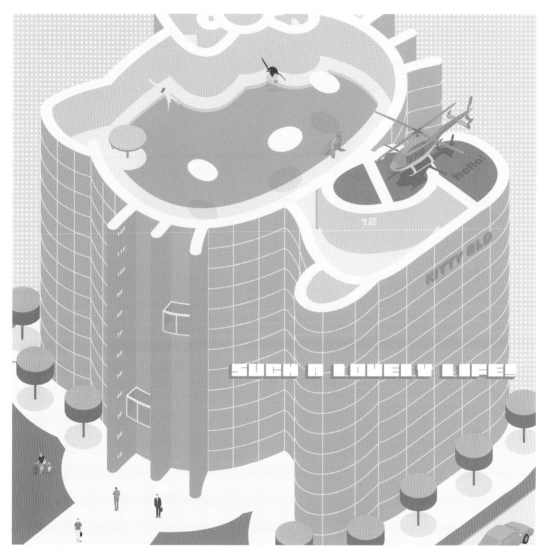

"It's hard to tell. What will be happening in the future is something we can't even imagine at this moment. A couple of years ago, we didn't expect to use the Internet and email this often. It's essential for us now. The future of graphic design is something we can't predict."

» Das ist schwer zu sagen. Was noch geschehen wird, können wir uns im Moment noch nicht einmal vorstellen. Vor einigen Jahren hätten wir auch nicht gedacht, dass wir Internet und E-Mail so ausgiebig und ständig benutzen würden. Dabei sind inzwischen beide für uns unerlässlich. Die Zukunft des Grafikdesigns lässt sich unmöglich vorhersagen.«

« C'est difficile à dire. A l'heure actuelle, on ne peut même pas imaginer ce que sera l'avenir. Il y a quelques années, qui aurait cru qu'on utiliserait autant l'internet et le courrier électronique ? Aujourd'hui, ils nous sont devenus indispensables. On ne peut pas prédire l'avenir du graphisme. »

Extra design
E shin@extra.jp.org

www.extra.jp.org
www.extract.jp
www.kgkgkg.com

Design group history
1997 Founded by Nobutaka Sato in Sapporo, Japan
1998 Shin Sasaki joined design group

Founders' biographies
Nobutaka Sato
1973 Born in Japan
Shin Sasaki
1974 Born in Japan

Recent exhibitions
2000 "Nisen Tokyo Exhibition", Journal Standard Shinjuku, Tokyo;
2001 "Poster Exhibition", IdN Fresh Conference 2001, Hong Kong; "onedotzero", Saatchi & Saatchi Gallery, Tokyo; "I love Utopia", Zouk, Singapore

Recent awards
2001 Gold Prize, Sapporo Art Directors Club

Clients
Air Do
Creative Review
IdN
MTV2
Orix
So-net Channel
Soulbossa Production
Ricoh

Project
Magazine Cover

Title
Extra Design

Client
Design Plex

Year
2001

Opposite page, top:

Project
Postcards

Title
Brown, & BB

Client
Self-published

Year
2000

Opposite page, bottom:

Project
Illustration

Title
Eating, & Fake

Client
Selfish

Year
2000

BRAUN with EXTRA DESIGN

Chocola BB with EXTRA DESIGN

YUM /jʌm/

People sometimes say 'yum' or 'yum yum'
to show that they think something tastes
or smells very good.

Don't worry. I'm free!

gelfish

C.R.D.
TIME TABLE
club radio dictionary
on air list

01 TOKYO SHIBUYA

SHIBUYA FM "VOICE" 78.4MHz
»MJ/INFO »SHIBUYA FM "VOICE" »CALL : 03.5456.4977
»FAX1 : 03-5456-4976 »HOME : » http://www.parco-city.co.jp/shibuya-fm/

SHIBUYA FM 78.4

	18:00	18:55	19:00

Mon

▶ **DEPTHEAD**
提供 : DEPT STORE

▶ **PRIMO PIATTO**
協力 : UNITED FUTURE ORGANIZATION
（矢部直・Raphael Sebbag）

Tue

▶ **AMBG – ANY MUSIC, BUT GOOD**
選曲 : EDWIN

▶ **LIVE C.R.D.**

Wed

▶ **HYSTERIC RADIO**
協力 : HYSTERIC GLAMOUR

▶ **RECOYA CONNECTION**
協力 : MUTEKI RECORDS, MANHATTAN RECORDS,
MANHATTAN RECORDS 2, DANCE MUSIC RECORDS ほか

Thu

▶ **MUSIC WAVE**
MUSIC WAVE : SAZABY

▶ **SPECIAL HOUR**

Fri

▶ **FROM TIME CAFE**
提供 : BEAMS

CLUBKING
»CALL : 03-3418-3399
»FAX3 : 03-3418-3545
MAIL : cord@clubking.com（担当 : 山川）

02 OSAKA MINAMI

YES-Fm 78.1M.Hz »MJ/INFO »CALL : 06-6646-1202 »FAX5 : 06-6646-1203
»HOME : » http://www.78i.net/

	19:00	19:58

Mon

▶ **DEPTHEAD**
提供 : DEPT STORE

Tue

▶ **AMBG – ANY MUSIC, BUT GOOD**
選曲 : EDWIN

Wed

▶ **HYSTERIC RADIO**
協力 : HYSTERIC GLAMOUR

Thu

▶ **MUSIC WAVE**
MUSIC WAVE : SAZABY

Fri

▶ **FROM TIME CAFE**
提供 : BEAMS

03 FUKUOKA TENJIN

YES-fm/V6_FM "FREE WAVE" 77.7M.Hz
»CALL : 092-734-4393 »FAX4 : 092-734-1982
»HOME : » http://freewave777.com

FREE FM WAVE

	23:00	24:00	25:00

Mon

▶ **AMBG – ANY MUSIC, BUT GOOD**
選曲 : EDWIN

Tue

▶ **RECOYA CONNECTION**
協力 : MUTEKI RECORDS, MANHATTAN RECORDS,
DANCE MUSIC RECORDS ほか

Wed

▶ **HYSTERIC RADIO**
協力 : HYSTERIC GLAMOUR

Thu

▶ **MUSIC WAVE**
MUSIC WAVE : SAZABY

Fri

▶ **PRIMO PIATTO**
協力 : UNITED FUTURE ORGANIZATION（矢部直・Raphael Sebbag）

▶ **FROM TIME CAFE**
提供 : BEAMS

Opposite page:

Project	**Project**
T-shirt	Page Layout
Title	**Title**
Love Tennis	Dictionary
Client	**Client**
Zoomit	Club King
Year	**Year**
1999	2001

Farrow Design

"A designer is duty bound to push the client as far as they will go."

Project
CD packaging
Sculpture: Yoko by Don
Brown courtesy of Sadie
Coles HQ

Title
Spiritualized
Let it come down

Client
Spaceman/Arista

Year
2001

"Clarity, Form, Function." »Klarheit, Form, Funktion.« «Clarté, forme, fonction.»

Farrow Design
23–24 Great James Street
Bloomsbury
London WC1N 3ES
UK

T +44 20 7404 4225
F +44 20 7404 4223

E studio@
farrowdesign.com

www.farrowdesign.com

Design group history
1995 Founded by Mark
Farrow in London

Founder's biography
Mark Farrow
1960 Born in Manchester,
England
Self-taught
1986–1990 3A, London
1990–1996 Farrow,
London
1996+ Farrow Design,
London

Recent exhibitions
1998 "Experimentadesign
99", Lisbon
2000 "Sound Design
2000", British Council,
global touring exhibition

Recent awards
1997–1998 Award (x10),
Music Week CAD
1998 Award, Most
Outstanding Record
Sleeve, D&AD
2001 Award, Most
Outstanding Consumer
Website, D&AD
2002 Award, Most
Outstanding Music
Packaging Design, D&AD;
Gold Award, Art Directors
Club of Europe

Clients
Atlantic Bar & Grill
BMG Records
Booth-Clibborn Editions
British Museum
Channel 5
Coast
Cream
Cream Records
D&AD
EMI Records
Epic Records
Gruppo Limited
Harvey Nichols
Levi Strauss Europe
London Records
Mash
MTV
Jasper Morrison
Museum für Gegenwarts-
kunst, Basle
Marc Newson Limited
Parlophone Records
Saatchi & Saatchi
Sadie Coles HQ
Science Museum,
London
SCP
Sony Music
Tate Modern
Virgin Records
WEA Records
Wilkinson Eyre Architects

Project
CD packaging

Title
Dave Clarke
Archive one

Client
Deconstruction

Year
1996

Project
Book cover

Title
D&AD Annual

Client
D&AD

Year
1999

Released
08 03 99

Available on
2xCD and 12"

Orbital Style

Opposite page:

Project
Poster

Title
Orbital
Style

Client
London Records

Year
1999

Project
Book design

Title
Kylie

Client
Darenote Ltd /
Booth-Clibborn Editions

Year
1999

Dávid Földvári

"Ugly=Beautiful"

Opposite page:

Project
Personal work, part of a
sequence of five images

Title
We believe

Client
Self-published

Year
2002

"There is still a fear of the unknown and a lack of trust that exists in current art direction, which in turn leads to designers and illustrators all too often producing comfortable and unchallenging work in order to survive. This leads to the mass media being flooded with an endless amount of visual information that essentially all looks the same, and as a result it fails to excite or convey anything new. Graphic designers and illustrators aren't machines that can churn out the same product endlessly, and the most successful projects are always those that allow for creative freedom and experimentation."

» Unter Artdirectors herrscht immer noch Angst vor allem Unbekannten und mangelndes Vertrauen, was Grafiker und Illustratoren allzu oft dazu veranlasst, gefällige und unprovokante Entwürfe zu produzieren, um zu überleben. Das führt dazu, dass die Massenmedien mit einer ausufernden Flut visueller Informationen überladen werden, die im Wesentlichen alle gleich aussehen und weder aufregend sind noch etwas Neues bringen. Grafiker und Illustratoren sind keine Maschinen, die kontinuierlich das immer gleiche Produkt ausstoßen können, und am erfolgreichsten sind schließlich immer die Projekte, die schöpferische Freiheit und Experimente zugelassen haben.«

« La peur de l'inconnu et la méfiance perdurent parmi les directeurs artistiques d'aujourd'hui. Du coup, les graphistes et les illustrateurs produisent trop souvent des travaux pépères et sans grand intérêt pour survivre. Les médias se retrouvent ainsi inondés d'un flot ininterrompu d'informations visuelles où tout se ressemble, n'apportant rien de nouveau ni d'excitant. Les créateurs ne sont pas des machines qui peuvent ressasser le même produit à l'infini et les projets les plus réussis sont toujours ceux qui laissent la part belle à la liberté, la créativité et l'expérimentation. »

Dávid Földvári
Big Photographic
Warehouse D4
Metropolitan Wharf
Wapping wall
London E1W 3SS
UK

T +44 20 7488 0794
F +44 20 7702 9366

E bp@bigactive.com

www.bigactive.com

Biography
1973 Born in Budapest
1992–1996 BA(Hons)
Graphic Design and
Illustration, Brighton
University, Sussex
1999–2001 MA
Communications, Royal
College of Art, London

Professional experience
1999+ Freelancer,
represented by Big
Photographic, London

Recent exhibitions
2001 "UKNY", Trump
Tower, New York

Clients
Dazed & Confused
Foot Action USA
London Records
Nike
Nova Magazine
Penguin
Random House
Real Pitch Project

Project
Album cover for the band
"A"

Title
HiFi Serious

Client
London Records, UK

Year
2002

Project
Single sleeve prototype
for the band "A"

Title
Flamespitter (early work in
progress for "Starbucks")

Client
London Records, UK

Year
2002

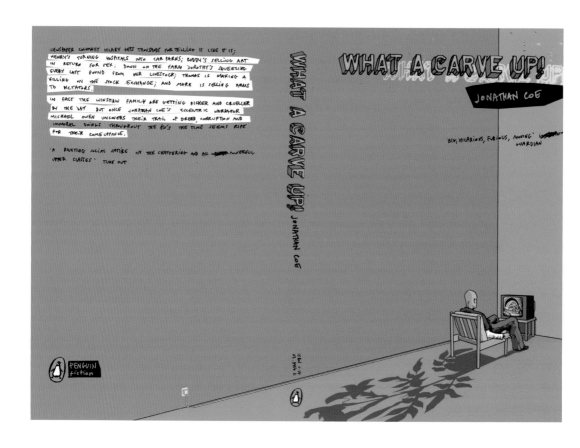

Opposite page:

Project
Book cover

Title
"What A Carve Up" by
Jonathan Coe

Client
Penguin, UK

Year
2001

Project
"Crash and Learn" ad
campaign, part of a
sequence of four images

Title
Masochist (Italian version)

Client
Nike ACG, Wieden
Kennedy Amsterdam,
The Netherlands

Year
2001

Tina Frank

"I want you to fall into my pictures and stay with them for some time."

Opposite page:

Project
CD Sleeve for MEGO 035:
Endless Summer, by
Christian Fennesz

Title
Endless Summer

Client
Mego

Year
2001

Mego 035

Endless Summer

FENNESZ

"It will be a 'wow' and a 'zoom', some things going fast, other things really slow. Design will become sound and sound will become design. Design will become anything and everything will become design. Even no-design will be designed. The public nowadays is already much more aware of graphic design than – lets say some 20 years ago. Even the regular school kid already knows the hipster-advantage of the perfect cool logo on their mobile telephones. Design will be needed in even more spaces, places we haven't yet thought about. We will be bombarded with moving design on every little street corner. What the poster-advertisements on the street are now will become big screens with flying pixels. Websites built to function as posters on the streets and used as starting points for the daily soap opera. I don't know yet if I will like it."

» Es wird ›wow‹ machen und ›zoom‹, manche Dinge werden superschnell sein, andere wieder richtig langsam. Design wird zu Sound und Sound wird zu Design. Design wird Nichts werden und alles wird zu Design. Selbst ›non-designte‹-Dinge werden absichtlich so entworfen. Die Öffentlichkeit ist heutzutage bereits viel aufmerksamer auf Design als – sagen wir – vor 20 Jahren. Selbst ein Schulkind kennt bereits den Hipster-Vorsprung, den Coolness-Faktor beim richtigen Logo am Display des eigenen Mobiltelefons. Design wird an immer mehr Stellen benötigt, an Plätzen, an die wir vorher noch gar nicht gedacht haben. Wir werden bombardiert werden mit bewegtem Design an jeder Straßenecke. Was heute die Straßenposter sind, werden in Zukunft riesige Bildschirme mit fliegenden Pixeln sein. Webseiten gebaut als Poster auf der Straße, als Startpunkte für die tägliche Seifenoper. Keine Ahnung, ob mir das gefallen wird …«

« Ce sera un ‹Hou la la!› et un ‹Zoom!›, certaines choses allant vite, d'autres très lentement. La création graphique deviendra sonore et le son deviendra graphique. Le graphisme deviendra tout, et n'importe quoi deviendra du graphisme. Même le non graphisme sera soumis au graphisme. Aujourd'hui, le public est déjà beaucoup plus au fait qu'il y a une vingtaine d'années. L'écolier lambda est déjà conscient de l'image qu'apporte le logo parfaitement cool de son portable. Le graphisme s'imposera dans plus d'espaces, dans des lieux auxquels nous n'avons pas encore pensé. A chaque coin de rue, nous serons bombardés par des graphismes animés. Les grandes affiches d'aujourd'hui seront remplacées par des écrans géants aux pixels volants. Des pages web seront conçues comme des affiches de rue et serviront de points de départ à des feuilletons à l'eau de rose quotidiens. Je ne sais pas encore si ça me plaira beaucoup. »

Tina Frank
designby frank/scheikl
Mayerhofgasse 20/6
1040 Vienna
Austria

T +43 1 505 60 66

E hello@frank.at

www.frank.at

Biography
1970 Born in Tulln, Austria
1989–1992 Studied Design at the Graphische Lehr- und Versuchsanstalt, Vienna

Professional experience
1992–1993 Designer, MetaDesign, Berlin
1994 Designer, Nofrontiere, Vienna
1995 Started own studio Inwirements Tina Frank, Vienna
1995 Co-founder and Art Director, U.R.L. Agentur für Informationsdesign GmbH, Vienna
1997 Co-founder, Skot (videoband), Vienna
1999 Co-founder, Lanolin (label dedicated to visual experiments)
2000 Co-founder, U.R.L., Berlin

Clients
Blumenkraft [TM]
Ellert Fotografie
design now austria
FontShop Austria
FontShop Germany
idea records
Kunstnet Austria
Mego / M.DOS / M.DBS
Mica (Music Information Center Austria)
Scope
UMG Germany
Zoom Kindermuseum

Project
LP Sleeve for MEGO 004: instrument, by Christian Fennesz

Title
instrument

Client
Mego

Year
1995

Project
LP Sleeve for MEGO 001:
fridge trax, by General
Magic & Pita

Title
fridge trax

Client
Mego

Year
1995

Project
CD Sleeve for MEGO 037:
asuma, by Ilpo Väisänen

Title
asuma

Client
Mego

Year
2001

Vince Frost

"Love It!"

Opposite page:

Project
CSD Lecture poster

Title
Frost lecture tour poster

Client
Charter Society of Design

Year
1999

"Our guiding principle at Frost Design is that we never let anything bland or recessive out the door. We accept that our work has to fight for attention amid a daily onslaught of media messages. Of course our work has to communicate the right proposition, be relevant to the target audience and use cost-effective media. That's taken as read. But above all, it has to get noticed. It must have impact. We create work that demands to be seen."

» Unser Prinzip bei Frost Design ist es, niemals etwas Langweiliges oder Rückschrittliches aus dem Haus zu lassen. Wir akzeptieren, dass wir darum kämpfen müssen, unserer Arbeit im Wust der täglich durch diverse Medien vermittelten Informationen Beachtung zu verschaffen. Natürlich müssen unsere Projekte die richtigen Angebote machen, die Zielgruppe tatsächlich ansprechen und kosteneffiziente Mittel einsetzen. Das wird vorausgesetzt. Vor allem aber müssen sie bemerkt werden, Wirkung zeigen. Unsere Entwürfe wollen gesehen werden.«

« Chez Frost Design, nous avons pour principe de ne jamais laisser sortir de nos bureaux quelque chose de neutre ou de récessif. Nous sommes conscients que notre travail doit s'efforcer de retenir l'attention dans un déluge permanent de messages médiatiques. Naturellement, il doit communiquer la bonne proposition, avoir un sens pour le public ciblé et être rentable. Cela paraît évident. Mais avant tout, il doit se faire remarquer. Il doit avoir un impact. Nous créons des travaux qui exigent d'être vus. »

Vince Frost
Frost Design
The Gymnasium
56, Kingsway Place
Sans Walk
London EC1R OLU
UK

T +44 20 7490 7994
F +44 20 7490 7995

E info@frostdesign.co.uk

www.frostdesign.co.uk

Design group history
1994 Founded by Vince Frost in London

Founder's biography
Vince Frost
1964 Born in Brighton, England
1965 Spent 16 years in Canada
1981 Graphic Design, West Sussex College of Design
1988 Freelance designer, Howard Brown and Pentagram, London
1989 Joined Pentagram on full-time basis
1992 Associate, Pentagram, London
1994 Founded Frost Design, London
1995 Art Director, The Saturday Independent Magazine, London
1996 Elected Fellow Chartered Society of Designers (FCSD)
2001 Art Director, Laurence King Publishing, London; Bath University Lecture; Design Indaba Lecture, Cape Town, South Africa; D&AD Awards Judging, Brighton; LAUS Awards Judging, Barcelona; University of Delaware, Newark, Delaware; ISTD Awards Judging; D&AD Lecture New Blood; Design Indaba Workshop Series 1 'A Frosty Day In Durban'; Design Indaba Workshop Series 2 'A Frosty Day In Cape Town'
2002 ICAD Judging Ireland; AIGA Lecture, Washington, DC; AGDA (Australian Graphics Design Association); 'A Frosty Day Down Under' 7 City's Sydney, Canberra, Brisbane, Hobart, Adelaide and Perth; University of Delaware, Newark, Delaware; The Typographic Circle @ RIBA; Elected AGI Member

Recent awards
1997 Merit Award (x4) and Distinctive Merit Award, Art Directors Club (ADC), 76th Annual Awards; Bronze, VK Paper Honour for the Best Typography and Silver, Typeworks Honour for Best Typography, Creative Circle; Shortlisted for Graphic Designer of the Year, BBC Design Awards; Merit (x3), D&AD Awards; Graphis Awards (x2); Distinctive Merit and Merit, New York Art Directors Club
1998 Merit (x4) and Silver Nomination, D&AD Awards
1999 Tokyo Type Director's Club award, TDC Annual; Merit Award, Art Directors Club (ADC), 78th Annual Awards; Highly Commended, The 10th Design Week Awards; Certificate of Excellence (x6), European Design Annual
2000 17th International Poster Biennale, Warsaw; Distinction Award, Art Directors Club (ADC), 79th Annual Awards; Winner, The 11th Design Week Awards; Highly Commended, The 11th Design Week Awards; Merit Award, Society of Publication Designers (SPD), USA; Certificate of Excellence (x3), European Design Annual
2001 Graphis Letterhead 5 (x2); D&AD Annual (x2), Silver nominated for D&AD Typography for Advertising; Elected Member ISTD
2002 Graphis Annual (x4)

Clients
400 Films
4th Estate Publishing
Architecture Association
Arts Foundation
Burnham Niker
Cicada
Clarks
D&AD
Design Council
Douglas and Jones
Faber and Faber
Financial Times
Fusion
Glassworks
Great Eastern Dining
Independent
Rooms
News International
Nike
Nokia
Laurence King Publishing
LIFT
Phaidon Press
Photonica
Polaroid
Polydor
Poole Pottery
Rotovision
Royal Mail
Sony
Serpentine Gallery
Thunderchild
Time Inc
Victoria & Albert Museum
Verdant
Violette Publishing
Virgin Records
Wapping Project

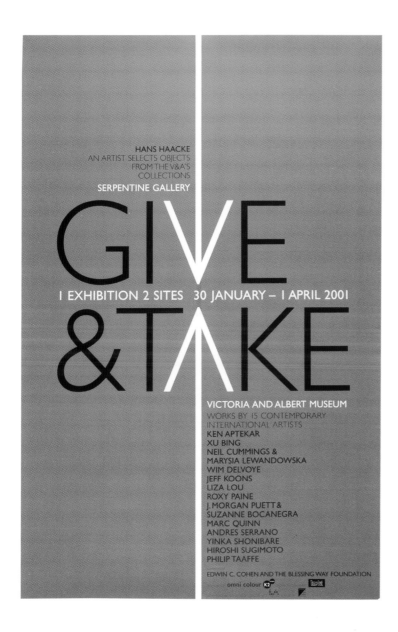

HANS HAACKE
AN ARTIST SELECTS OBJECTS
FROM THE V&A'S
COLLECTIONS
SERPENTINE GALLERY

GIVE

I EXHIBITION 2 SITES 30 JANUARY – I APRIL 2001

&TAKE

VICTORIA AND ALBERT MUSEUM
WORKS BY 15 CONTEMPORARY
INTERNATIONAL ARTISTS
KEN APTEKAR
XU BING
NEIL CUMMINGS &
MARYSIA LEWANDOWSKA
WIM DELVOYE
JEFF KOONS
LIZA LOU
ROXY PAINE
J. MORGAN PUETT &
SUZANNE BOCANEGRA
MARC QUINN
ANDRES SERRANO
YINKA SHONIBARE
HIROSHI SUGIMOTO
PHILIP TAAFFE

EDWIN C. COHEN AND THE BLESSING WAY FOUNDATION
omni colour

Project
Identity and Signage for
joint exhibition between
the Victoria & Albert
Museum and Serpentine
Gallery

Title
Give & Take

Client
Victoria & Albert Museum /
Serpentine Gallery

Year
2000

Project
Poster

Title
LIFT 01

Client
London International
Festival of Theatre

Year
2000

Project
Photonica European
Catalogue

Title
Photonica E 43

Client
Photonica

Year
1999

James Goggin

"Hand-made, lost-found, multi-coloured, faux-naïf, simple-abstract, content-driven."

Opposite page:

Project
Screen-print

Title
Golden Boxes

Client
Self-published

Year
2002

"It should be remembered that graphic design, in comparison to contemporary art or architecture for example, is still a largely invisible discipline to the general public. Fashion and architecture are self-explanatory in terms of their presence in everyday society, whereas graphic design frequently occupies an area of transparency: when looking at a sign, reading a book or opening a milk carton, its purpose is primarily that of a conduit, transmitting information between content and user. Designers who combine this functional latency with a bold, thoughtful, playful and at times cryptic (even subversive) aesthetic have the most success by not only informing the audience, but also engaging them – making them read between the lines. While the work of graphic designers will continue to achieve ever-increasing visibility – particularly through multi-disciplinary practice in the realms of fashion, film, music and internet – whether or not it's actually recognised as graphic design is another story."

» Man darf nicht vergessen, dass die Arbeit der Grafiker im Gegensatz etwa zur zeitgenössischen bildenden Kunst oder Architektur von der breiten Öffentlichkeit kaum wahrgenommen wird. Mode und Architektur erklären sich selbst, weil sie uns alltäglich begegnen und umgeben, während die Erzeugnisse der Grafiker häufig gewissermaßen unsichtbar sind: Wenn die Menschen ein Schild sehen, ein Buch lesen oder eine Milchtüte öffnen, dann fungieren diese Dinge vor allem als Medium, das dem Benutzer Informationen über den Inhalt vermittelt. Designer, die diese funktionelle Latenz mit kühner, durchdachter, spielerischer und mitunter rätselhafter (ja sogar subversiver) Ästhetik kombinieren, sind deshalb am erfolgreichsten, weil sie das Publikum nicht nur informieren, sondern auch mental beanspruchen – es zwischen den Zeilen lesen lassen. Die Arbeit der Grafikdesigner wird sich auch weiterhin zunehmend bemerkbar machen — besonders durch fachübergreifende Projekte in den Bereichen Mode, Film, Musik und Internet –, ob das dann aber noch als Grafikdesign aufgefasst wird, steht auf einem anderen Blatt.«

« Il faut se souvenir que le graphisme, comparé à l'art contemporain ou à l'architecture notamment, est une discipline encore largement inconnue du grand public. La mode et l'architecture s'expliquent d'elles-mêmes par leur présence quotidienne dans la société, alors que la création graphique occupe fréquemment une zone de transparence : quand on regarde un panneau de signalisation, qu'on lit un livre ou qu'on ouvre une brique de lait, elle sert avant tout de vecteur, transmettant l'information entre le contenu et l'utilisateur. Les graphistes qui conjuguent cette latence fonctionnelle avec une esthétique audacieuse, réfléchie, ludique et parfois cryptique (voire subversive) sont ceux qui réussissent le mieux, non seulement à informer le public, mais également à le séduire, à lui faire lire entre les lignes. Si le travail des graphistes continue à être de plus en plus visible, notamment à travers des pratiques multidisciplinaires dans les domaines de la mode, du cinéma, de la musique et de l'internet, cela ne signifie pas pour autant qu'il soit forcément reconnu en tant que création graphique. »

James Goggin
Practise
84 Teesdale Street
London E2 6PU
UK

T/F +44 20 7739 8934

E james@practise.co.uk

www.practise.co.uk
www.all-weather.org

Biography
1975 Born in Tamworth, Australia
1994–1997 BA (Hons) Visual Communication, Ravensbourne College of Design and Communication, London
1997–1999 MA Graphic Design, Royal College of Art, London

Professional experience
1999 Established own studio "Practise" in London
1999–2000 Lectured and organized workshops in the UK and Switzerland
2000 Started clothing label in collaboration with his wife, Shan, under the name "Shan James"
2001 Both "Practise" and "Shan James" moved to Auckland, New Zealand, for one year. Continued working in UK, Europe and Japan
2002 Founded clothing label "All Weather", making screen-printed T-shirts and sweatshirts

Recent exhibitions
1999 "A Grand Design", Victoria & Albert Museum, London
2001 "Inside Out", Kiasma Museum of Contemporary Art, Helsinki
2001 "Favourite Things", Hat on Wall Gallery, London

Recent awards
1998 National Magazine Company Award
1999 Royal College of Art/Penguin Book Essay Prize

Clients
Anthony d'Offay Gallery
Book Works
Booth-Clibborn Editions
Browns Focus
Channel 4
Concrete PR/Concrete Shop
Fallon (London)
fig-1
Helen Hamlyn Research Centre
Lineto
Preen
Random House
Routledge
Royal College of Art
Shan James
Victoria & Albert Museum
ZOO

Project
Screen-printed cotton T-shirt, Spring/Summer 2002 collection

Title
Air T-shirt

Client
Shan James

Year
2001

Opposite page:

Project
Screen-printed T-shirts + sweatshirts

Title
All Weather

Client
Self-published

Year
2001/2002

Project
Website

Title
practise.co.uk

Client
Self-published

Year
2001

Project
Website

Title
practise.co.uk

Client
Self-published

Year
2001

Fernando Gutiérrez

"It all begins with an idea (ideas make money: money doesn't make ideas) and you respond to that idea, using your knowledge to present it in the most seductive, engaging manner possible."

Opposite page:

Project
Magazine cover design

Title
Matador Volume E

Client
Matador / La Fabrica

Year
2000

MATADOR

Volumen E 7.500 Ptas. 45 Euros Revista de Cultura, Ideas y Tendencias 1995-2022

"There are more design students and more designers than ever. There are more magazines than ever. More access to information than ever. And more information to decipher than ever. Craft and vocation are being left behind. Good design will prevail, but the amount of bad design is overwhelming. We shouldn't be misled. The struggle continues."

» Es gibt heute mehr Grafikstudenten und Grafiker als je zuvor. Mehr Zeitschriften als je zuvor. Leichteren Zugang zu Informationen als je zuvor. Und mehr zu entschlüsselnde Informationen als je zuvor. Handwerk und Berufung werden vernachlässigt. Gutes Design wird sich durchsetzen, aber die Menge von schlechtem Design ist überwältigend. Wir sollten uns nicht in die Irre führen lassen. Der Kampf geht weiter.«

«Il n'y a jamais eu autant de créateurs et d'étudiants graphistes. Il n'y a jamais eu autant de publications. Jamais l'information n'a été aussi accessible et il n'y a jamais eu autant d'informations à déchiffrer. L'artisanat et la vocation restent sur la touche. La bonne création perdurera mais on est submergé par des réalisations médiocres. Ne nous égarons pas. Le combat continue. »

Fernando Gutiérrez
Pentagram Ltd.
11 Needham Road
London W11 2RP
UK

T +44 20 7229 3477
F +44 20 7727 9932

E email@pentagram.co.uk

www.pentagram.co.uk

Biography
1963 Born in London
1983–1986 BA Graphic Design, London College of Printing

Professional experience
1986–1992 Graphic designer, CDT Design, London
1990 Graphic designer, Summa, Barcelona
1991 Associate, CDT Design, London
1993–2000 Co-founding partner of Grafica, Barcelona
2000 Became a partner of Pentagram

Recent awards
2001 New York Art Directors Club Silver Award, Colors magazine

Clients
Colors
Hermes
El Pais
EPS magazine
La Compania de Vinos
Matador
Phaidon Press
Reina Sofia
Telmo Rodriguez
Tentaciones
The Friday Supplement
Vanidad

Project
Editorial

Title
Tentaciones

Client
El Pais

Year
1994–the present

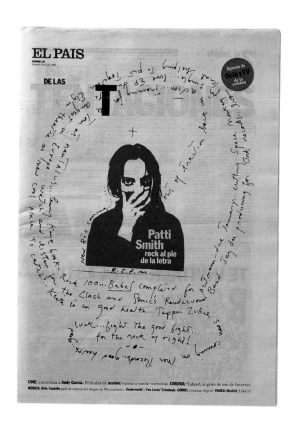

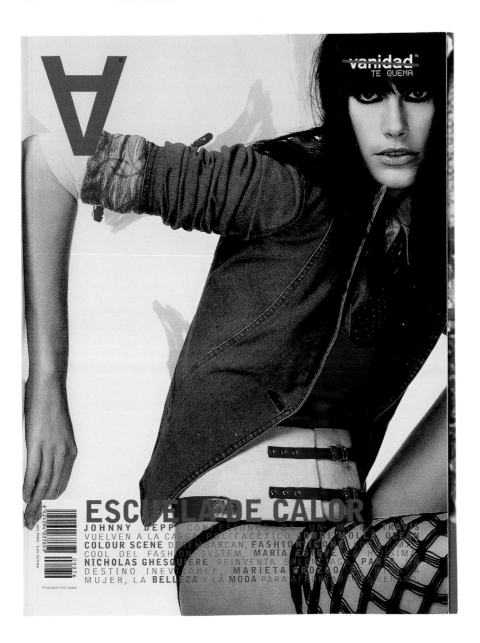

Project
Magazine cover design

Title
Vanidad

Client
Vanidad

Year
1998

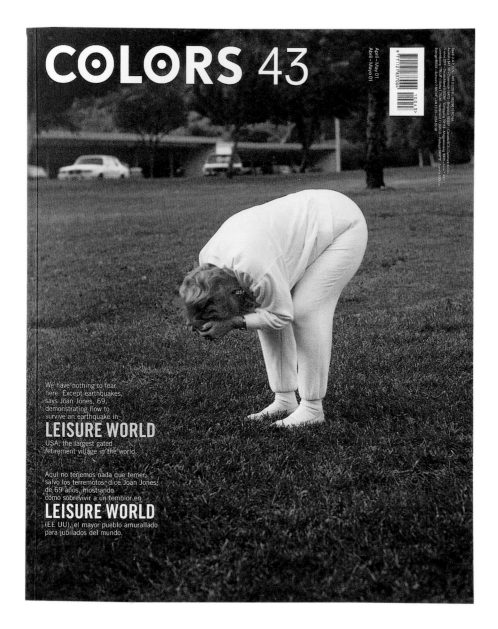

Project
Magazine cover design

Title
Colors – pictured: issue 43

Client
Benetton Group Spa /
La Fabrica

Year
2000–the present

Project
Exhibition catalogue

Title
F[r]icciones

Client
Aldeasa / Museo Nacional
Centro de Arte Reina
Sofia, Madrid

Year
2000

Ippei Gyoubu

"Coexistence of the bright and dark sides."

Opposite page:

Project
Event flyer

Title
Camou

Client
Camou

Year
2001

"I consider graphic design to be 'all things'. I think that the point of calling it graphic design will become nonsense, and that the obstacle of the name will be lost from now on. This means graphic design will become 'natural'. Graphic design is not a sublime thing, but probably has already reached the stage where it has transcended the wall which is not visible to all eyes, and has formed a still newer form. And it will continue expanding from now on, because graphic design is 'all things'."

» Für mich ist Grafikdesign allumfassend. Irgendwann wird man an den Punkt kommen, denke ich, an dem die Bezeichnung unsinnig geworden ist und keine Einschränkung mehr bildet. Das heißt, grafisches Gestalten wird ›natürlich‹, selbstverständlich sein. Die Gebrauchsgrafik schwebt keinesfalls in höheren Sphären, hat aber dennoch vermutlich ein Stadium erreicht, in dem sie die nicht für alle sichtbare Fachgrenze bereits überschritten und eine noch aktuellere Ausprägung gebildet hat. Das Grafikdesign wird von jetzt an expandieren, eben weil es allumfassend ist.«

«Je considère la création graphique comme toutes choses». Le fait de l'appeler graphisme n'aura plus de sens et l'obstacle que représente ce nom sera oublié. En d'autres termes, le graphisme deviendra ‹naturel›. La discipline en soi n'a rien de sublime, mais elle a probablement déjà franchi le cap où elle a transcendé ce mur que tout le monde ne peut pas voir pour revêtir une forme encore plus nouvelle. Elle continuera à s'étendre parce que le graphisme est ‹toutes choses›».

Ippei Gyoubu
3–40–22–201 Esaka chou
Suita city
Osaka 564–0063
Japan

T/F +81 6 6821 0710

E ippeix@
ga3.so-net.ne.jp

www001.upp.so-
net.ne.jp/ippei_gyoubu/

Biography
1974 Born in Japan
1989 Art high school
1992 Kobe Design
University Art College

Professional experience
1996–2001 Character designer, SNK (Japanese video game company)
2001 Began working as a freelance designer

Clients
Bijutsu Shuppan-Sha
Knee High Media Japan

Project
Character from comic strip "MAMMOTH" magazine

Title
The SPANKY

Client
Knee High Media Japan

Year
2001

Opposite page:

Project
Comic strip

Title
planet of the fusion

Client
Bijutsu Shuppan-Sha

Year
2001

Project
Illustration for Comickers
magazine

Title
Marshmallow

Client
Bijutsu Shuppan-Sha

Year
2001

Hahn Smith Design Inc.

"No rabbits, no hats."

Opposite page:

Project
Exhibition catalogue

Title
Arnaud Maggs: Works
1976–1999

Client
The Power Plant
Contemporary Art Gallery

Year
1999

"The best work will always be teamwork. A great game of tennis or hockey is between two skill sets. Design is always at its best when there are challenges and responses, whether it is between the client and designer, writer and designer, designer and artist, or a collaboration between designers. As exciting as the opportunities are that new technology create – and the speed and reach that are now possible – it always comes down to vision and content which will make good work endure. Good design should always consider the way we live and the broadest possible context. We're not sages, we're just trying to do the best we can, to add something to the world, and to earn a decent living."

» Die besten Lösungen entstehen immer als Gemeinschaftsarbeiten. Ein tolles Tennis- oder Hockeymatch ergibt sich aus dem Zusammenspiel von Könnern. Design ist immer dann am besten, wenn es sich Herausforderungen stellt, gleichgültig, ob diese aus dem Zusammentreffen von Auftraggebern und Designern, Autoren und Designern, Künstlern und Designern oder Designern untereinander entstehen. So spannend die von der neuen Technologie gebotenen Möglichkeiten mit ihrer Geschwindigkeit und Reichweite auch sind, letzten Endes kommt es auf die Idee und den Inhalt an, um einer guten Arbeit dauerhaften Wert zu verleihen. Gutes Design sollte immer unsere Lebensart und einen möglichst umfassenden Kontext berücksichtigen. Wir sind keine Weisen, wir versuchen nur unser Bestes zu tun, einen Beitrag zu leisten und genug Geld zu verdienen, um gut zu leben.«

« Les meilleures réalisations seront toujours des travaux d'équipe, comme un beau match de tennis ou de hockey nécessite d'opposer deux équipes compétentes. La création graphique est toujours plus performante lorsqu'il y a des défis et des réponses, que cela se passe entre le client et le créateur, le rédacteur et le créateur, le créateur et l'artiste ou au sein d'une collaboration entre graphistes. Aussi excitantes que soient les possibilités créées par les nouvelles technologies – ainsi que leur vitesse et leur portée – on en revient toujours à la vision et au contenu qui font qu'un bon travail tient la route ou pas. Le bon graphisme devrait toujours prendre en compte la manière dont on vit et le contexte le plus large possible. Nous ne sommes pas des sages, nous essayons simplement de faire de notre mieux, d'apporter quelque chose au monde et de gagner convenablement notre vie. »

Hahn Smith Design Inc.
398 Adelaide Street West, Suite 1007
Toronto
Ontario M5V 1S7
Canada

T +1 416 504 8833
F +1 416 504 8444

E studio@
hahnsmithdesign.com

Design group history
1995 Founded by Alison Hahn and Nigel Smith in Toronto

Founders' biographies
Alison Hahn
1957 Born in Toronto
1981–1985 BFA, Art History and Textile Design, Nova Scotia College of Art and Design, Halifax, Canada
Nigel Smith
1962 Born in Toronto
1981–1984 Fine Art and Graphic Design, Ontario College of Art, Toronto

Recent exhibitions
1998 "AIGA 50 Books Awards", New York; "i-D magazine – Annual Design Review", New York
1999 "100 Show", American Center for Design, Chicago
2000 "Design Effectiveness Award", Toronto
2001 "National Post/Design Exchange Awards", Toronto
2002 "AIGA 50 Books Awards", New York

Recent awards
1997–1999 Nominated annually for the Chrysler Awards
1998 Ontario Association of Art Galleries Award; AIGA 50 Books Award; Advertising and Design Club of Canada Award; American Association of Museums, Publications Design Competition; I.D. magazine – Annual Design Review
1999 Design Effectiveness Awards – Finalist; Design Effectiveness Awards – Silver; 100 Show – American Center for Design
2000 Presidential Design Awards; Design Effectiveness Awards; Alcuin Society Award for Excellence in Book Design
2001 National Post – Design Exchange Awards; Ontario Association of Art Galleries Award
2002 American Association of Museums
2002 AIGA 50 Books Award

Clients
Art Gallery of Toronto
Canadian Broadcasting Corporation
CIBC Development Corporation
Cooper-Hewitt, National Design Museum
Design Exchange
Dia Center for the Arts
Flammarion Publishers
George R. Gardiner Museum of Ceramic Art
Harvard Design School
Mattel
The Museum of Modern Art, New York
National Film Board of Canada
Power Plant
Rizzoli International Publications
Steelcase Canada
The Whitney Museum of American Art

Opposite page:

Project
Newsletter & gallery brochures

Title
The Power Plant members' quarterly newsletter

Client
The Power Plant Contemporary Art Gallery

Year
1999

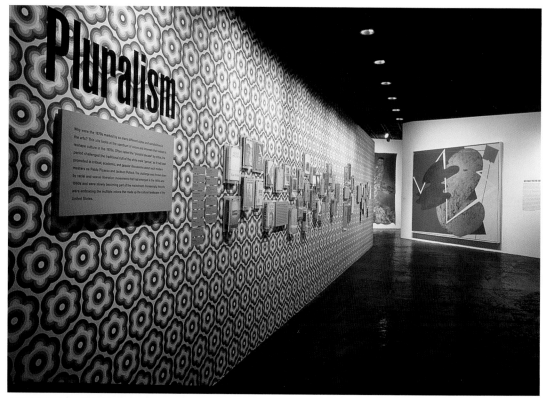

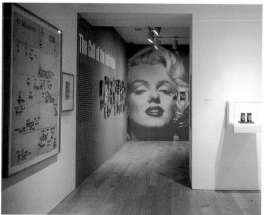

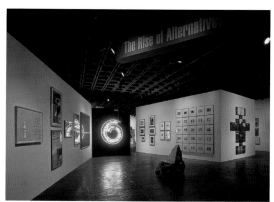

tim hawkinson

Opposite page:

Project
Exhibition graphics

Title
The American Century,
Part 2, 1950–2000

Client
The Whitney Museum of
American Art

Year
1999

Project
Exhibition catalogue

Title
Tim Hawkinson

Client
The Power Plant
Contemporary Art Gallery

Year
2000

Angus Hyland

"Continental modernism meets British eclecticism."

Opposite page:

Project
Magazine cover design

Title
Nikkei Design, issue dated
April 1999

Client
Nikkei Design

Year
1999

NIKKEI DESIGN

4
1999

特集／流通のデザイン
●陳腐化と停滞をブランディングで打破
特別リポート／アップルを蘇らせたデザインの力

"The discipline of graphic design will continue to evolve through technological and aesthetic advances, adapting to meet the needs of the market in an increasingly fashion-conscious world."

» Der Beruf des Grafikers wird sich infolge technischer und ästhetischer Fortschritte entwickeln und sich den Erfordernissen des Marktes in einer zunehmend modebewussten Welt anpassen.«

« Le graphisme continuera à évoluer au fil des progrès techniques et esthétiques, s'adaptant pour satisfaire les besoins du marché dans un monde de plus en plus axé sur la mode. »

Angus Hyland
Pentagram Design Ltd.
11 Needham Road
London W11 2RP
UK

T +44 20 7229 3477
F +44 20 7727 9932

E email@pentagram.co.uk

www.pentagram.com

Biography
1963 Born in Brighton, England
1982–1986 BA (Hons) Media and Production Design, London College of Printing
1987–1988 MA Graphic Design, Royal College of Art, London

Professional experience
1988 Founded his own studio
1998+ Director, Pentagram
2001 Edited Pen and Mouse: Commercial Art and Digital Illustration (Laurence King)

Recent exhibitions
1998 "Work From London", British Council touring exhibition
1999 "Ultravision", British Council touring exhibition
2000 "Symbol", London College of Printing
2001–2002 "Picture This", British Council touring exhibition, curated by Angus Hyland

Recent awards
1999 D&AD Silver Award; Big Crit Critics Awards (x2)
2000 Grand Prix, Scottish Design Awards
2002 Top Ten Graphic Designers in the UK, Independent on Sunday's selection

Clients
Asprey
BBC
BMP DDB
British Council
British Museum
Canongate Books Ltd
Crafts Council
DCMS
Eat
EMI
Garrard
Getty Images
Globe Theatre
The Imagebank
Penguin Books
Royal Academy
Royal College of Art
Victoria & Albert Museum
Virgin Classics

Project
Poster design

Title
"Tear Me Up" poster (for a student subscription offer to the magazine Creative Review)

Client
Creative Review

Year
1996

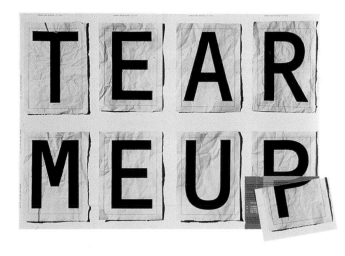

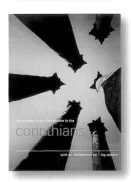

Project
Book design and
packaging

Title
The Pocket Canon Bibles

Client
Canongate Books

Year
1998

Crafts Council Gallery,
44a Pentonville Road,
Islington, London N1 9BY
Tel 0171 278 7700
5 minutes from
Angel tube

Free entry.
Tues to Sat 11- 6,
Sun 2- 6, Closed Mon
& Disabled Access

NO PICNIC

9.7.98 – 30.8.98

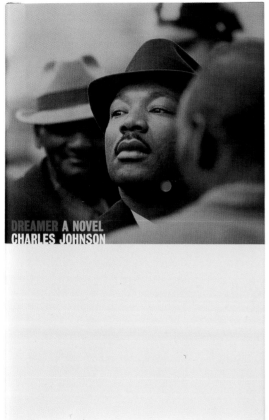

Opposite page:

Project
Poster

Title
"No Picnic" exhibition

Client
Crafts Council

Year
1998

Project
Book cover

Title
Dreamer by Charles
Johnson

Client
Canongate Books

Year
1999

Project
Book cover

Title
Scar Culture by Toni
Davidson

Client
Canongate Books

Year
1999

Hideki Inaba

"Thinking is very difficult and very easy."

Opposite page:

Project
Magazine cover

Title
SAL magazine.
Vol. 003 cover art

Client
SAL

Year
2001

"Either everything will be called design
or nothing will be called design. The
public will decide the direction of
design."

» Entweder wird alles als Design
bezeichnet werden oder nichts.
Die Öffentlichkeit wird die Richtung
bestimmen, die das Grafikdesign
einschlägt.«

« Soit tout sera appelé design soit
rien ne sera appelé design. Le
public décidera de l'orientation
du graphisme. »

Hideki Inaba
Hideki Inaba Design
PK108 2–32–13
Matsubara Setagaya-ku
Tokyo 156–0043
Japan

T +81 3 3321 1766
F +81 3 3321 1766

E inaba@t3.rim.or.jp

Biography
1971 Born in Shizuoka,
Japan
1993 Degree in Science
and Engineering, Tokai
University, Japan

Professional experience
1997 Started as a
freelance graphic
designer in Tokyo
1997–2001 Art Director,
+81 magazine, Japan
1997+ Art Director,
GASBOOK series, Japan
2001+ Art Director, SAL
free magazine, Japan

Recent exhibitions
2001 "Movement",
Sendai Mediatheque,
Sendai, Japan; "Buzz
Club", P.S.1, New York
2002 "JaPan Graphics",
RAS Gallery, Barcelona

Clients
+81
GASBOOK /
DesignEXchange
IdN / Hong Kong
NTT
SAL
Shift Production
Sony Music
Walt Disney
Wella Japan

Project
CD cover

Title
RE:MOVEMENT 1

Client
SAL

Year
2001

Opposite page:

Project
Magazine cover art

Title
"IdN" magazine
(Hong Kong)
cover art

Client
IdN systems design
limited

Year
2001

Opposite page:

Project
Magazine

Title
Artwork from "+81"
magazine

Client
+81

Year
2000

Project
Magazine covers

Title
"+81" magazine
vol. 10
vol. 11

Client
+81

Year
2000–2001

Intro

"Aesthetics first"

Opposite page:

Project
Poster

Title
Howie B - Folk

Client
Polydor

Year
2001

"The increasing use of graphic design as a purely commercial tool is devaluing its currency. The big design groups, and the big buyers of design, talk about 'difference', but they really mean sameness: everything looks the same. Design has been supplanted by branding, but no member of the public ever said: look at that branding! It means that design is becoming a visual sandwich-spread, and the result is blandness, uniformity and timidity. And paradoxically this is being done at a time when interest in visual culture has reached a high-point."

» Die Tatsache, dass die Gebrauchs-grafik in zunehmendem Maße aus-schließlich zur Werbung eingesetzt wird, wertet sie ab. Die großen Designbüros und die großen Auftrag-geber sprechen von ›Unterschied‹, meinen in Wirklichkeit aber ›Gleich-heit‹: Alles sieht gleich aus. Design ist durch Markenbildung ersetzt worden, aber keiner würde sagen: ›Guck dir mal diese Markenbildung an!‹ Das bedeutet, dass die grafische Gestal-tung zum visuellen Brotaufstrich geworden ist, und das Resultat sind Reizlosigkeit, Uniformität und Ängstlichkeit. Paradoxerweise geschieht das zu einer Zeit, in der das Interesse an der visuellen Kultur einen Höhepunkt erreicht hat.«

« Le recours croissant au graphisme comme un outil purement commer-cial le dévalue. Les grands bureaux et les grands acheteurs de graphisme parlent de ‹différence› mais il faut plutôt comprendre ‹uniformité› : tout se ressemble. Le design a été sup-planté par la stratégie de marque mais personne dans la rue ne s'est jamais écrié ‹Oh, regarde cette stra-tégie de marque !›. Cela signifie que la création graphique est en train de devenir une pâte à tartiner visuelle. Le résultat est monotone, neutre et timoré. Paradoxalement, cela se produit à une époque où l'on s'est rarement autant intéressé à la culture visuelle. »

Intro
35 Little Russell Street
London WC1A 2HH
UK

T +44 20 7637 1231
F +44 20 7636 5015

E jo@intro-uk.com

www.introwebsite.com

Design group history
1988 Co-founded by Katy Richardson and Adrian Shaughnessy in London

Recent exhibitions
1998 "Sound Design", Levi's Gallery, London (a travelling exhibition of UK record sleeve design)
2000 "Sonar Festival", Barcelona

Recent awards
1998 Best Design Team, CADS
2001 Best Design Team, CADS
2002 Best Direct Mail, Design Week Awards; Best Album Design, CADS

Clients
Art Fund
Barbican
BBC
British Council
Channel 4
Deutsche Bank
EMI
Mute
Penguin
Royal Academy of Music
Sony

The New Penguin Book of English Verse

Project
Book cover

Title
The New Penguin Book of
English Verse

Client
Penguin

Year
2001

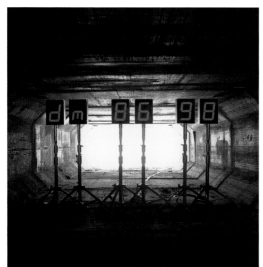
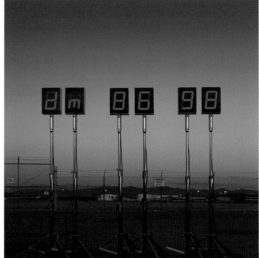
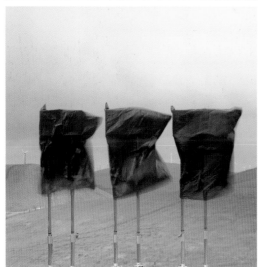

Project
Record covers

Title
Depeche Mode – singles
1986–98

Client
Mute

Year
1998

Project
CD booklet

Title
Primal Scream –
Exterminator

Client
Creation

Year
2000

Scott King

"There's no point in doing decorative design… it would just interfere with what I had to say…"

Opposite page:

Project
Poster

Title
Joy Division, 2 May 1980,
High Hall, The University
of Birmingham, England

Client
Self-published

Year
1999

Joy Division, 2 May 1980, High Hall, The University of Birmingham, England

"For me the worth of graphic design is its role in heightened moments of popular culture, the times when graphic design has contributed to inflicting change on society at large (Wyndham Lewis' 'Blast', Paris '68, British Punk …). I approach all my projects from the point of view that they are potentially a vehicle that can comment on different aspects of society, while making work that is visually exciting."

» Für mich liegt der Wert der Gebrauchsgrafik in der Rolle, die sie in Hochzeiten der populären Kultur spielt, Zeiten, in denen sie zu allgemeinen gesellschaftlichen Veränderungen beigetragen hat (z. B. Wyndham Lewis' ›Blast‹, Paris 1968, oder die britische Punkbewegung). Ich gehe bei allen meinen Projekten davon aus, dass sie potenziell ein Vehikel für einen Kommentar zu verschiedenen gesellschaftlichen Phänomenen darstellen. Dabei versuche ich, optisch ansprechende Arbeiten zu produzieren.«

« Pour moi, la valeur du graphisme réside dans son rôle lors des moments forts de la culture populaire, lorsqu'il contribue à apporter du changement dans la société dans son ensemble (‹Blast› de Wyndham Lewis, Paris en mai 68, le punk britannique). J'aborde chacun de mes projets comme s'ils avaient le potentiel de commenter différents aspects de la société, tout en réalisant un travail qui soit visuellement excitant. »

Scott King
35 Baker's Hill
London E5 9HL
UK

T +44 20 8806 8336

E info@scottkingltd.com

www.scottkingltd.com

Biography
1969 Born in East Yorkshire, England
1988–1992 BA (Hons) Graphic Design, University of Hull

Professional experience
1993–1996 Art Director, i-D magazine, London
1997+ Co-founder of CRASH project, London
1999+ Represented as an artist by Magnani gallery, London
2000+ Scott King Limited, London
2001–2002 Creative Director, Sleazenation magazine, London

Recent exhibitions
1998 "The Problem Is You", ICA, London; "London's Burning with Boredom Now", billboard, Cubitt, London
1999 "How Shall We Behave?", Robert Prime, London; CRASH, ICA, London; CRASH, billboard, the Westway, London, commissioned by the ICA; "Urban Islands", Cubitt, London
2000 "The Robin Hood Complex", Forde, Geneva; "Etat des Lieux #2", Centre d'Art Contemporain, Fribourg; "Flatplan", Magnani, London
2001 "Part True Part False Like Everything", San Filippo, Torino
2002 "Scott King", Magnani, London; "Air Guitar", various galleries, UK

Recent awards
2001 Total Publishing Magazine Design Awards, Best Front Cover of the Year; and Best Designed Feature of the Year

Clients
Blast First / Mute
Earl Brutus
Institute of Contemporary Arts (ICA)
Malcolm McLaren
Michael Clark Dance Company
Pet Shop Boys
Sleazenation Magazine

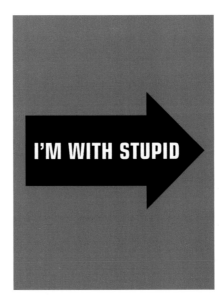

Project
Print

Title
I'M WITH STUPID

Client
Scott King

Year
2001

Opposite page:

Project
Magazine

Title
Sleazenation

Client
Sleazenation

Year
2001

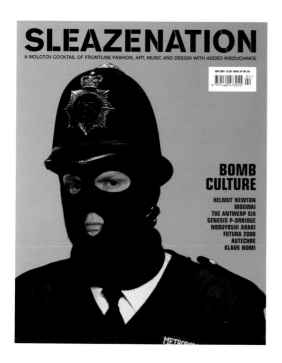

SLEAZENATION

A MOLOTOV COCKTAIL OF FRONTLINE FASHION, ART, MUSIC AND DESIGN WITH ADDED INSOUCIANCE

BOMB CULTURE

HELMUT NEWTON
MOGWAI
THE ANTWERP SIX
GENESIS P-ORRIDGE
NOBUYOSHI ARAKI
FUTURA 2000
AUTECHRE
KLAUS NOMI

Some people should be shot
Our photographers take on Britain

Sonic Youth

y

oung people: Sonic Youth – sacred cows who haven't made a decent record since Daydream Nation? Or the only living rock band who got out of grunge alive and went deeper underground, where no other rock band has gone before, to make NOIZE and fuck royally with the program? The answer is, whichever way you want it. Kim Gordon: "When I meet people who ask me what I do, I say I play in a band; they're like The Beatles, but more fucked up."

The trouble, or supreme joy, of Sonic Youth, is that any one of them, including Chicago genius Jim O'Rourke and former John Cage percussionist (and Kim Gordon high school pal) William Winant, who join us for dinner the night after their performance at SONAR (a festival of electronic music held annually in Barcelona), are so individually prolific and active across the entire spectrum of the arts, that to which a tape recorder on the table and attempt to encompass all of their activities with equal respect, and crack the enigmatic nut that Sonic Youth has become, is, ultimately, to invite noble failure.

For the record: At 43, Thurston Moore looks like, and occasionally acts like, an 18 year-old skate punk brat. It's freaky. Lee Ranaldo's partner, photographer/artist Leah Singer, is imminently due to give birth to the couple's first child. He seems vaguely distracted. Jim O'Rourke is dressed for a Chicago winter and often breaks into high-pitched hysterical giggling. He eats nothing except dessert, surviving on three espressos and cigarettes. Steve Shelley says little. "I mean, we talk about experimental music for an hour," he finally offers during his chocolate mousse, "and each one of us has

Whilst the UK press has gone 'mad' for the pretty progenitors of New York's current rock'n'roll renaissance, Sonic Youth remain largely unimpressed. Rather than delighting in stylised retrospection, the key for 'the Youth' is – and always has been – moving forward musically. Sleaze caught up with Thurston Moore, Kim Gordon, Lee Ranaldo, Steve Shelley, William Winant and new member Jim O'Rourke over dinner, to discuss their forays into avant garde, experimental music and to contemplate the changing face of New York. Text Lauren Zoric Photography Alasdair McLellan

Fig. 03: **Pet Shop Boys** I get along

I saw a couple in the supermarket today. They were in love. I wonder if they met there? I could go there today...I am out of fish fingers.

Fiercely independent, me.

I love internet chat rooms. They're better than being in a real club or pub.

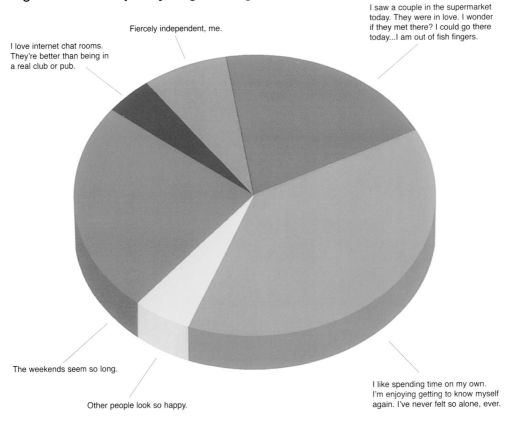

The weekends seem so long.

Other people look so happy.

I like spending time on my own. I'm enjoying getting to know myself again. I've never felt so alone, ever.

Project
CD single sleeve

Title
I Get Along

Client
Parlaphone Records

Year
2002

Project
CD artwork for Earls
Brutus album "Tonight
You are the Special One"

Title
I've got a Window
Wednesday

Client
Island Records

Year
1998

KM7

"Fight for optical pleasure!"

Opposite page:

Project
Magazine spread for the
issue 'mafia'

Title
Mafia-Style

Client
Styleguide Magazine

Year
2001

"Moving in a world in which reality is becoming more and more a subject to the media, in which MTV-isions dominate and transform our personal way of seeing things, in a world where the media are pushing forward an obfuscation of regionality, I simply want to underline the importance of reaching back to your gut feeling. Create, don't imitate!"

»In einer Welt, in der die Realität immer mehr von den Medien gezeichnet wird, die MTVisierung unsere Sicht der Dinge bestimmt und regionale Grenzen verschwinden lässt, empfinde ich persönlich es als besonders wichtig, auf sein eigenes, aus-dem-Bauch-heraus-Gefühl zu vertrauen. Create, don't imitate!«

«Évoluant dans un monde où la réalité est de plus en plus assujettie aux médias, où les MTV-isations dominent et transforment nos manières individuelles de voir les choses, où les médias favorisent l'obscurcissement des caractères régionaux, je tiens simplement à souligner l'importance de se fier à son instinct. Créez, n'imitez pas!»

Designbureau KM7
Schifferstrasse 22
60594 Frankfurt/Main
Germany

T +49 69 9621 8130
F +49 69 9621 8122

E mai@km7.de

www.km7.de

Design group history
1994 Founded by Klaus Mai in Frankfurt

Founder's biography
1960 Born in Schwäbisch Hall, Germany
1990 Intern, Paul Davis Studio, New York
1991–1994 Art Director, Trust Advertising Acency, Frankfurt
1994 Founded own design studio, KM7

Recent awards
1991 Honourable Mention, Art Directors Club Germany
1993 Honourable Mention (x2), Art Directors Club Germany
1995 Silver Medal and Honourable Mention, Art Directors Club Germany
1996 Award for Best Packaging in Mexico; Silver Medal and Honourable Mention, Art Directors Club Germany
1998 Honourable Mention, Art Directors Club Germany
2001 Honourable Mention (x2), Art Directors Club Germany
2002 Award for Best Designed Book, Stiftung Buchkunst

Clients
Audi
DaimlerChrysler
Die Gestalten Verlag
MTV
Nike
Rockbuch Verlag
Sony Music
Swatch
Universal Music
Volkswagen

Project
CD-Cover for the band "Funky Bees"

Title
Eifersucht

Client
Wolf Promotion

Year
1999

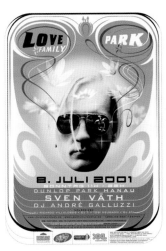

Project
Poster for the compilation
"Love Family Trax"
Poster for the event "Love
Family Park"

Title
Love Family Park

Client
Fedi Chourkair

Year
2001

Project
On-Air-Design for the
television station MTV

Client
MTV networks

Year
1999

Opposite page:

Project
Album cover for the band
"Tokyo Ghetto Pussy"

Title
Disco 2001

Client
Sony Music
Entertainment

Year
1997

Gudmundur Oddur Magnússon

"We must infuse matter with spirit."

Opposite page:

Project
Exhibition poster

Title
Ofeigur Listhus

Client
Ofeigur Gallery /
Dr. Bjarni H. Thorarinsson,
visiotect

Year
2001

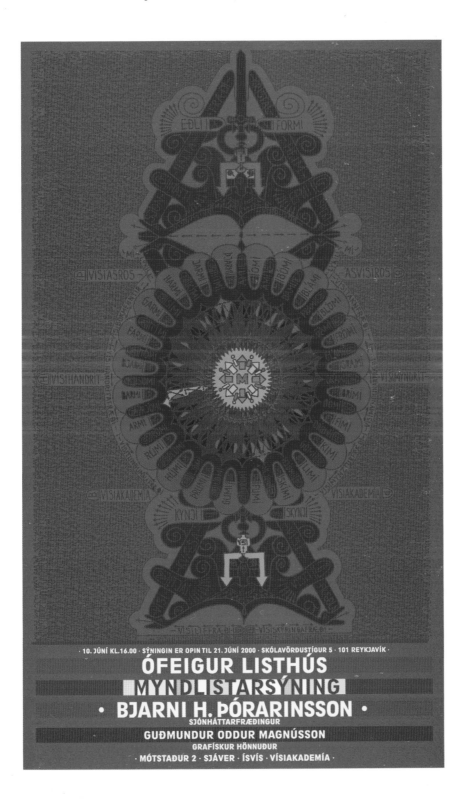

"In retrospect I have always been more interested in the use of visual language rather than finding a 'new' one. My masters more or less emphasized that our world is more about manipulating existing forms and ideas than finding new ones. If something 'new' happens, it never happens because you intend it to but because of pure happy accidents. But controlling or masterminding visual language is not an easy process. You need all human resources: from technical skill, historical awareness and research capabilities to emotional sensations and spirituality. I have a sense of a 'new' Middle-Ages era – by this I mean that we must study the inner light – the study of natural light is over anyway. We must infuse matter with spirit. I sometimes hear the argument that graphic designers must work on three levels only; otherwise it's not visual communication – fine art can work on multi-levels but graphic design only on three! If that was true, graphic art would be boring and reduced to the status of a mere product."

»Wenn ich zurückblicke, habe ich mich schon immer mehr für den Gebrauch der bereits vorhandenen Bildsprache interessiert als für die Erfindung einer ›neuen‹. Meine Lehrer haben mehr oder weniger stark betont, dass es in unserem Beruf eher um das Manipulieren bestehender als um das Erfinden neuer Formen und Ideen geht. Etwas Neues geschieht nicht, weil man das beabsichtigt hat, sondern als glücklicher Zufall. Aber die Bildsprache im Griff zu haben ist keine einfache Angelegenheit. Man braucht dafür sämtliche zur Verfügung stehenden Mittel von technischem Können und Forschergeist über Geschichtsbewusstsein bis zu Gefühlen und Spiritualität. Mir kommt die heutige Zeit wie ein neues Mittelalter vor. Damit meine ich, dass wir uns mit dem inneren Licht befassen sollten, weil die Analyse des natürlichen Lichts ja bereits abgeschlossen ist. Wir müssen der Materie Geist einhauchen. Manchmal wird argumentiert, Grafikdesigner dürften nur auf drei Ebenen arbeiten, sonst wäre ihre Arbeit keine visuelle Kommunikation. Die bildende Kunst könne auf sehr viel mehr Ebenen arbeiten und wir Grafiker nur auf dreien! Wenn das stimmte, wäre unsere Arbeit langweilig und auf den Status eines bloßen Produkts reduziert.«

«Avec le recul, je me rends compte que j'ai toujours été plus intéressé par le recours au langage visuel plutôt que par la découverte d'un ‹nouveau› langage. Mes maîtres ont toujours souligné que, dans notre monde, il s'agissait plus de manipuler des formes et des idées existantes que d'en trouver de nouvelles. Quand il se passe quelque chose de ‹neuf›, ce n'est jamais parce qu'on l'a voulu mais par un heureux hasard. Toutefois, contrôler ou organiser le langage visuel n'est pas une mince affaire. Cela requiert toutes les ressources humaines : des compétences techniques, une conscience historique et des capacités de recherche aux émotions et à la spiritualité. Je sens venir un ‹nouveau› Moyen Âge, je veux dire par là que nous devons étudier la lumière intérieure (de toutes manières, l'étude de la lumière naturelle est terminée). Nous devons infuser de l'esprit à la matière. J'entends parfois dire que les graphistes ne doivent travailler que sur trois niveaux, sinon ce n'est plus de la communication visuelle. Autrement dit, les beaux-arts peuvent utiliser de nombreux niveaux mais le graphisme uniquement trois ! Si c'était le cas, la création graphique serait ennuyeuse et réduite au statut de simple produit. »

Gudmundur Oddur Magnusson
Storholt 18
105 Reykjavik
Iceland

T +354 692 5356
F +354 562 3629

E goddur@lhi.is

Biography
1955 Born in Akureyri, Iceland
1976 Foundation course, Icelandic College of Arts and Crafts, Reykjavik
1977 Printmaking, Icelandic College of Arts and Crafts, Reykjavik
1978–1980 Mixed Media, Icelandic College of Arts and Crafts, Reykjavik
1986–1989 Graphic Design, graduated with honours, Emily Carr College of Art and Design, Vancouver, Canada
1994 Workshop with Wolfgang Weingart
1999 Workshop with David Carson

Professional experience
1981–1984 Co-founder and director of The Red House Gallery, Akureyri
1989–1991 Graphic designer, ION design, Vancouver
1991–1992 Graphic designer in Akureyri
1992+ Instructor in graphic design and freelance graphic designer
1995–1999 Head of Graphic Design Department, Icelandic College of Arts and Crafts, Reykjavik
1999+ Director of Studies, Iceland Art Academy

Clients
Akureyri Art Museum
Akureyri Summer Art Festival
Badtaste Record Company
Iceland Art Academy
Iceland Art Festival
Iceland Genomics Corporation
Icelandic Parliament
Icelandic Political Science Association
Kitchen Motors rec. company
Reykjavik Art Museum
Reykjavik Jazz Festival
The Living Art Museum
University of Iceland

Project
CD cover

Title
Kerfill

Client
Badtaste Record Company

Year
1999

Opposite page:

Project
Exhibition poster

Title
Brilljonskvida

Client
Dillon Bar /
Dr. Bjarni H. Thorarinsson, visiotect

Year
2001

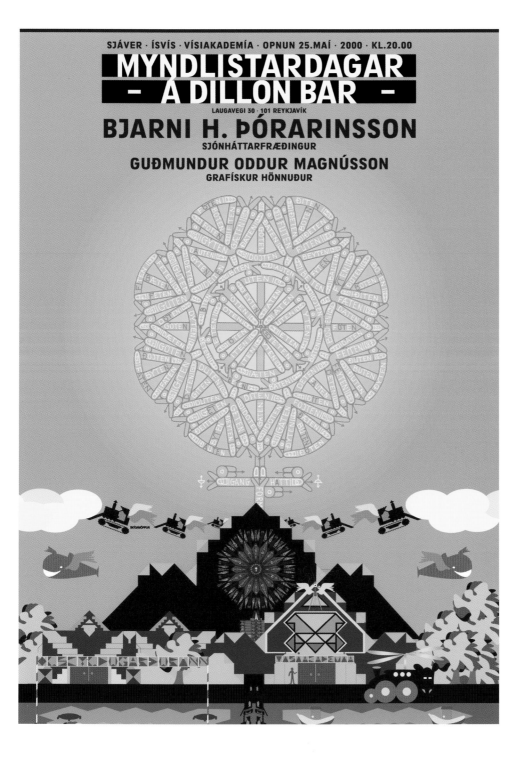

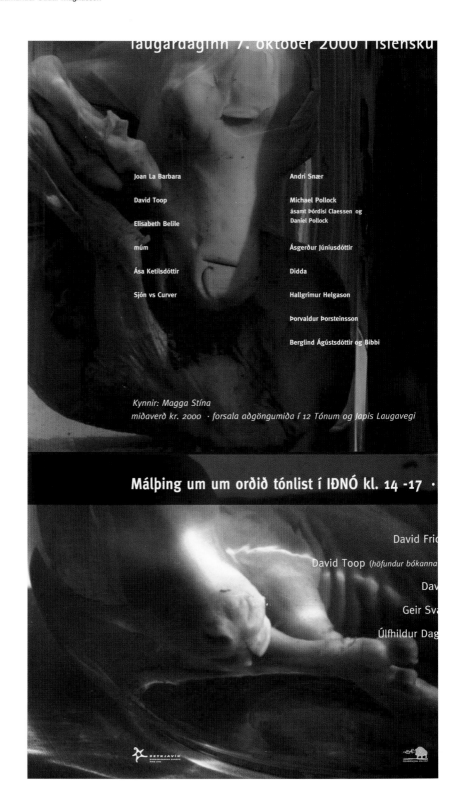

Project
Music and poetry festival
poster

Title
The Word Music

Client
Badtaste Record
Company

Year
2000

Project
Cover for poetry book

Title
Okkar a milli
(Just Between us)

Client
Mal & Menning
Publishers

Year
1999

Karel Martens

"With the given content, to call attention – in a personal way – to my client's message."

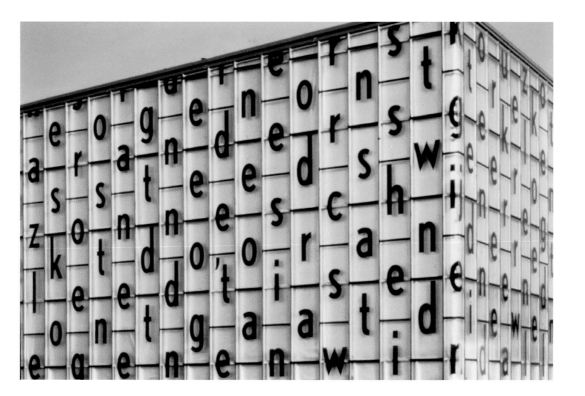

Project
Façade design for
the Veenman Printers
building, Ede,
The Netherlands

Title
The Veenman Printers
building, Ede,
The Netherlands

Client
Neutelings Riedijk

Year
1996

"Being there. Nowadays the client is no longer an expert who knows about a special product and is concerned to inform the public about it. More often the client is a committee or a general manager, concerned with 'being out there' and visible with its product.

The designer must still possess expertise (insight, knowledge and command of materials and techniques), but his personal signature has become more important. It may be almost the main issue in the struggle for the attention of the public. In addition, the first stages of the technical realization of design are now also in the hands of the designer. So more than ever before, the designer can make his presence visible. With this development, the goal of graphic design, which used to be to inform the public, has become more focused on the designer: for example, being present here in this book. Being there? Information about the product or about the designer? That is the question."

» Präsent sein. Heute ist der Kunde nicht mehr der Experte, der alles über ein Produkt weiß und der Öffentlichkeit sein Wissen mitteilen will. Meistens ist der Kunde ein Ausschuss oder ein Generaldirektor, der mit seinem Produkt in ›der Welt da draußen‹ präsent sein und wahrgenommen werden will.

Der Designer muss immer noch ein Spezialist sein, aber sein persönlicher Stil ist wichtiger geworden und vielleicht das entscheidende Merkmal im Kampf um öffentliche Beachtung. Hinzu kommt, dass heute auch die Anfangsphasen der technischen Herstellung beim Grafiker liegen. Deshalb kann er mehr denn je sich selbst, seinen Stil und seine Arbeit in den Vordergrund stellen. So hat sich das Ziel des Grafikdesigns, die Öffentlichkeit zu informieren, stärker auf den Designer verlagert, zum Beispiel, in diesem Buch präsent zu sein. Präsent sein? Information über das Produkt oder über den Designer? Das ist hier die Frage.«

« Etre présent. Aujourd'hui, le commanditaire n'est plus un expert qui connaît parfaitement un produit dont il veut informer le public. Le plus souvent, il s'agit d'un comité ou d'un directeur général surtout soucieux ‹d'être présent› sur le marché et de la visibilité du produit.

Le graphiste reste le détenteur d'un savoir-faire (une compréhension, une connaissance et une maîtrise des matériaux et techniques) mais sa signature a pris de l'importance. Elle peut même devenir l'élément déterminant dans le combat pour attirer l'attention. En outre, les premières étapes de la réalisation technique du graphisme sont désormais entre les mains du créateur. Il peut donc, plus que jamais, rendre sa présence visible. L'objectif de la création graphique, qui était autrefois d'informer le public, est devenu plus centré sur le graphiste lui-même : par exemple, être présent ici dans ce livre. Etre présent ? Informer sur le produit ou sur le créateur ? Là est la question. »

Karel Martens
Monumentenweg 21A
6997 AG Hoog-Keppel
The Netherlands

E km@
werkplaatstypografie.org

Biography
1939 Born in Mook en Middelaar, The Netherlands
1961 Commercial Art and Illustration Degree, School of Art and Industrial Art, Arnhem

Professional experience
1961+ Freelance graphic designer specializing in typography
1977+ Taught graphic design at Arnhem School of Art; Jan van Eyck Academie, Maastricht; School of Art, Yale University, New Haven, Connecticut
1997 Co-founded the ArtEZ typography workshop with Wigger Bierma for postgraduate education in Arnhem

Recent exhibitions
1999 Nominations for Rotterdam Design Prize, Museum Boijmans Van Beuningen, Rotterdam; "Mooi maar goed" (Nice but Good), Stedelijk Museum, Amsterdam; "Type on the edge: The work of Karel Martens", The Yale University Art Gallery, New Haven, Connecticut
1999–2002 Roadshow of Dutch graphic design, Institut Néerlandais, Paris; Villa Steinbeck, Mulhouse; Musée des Beaux-Arts, Valence; Maryland Institute College of Art, Baltimore; ADGFAD; Laus 01, Barcelona; Erasmushuis, Djakarta; Design Center Stuttgart; Gallery AIGA, New York

Recent awards
1998 Gold Medal, World's Best Book Design Award, Leipzig Book Fair
1999 Nomination for the design of the façade of the Veenman printing works, Ede, Rotterdam Design Prize

Clients
Amstelveen
Apeldoorn
Arnhem
Artez
Bibliotheek TU Delft
Bureau Rijksbouwmeester
De Architecten Cie
De Haan
De Nijl Architecten
Drukkerij Romen en Zonen
Drukkerij SSN
Drukkerij Thieme
Filmhuis Nijmegen
Fonds voor Beeldende Kunsten
Frienden Holland
Geertjan van Oostende
Gelderse Cultuurraad
Hoogeschool voor de Kunsten
Jan van Eyck Academie
Juriaan Schrofer
Katholiek Documentatie Centrum
Keppelsch ijzergieterij
Konduktor Elektro
KPN Nederland
Ministry of Finance
Ministry of Justice
Ministry WVC
Museum Boijmans Van Beuningen
NAi Publishing
Nederlandse Staatscourant
Nel Linssen
Neutelings Riedijk Architecten
Nijmeegs Museum 'Commanderie van St. Jan'
Nijmeegse Vrije Akademie
PTT Kunst en Vormgeving
Rijksmuseum Kröller Müller
Kluwer Publishing
Manteau Publishing
Paul Brand Publishing
Simeon ten Holt
Stedelijk Museum
Stichting Altena
Boswinkel Collectie
Stichting Holland in Vorm
Stichting Joris Ivens
Stichting Leerdam
Stichting Nijmeegse Jeugdraad
Stichting Oase
Stichting Post-Kunst-vakonderwijs
Stiftung Museum Schloss Moyland
SUN Publishing
Te Elfder Ure
Tijdschrift Jeugd en Samenleving
Van Lindonk Publishing
Van Loghum Slaterus
Vereniging Rembrandt
Wolfsmond
World Press Photo

De functie
van de vorm

Van den Broek
en Bakema
1948–1988
Architectuur en
stedenbouw

NAi uitgevers

Van den Broek en Bakema 1948–1988 Architectuur en stedenbouw
De functie van de vorm

Het Rotterdamse architectenbureau Van den Broek en Bakema heeft sinds 1948 een indrukwekkend oeuvre gerealiseerd in binnen- en buitenland. Vooral in de jaren vijftig en zestig speelde het bureau een rol van betekenis, in architectuur, stedenbouw en de spectaculaire synthese daarvan in megastructuren die door Van den Broek en Bakema werden aangeduid als 'architectuur-urbanisme'. Het bureau is verantwoordelijk voor een keur aan bekende projecten zoals de vertrekhal van de Holland Amerika Lijn en het winkelcentrum De Lijnbaan in Rotterdam, bungalowparken van Sporthuis Centrum, de aula van de Technische Hogeschool in Delft, woonwijken als Klein Driene in Hengelo en 't Hool in Eindhoven, en kantoorgebouwen voor Het Parool, de Postcheque- en Girodienst, Heineken, Siemens en Amro. De verschillende essays in deze publicatie behandelen de ideeën van Van den Broek en Bakema, vooral hun grote betrokkenheid bij mens en maatschappij komt hierbij aan de orde. Ook wordt een beeld gegeven van de werkwijze van het bureau. Daarnaast bevat de publicatie een rijk geïllustreerd deel waarin een veertigtal architectonische en stedenbouwkundige projecten wordt gedocumenteerd. De projecten en de verhalen erachter, de inspiraties en de geest van waaruit gedacht werd, zijn vandaag nog altijd van betekenis.

Nederlands Architectuurinstituut, Rotterdam

Project
Book designed with
Stuart Bailey and Patrick
Coppens

Title
Van den Broek en
Bakema 1948–1988

Client
NAi Publishers

Year
2000

printed matter drukwerk

ISBN 0-907259-20-0

9 780907 259206

extended edition

Book Fair — revised and

Letter at the Leipzig

Awarded the Golden

Winnaar van de

Goldene Letter op de

Buchmesse Leipzig —

uitgebreide heruitgave

Project
Book designed with Jaap
van Triest

Title
Karel Martens printed
matter \ drukwerk

Client
Heineken, Amsterdam /
Hyphen Press, London

Year
1996

Opposite page:

Project
Animation

Title
Not for Resale

Client
Self-published

Year
1997–2000

Me Company

"Go further out and faster."

Opposite page:

Project
Björk. Selmasongs

Title
Björk as Selma 1

Client
One Little Indian Records

Year
1999

" The modern, technologically enhanced process of graphic design is already causing people to reconsider what the category means. It's branching out into so many new areas, drawing inspiration and knowledge as it goes. This blurring of conceptual and creative boundaries is vital to the development of the category."

» Der moderne, technisch vorange-triebene Prozess des grafischen Gestaltens gibt schon jetzt Anlass darüber nachzudenken, was Grafik-design eigentlich bedeutet. Grafiker sind heute im Begriff, in viele neue kreative Bereiche vorzudringen und dabei ungewöhnliche Anregungen aufzunehmen und neues Wissen zu erwerben. Und gerade dieses Verwischen konzeptueller und gestalterischer Grenzen ist wesentlich für die Weiterentwicklung des Grafik-designs.«

« Les procédés modernes de la création graphique, renforcés par la technologie, nous incitent déjà à revoir le sens de cette discipline. Elle étend ses ramifications dans un nombre croissant de nouveaux secteurs, puisant son inspiration et ses connaissances sur le tas. Ce flou croissant des frontières conceptuelles et créatives est vital pour l'évolution de ce domaine. »

ME Company
14 Apollo Studios
Charlton Kings Road
Kentish Town
London NW5 2SA
UK

T +44 20 7482 4262
F +44 20 7284 0402

E paul@
 mecompany.com

www.mecompany.com

Design group history
1985 Founded by Paul White in London
2001 Chromasoma was created to run as a sister company to Me Company

Founders' biographies
Paul White (Founder)
1959 Born in England
Trained as graphic designer and illustrator
Alistair Beattie (Partner)
1970 Born in England
1992 BA (Hons) English Literature and Language, Oxford University

Recent exhibitions
2001 "Luminous", G8 Gallery, Tokyo
2002 "Luminous", Visionaire Gallery, New York

Clients
+81
Apple
Björk
Cartoon Network
Coca-Cola
Create
Creative
Dave Clarke
East West
FIFA
Fuji
Hussein Chalayan
I.D.
Idea
IdN
Julien McDonald
Kelis
Kenzo
Kirin
Laforet

MCA
Mercedes
MTV
Nike
One Little Indian Records
Review
Shots
Sony Creative Products
Sony Playstation
Studio Voice
The Face
Toyota
UEFA
Visionaire
V Magazine
Warners
Wired
Zoo
Zoozoom

Project
Big Horror

Title
Pandora 2

Client
Big Magazine

Year
2000

Project
Explorer

Title
Explorer 5.7 &
Explorer 4.2

Client
Self-published

Year
2001

Project
Numero Manga
magazine spreads

Title
Action Gun £
Big Gun

Client
Numero Magazine

Year
2001

Opposite page:

Project
Numero Orchids
magazine artwork

Title
Coelogyne 2.1

Client
Numero Magazine

Year
2001

MetaDesign

"Design forms the core of our company and is the focus of all that we do."

Project
Corporate design and
brand development of
Stylepark.com

Title
Brochure concept

Client
Stylepark

Year
2000

"Our name is MetaDesign because we think beyond design, grasping it as a strategic task. This means that, among other things, we consider and integrate design implementation strategies at the outset of every project. The future of graphic design combines basic design skills with the advanced possibilities of information technology – integrating movement, space and sound into highly complex user experiences. However, high complexity demands clear design strategies, systemizing message and emotion into easily understood communication. Through innovative and experimental use of the changing technological possibilities, graphic designers set the tone in the creation of new visual languages, thus contributing to the emergence of cultural trends."

» Wir heißen MetaDesign, weil wir über das Gestalten hinausdenken und es als strategische Aufgabe ansehen. Das bedeutet unter anderem, dass wir uns bei jedem Projekt zunächst Gedanken über die Umsetzung von Gestaltungsstrategien machen und diese dann verarbeiten. Die Gebrauchsgrafik der Zukunft kombiniert grundlegendes gestalterisches Wissen und Können mit den fortschrittlichen Methoden der Informationstechnologie und verbindet Bewegung, Raum und Ton für die Benutzer zu hoch komplexen Erlebnissen. Hohe Komplexität erfordert jedoch klare Gestaltungsstrategien, die Botschaft und Emotion in leicht verständliche Mitteilung bringen. Infolge neuartiger, auch experimenteller, Anwendungen der sich rasch weiterentwickelnden technischen Gegebenheiten wirken Grafiker essenziell an der Schaffung neuer Bildsprachen mit und leisten so einen Beitrag zu neuen kulturellen Trends.«

« Nous nous appelons MetaDesign parce que nous pensons au-delà du design, l'abordant comme une tâche stratégique. Cela signifie que, entre autres choses, nous concevons et intégrons des stratégies d'applications graphiques au début de chaque projet. L'avenir du graphisme associe les compétences de bases aux possibilités avancées de la technologie informatique, intégrant le mouvement, l'espace et le son dans des expériences d'utilisateurs très complexes. Toutefois, cette grande complexité nécessite des stratégies de design très claires, systématisant le message et l'émotion dans une communication facilement compréhensible. A travers une exploitation innovatrice et expérimentale des possibilités changeantes de la technologie, les graphistes inventent de nouveaux langages visuels, contribuant ainsi à l'émergence de tendances culturelles. »

MetaDesign AG
Leibnizstrasse 65
10629 Berlin
Germany

T +49 30 59 00 54 0
F +49 30 59 00 54 111

E mail@metadesign.de

Design group history
1990 Co-founded by Hans C. Krüger, Ulrike Mayer-Johanssen and Prof. Erik Spiekermann in Berlin
1993 MetaDesign West founded in San Francisco
1999 Prof. Erik Spiekermann left the company
2000 MetaDesign Suisse AG founded in Zürich
2001 Hans C. Krüger left the company

Founders' biographies
Ulrike Mayer-Johanssen
1958 Born in Osterburken, Germany
1976–1979 Studied Stage and Graphic Design, Merz-Akademie, Stuttgart
1981–1986 Visual Communication and Painting, HdK (Academy of Art), Berlin
1987 Partner, FAB Kommunikation, Berlin
1990–1991 Special teaching post at the Institute of Journalism and Communication Politics, Berlin
1992+ Held seminars and workshops for the International Design Centre (IDZ), Berlin; Collaborated with Frauke Bochnig (Psychologist at IDZ); Lectured on the Cultural and Marketing Management course at the HfM (Academy of Music), Berlin
1993+ Held seminars and lecturers for RankXerox Germany on colour and form theory
1997+ Held seminars, lectures and workshops for the European School of Management (EAP)

Recent exhibitions
1997 "Wegbereiter – Innovationen und Design aus Berlin und Brandenburg", touring exhibition, IDZ (International Design Centre Berlin), Berlin, Frankfurt/Main and Leipzig
2000 "Fünfzig Jahre Italienisches und Deutsches Design" (Fifty Years of Italian and German Design), Kunst- und Ausstellungshalle der Bundesrepublik Deutschland, Bonn

Recent awards
1999 Merit Award, Art Directors Club, New York; CyberFinalist, Cannes Lions; Excellent Design, Industry Forum Design, Hanover; Gold World Medal, The New York Festival
2000 Shortlist-Winner, TV Movie Award; Shortlist-Winner, Cyber Lions
2001 Red Dot Award 2001, Design Zentrum NRW

Clients
Access
Audi
Berliner Verkehrsbetriebe
Bluewin
Bosch
BP
Bugatti
DMC2
Encyclopaedia Britannica
ETalentWorks
Europäische Verlagsanstalt / Rotbuch Verlag
Gedas
Heidelberger Druckmaschinen
Hewi
IGuzzini
Information Objects
Lucerne Festival
Lamborghini
Nike
Novartis
Popp
Robert Koch-Institut
Roland Berger
Stylepark
The Glasgow School of Art
Verkehrsbetriebe Potsdam
VIAG Interkom
Volkswagen
Voith
Whirlpool

Top:

Project
Corporate design and
brand development of
Stylepark.com

Title
Basic elements

Client
Stylepark

Year
2000

Bottom:

Project
Online concept and
design of Stylepark.com

Title
Online design

Client
Stylepark

Year
2000

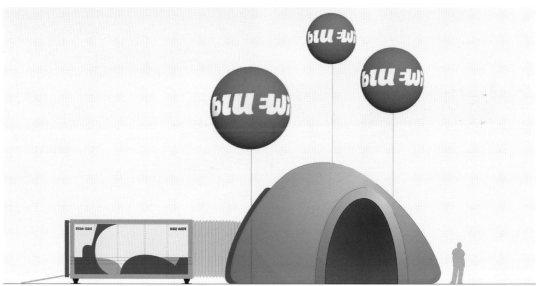

Top:

Project
Creation of a new brand

Title
Event architecture,
trade fair stand

Client
Bluewin

Year
2000–2001

Bottom:

Project
Creation of a new brand

Title
Event architecture, glass-
walled containers and
inflatable tent called
the "Pneu"

Client
Bluewin

Year
2000–2001

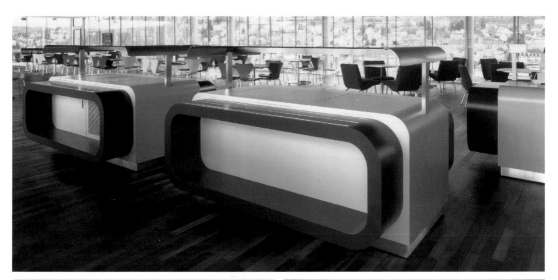

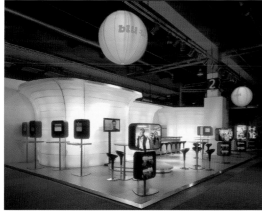

Top:

Project
Creation of a new brand

Title
Interior design, employees
area

Client
Bluewin

Year
2000–2001

Bottom:

Project
Creation of a new brand

Title
Corporate site

Client
Bluewin

Year
2000–2001

Mevis & van Deursen

"Our approach is experimental and content-based."

Project
Catalogue cover

Title
From Green Glass to
Airplane – recordings

Client
Artimo / Stedelijk
Museum, Amsterdam

Year
2001

"As a studio we mainly design posters, catalogues and identities for cultural institutions. We don't believe in conventions. Design should reflect contemporary cultural developments. In the future, we will have a better understanding of our world through information. We will even have more access to information through the effect of globalization, new media, cheaper printing techniques and so on. Graphic designers are desperately needed in this development. Their work is the most significant expression of our time."

»Als Firma gestalten wir hauptsächlich Plakate, Kataloge und Logos für Kulturinstitutionen. Wir glauben nicht an Konventionen. Design sollte zeitgenössische kulturelle Entwicklungen abbilden. In Zukunft werden wir aufgrund der verfügbaren Informationen unsere Welt besser verstehen. Die Globalisierung erleichtert den Zugang zu mehr Information durch die neuen Medien, ebenso durch billigere Drucktechniken und anderes mehr. Grafiker sind ganz dringend auf diese Entwicklung angewiesen. Ihr Werk ist erster und wichtigster Ausdruck unserer Zeit.«

« En tant que bureau de graphisme, nous concevons principalement des affiches, des catalogues et des identités pour des institutions culturelles. Nous ne croyons pas aux conventions. Le graphisme devrait refléter les développements culturels contemporains. A l'avenir, l'information nous permettra de mieux comprendre notre monde. Elle nous sera rendue encore plus accessible par la mondialisation, les nouveaux médias, des techniques d'impression meilleur marché, etc. Les graphistes sont indispensables à cette évolution. Leur travail est l'expression la plus significative de notre temps. »

Mevis & van Deursen
Geldersekade 101
1011 EM Amsterdam
The Netherlands

T +31 20 623 6093
F +31 20 427 2640

E mevd@xs4all.nl

Design group history
1987 Co-founded by Linda van Deursen and Armand Mevis in Amsterdam

Founders' biographies
Linda van Deursen
1961 Born in Aardenburg, The Netherlands
1981–1982 Academy voor Beeldende Vorming, Tilburg
1982–1986 BA Fine Art, Gerrit Rietveld Academy, Amsterdam
Armand Mevis
1963 Born in Oirsbeek, The Netherlands
1981–1982 Academy St. Joost, Breda
1982–1986 BA Fine Art, Gerrit Rietveld Academy, Amsterdam

Recent exhibitions
1998 "Standpunten", Kunsthal, Rotterdam; "Mevis & Van Deursen", St Lucas College, Antwerp; "Do Normal", San Francisco Museum of Modern Art; "Best Book Designs", Stedelijk Museum, Amsterdam
1999 "Mooi maar goed", Stedelijk Museum, Amsterdam; "Best Book Designs", Stedelijk Museum, Amsterdam
2000 "Best Book Designs", Stedelijk Museum, Amsterdam; "Mevis & Van Deursen", Zagrebacki Salon, Zagreb
2002 "Design Now: Graphics", Design Museum, London; "Dát was vormgeving – KPN Art & Design", Stedelijk Museum Amsterdam; "Best Book Designs", Stedelijk Museum, Amsterdam

Recent awards
1998 I.D. Forty (40 Best Designers Worldwide); Best Book Design, Amsterdam
1999 Best Book Design, Amsterdam; Nomination Theatre Poster Award
2000 Best Book Design, Amsterdam; Nomination Theatre Poster Award
2002 Best Book Design, Amsterdam

Clients
Artimo Foundation
Bureau Amsterdam
Gastprogrammering Het Ludion-Gent, Amsterdam
Muziektheater
NAi Publishers
Netherlands Design Institute
Stedelijk Museum Bureau Amsterdam
Stichting Fonds voor Beeldende Kunst, Vormgeving en Architectuur
010 Publishing
Thames & Hudson
TPG Post
Viktor & Rolf
Walker Art Center

Project
Catalogue

Title
If/Then (single page)

Client
Published by Netherlands Design Institute on the occasion of the "Doors of Perception" conference on Play

Year
1999

Project
Catalogue spreads

Title
From Green Glass to
Airplane – recordings

Client
Artimo / Stedelijk
Museum, Amsterdam

Year
2001

Project
Book

Title
Los Amorales

Client
Artimo

Year
2001

Project
Book

Title
Los Amorales

Client
Artimo

Year
2001

J. Abbott Miller

"Graphic design is a meta-language that can be used to magnify, obscure, dramatize, or re-direct words and images. It can be powerful, elegant, banal, or irrelevant. It's not inherently anything at all, but pure potential."

Opposite page:

Project
Poster

Title
The Work of Charles and
Ray Eames: A Legacy of
Invention

Client
Cooper-Hewitt, National
Design Museum

Year
2000

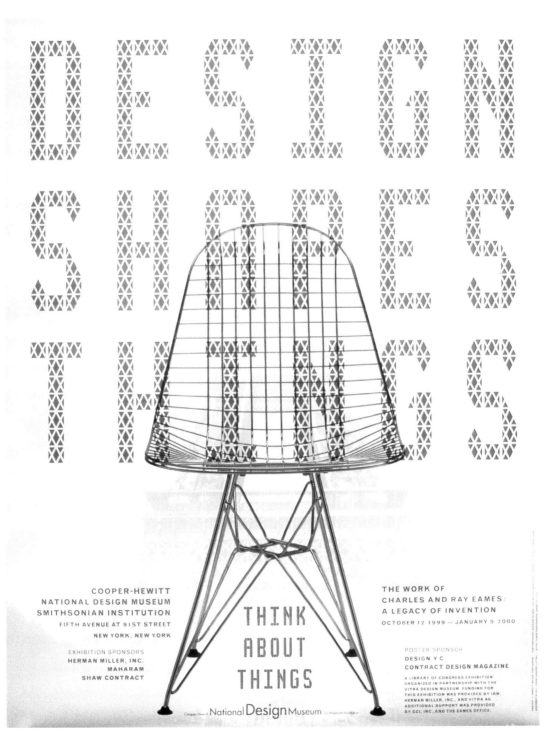

DESIGN SHAPES THINGS

COOPER-HEWITT
NATIONAL DESIGN MUSEUM
SMITHSONIAN INSTITUTION
FIFTH AVENUE AT 91ST STREET
NEW YORK, NEW YORK

EXHIBITION SPONSORS
HERMAN MILLER, INC.
MAHARAM
SHAW CONTRACT

THINK
ABOUT
THINGS

THE WORK OF
CHARLES AND RAY EAMES:
A LEGACY OF INVENTION
OCTOBER 12 1999 — JANUARY 9 2000

POSTER SPONSOR
DESIGN Y C
CONTRACT DESIGN MAGAZINE

A LIBRARY OF CONGRESS EXHIBITION
ORGANIZED IN PARTNERSHIP WITH THE
VITRA DESIGN MUSEUM. FUNDING FOR
THIS EXHIBITION WAS PROVIDED BY IBM,
HERMAN MILLER, INC., AND VITRA AG.
ADDITIONAL SUPPORT WAS PROVIDED
BY CCI, INC., AND THE EAMES OFFICE.

Cooper-Hewitt National Design Museum Smithsonian Institution

"Graphic design faces a potential absorption into information technologies that combine words, imagery, numerical data, voice, and other sensory communication. As the information technologies of the future lay claim to an ever-broadening synthesis of information formats, design is poised to participate in this culture, or to be swallowed up. Design will have to recognize its future as a humanistic filter for media, a blend of art and science that defends the reader, user, and interpreter of codes."

» Die Gebrauchsgrafik sieht sich von der Vereinnahmung durch die Informationstechnologien bedroht, die Worte, Bilder, numerische Daten, Stimme und andere Formen sinnlicher Kommunikation miteinander kombiniert. Da die Informationstechnologien der Zukunft Anspruch auf eine immer umfassendere Synthese von Informationsformaten erheben, stehen die Grafiker in den Startlöchern, um zu dieser Kulturleistung beizutragen – oder von ihr verschluckt zu werden. Die Branche muss ihre Zukunft in ihrer Funktion als humanistischer Filter der Medien sehen, eine Mischung aus Kunst und Wissenschaft, die Leser, Nutzer und Interpreten von Codes schützt.«

« La création graphique risque d'être absorbée par les technologies de l'information qui associent les mots, les images, les données numériques, la voix et d'autres formes de communication sensorielle. A mesure que ces technologies du futur accapareront une synthèse toujours plus vaste des formats de l'information, le graphisme devra choisir entre participer à cette culture ou se laisser engloutir. Il devra prendre conscience de son rôle de filtre humaniste des médias, mélange d'art et de science qui défend le lecteur, l'utilisateur et l'interprète des codes. »

J. Abbott Miller
Pentagram Design
204 Fifth Avenue
New York
NY 10010
USA

T +1 212 683 7000
F +1 212 532 0181

E miller@pentagram.com

www.pentagram.com

Biography
1963 Born in Gary, Indiana
1981–1985 Art and Design, Cooper Union School of Art, New York
1989–1992 Art History, City University, New York

Professional experience
1988+ Taught at various universities in both Europe and the US
1989 Founded studio Design/Writing/Research, New York
1999 Joined Pentagram's New York office as a principal
1997+ Editor of 2wice magazine, New York
1999+ Member, Alliance Graphique Internationale (AGI)
1995+ Member, Editorial Board of Eye magazine, London

Recent exhibitions
1998 "The Multiple", permanent exhibition, Davis Museum and Cultural Center, Wellesley College, Wellesley, Massachusetts
1998–1999 "The 30th Anniversary Covers Tour", touring exhibition for Rolling Stone magazine
1999 "J. Abbott Miller: Design/Writing/Research", Pentagram Gallery, London
1999–2000 "Village Works: Photography by Women in China's Yunnan Province", Davis Museum and Cultural Center, Wellesley College, Wellesley, Massachusetts; "John Bull and Uncle Sam: Four Centuries of British-American Relations", the Library of Congress, Washington
2000 "Art of the Ancient Americas", permanent exhibition, Davis Museum and Cultural Center, Wellesley College, Wellesley, Massachusetts; "Divine Mirrors: The Madonna Unveiled", permanent exhibition, Davis Museum and Cultural Center, Wellesley College, Wellesley, Massachusetts; "RockStyle", the Rock and Roll Hall of Fame and Museum, Cleveland, Ohio
2000–2001 "On the Job: Design and the American Office", the National Building Museum, Washington, DC; "Lennon: His Life and Work", the Rock and Roll Hall of Fame and Museum, Cleveland, Ohio; "Cold War Modern: The Domesticated Avant-Garde", Davis Museum and Cultural Center, Wellesley College, Wellesley, Massachusetts
2002–2003 "Harley-Davidson 100th Anniversary exhibition", worldwide touring show

Recent awards
1998 International Center of Photography Infinity Award, New York

Clients
2wice Arts Foundation
Architecture Magazine
Cooper-Hewitt, National Design Museum
Davis Museum and Cultural Center, Wellesley College
Geoffrey Beene
Guggenheim Museum
Harley-Davidson
Library of Congress
The Museum of Modern Art, New York
National Building Museum
Rock and Roll Hall of Fame and Museum
Rolling Stone
Smithsonian Institution
Vitra
Whitney Museum of American Art

Project
Magazine covers

Title
Editorial design for 2wice
magazine

Client
2wice Arts Foundation

Year
1997–present

Project
Magazine spreads

Title
"Rites of Spring" issue of
2wice magazine

Client
2wice Arts Foundation

Year
2000

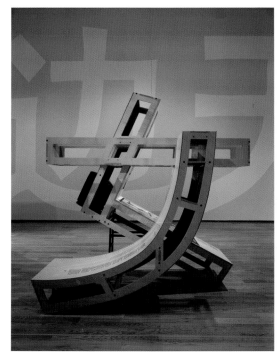

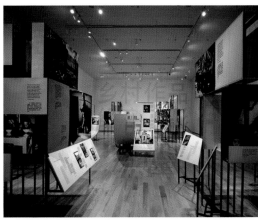

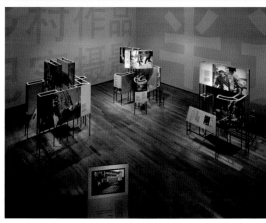

Project
Exhibition design

Title
Village Works:
Photography by Women
in China's Yunnan
Province

Client
Davis Museum / Cultural
Center, Wellesley College

Year
1999

M/M (Paris)

"It is almost by virtue of a logical development in the history of art that we have been called today to work in the field of design."

Opposite page:

Project
Generic poster for a series of art films, in collaboration with Pierre Huyghe & Philippe Parreno

Title
Ann Lee: No Ghost Just A Shell

Client
Anna Sanders Films

Year
2000

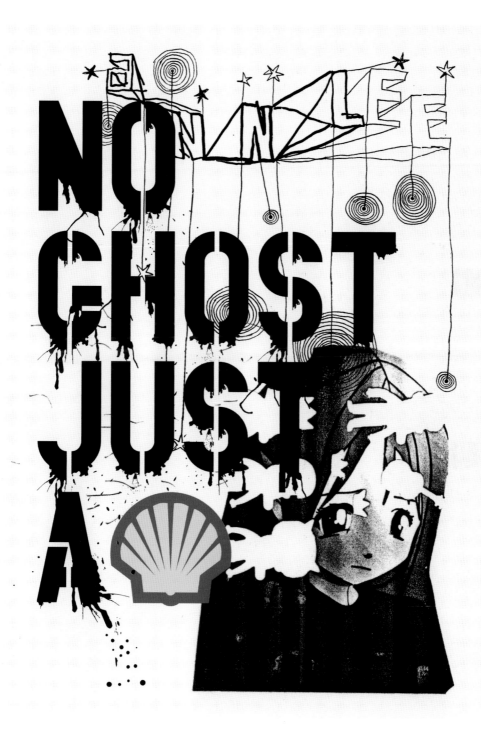

"An image never interests us as such. Its relevance lies in the fact that it contains the sum of preceding dialogues, stories, experiences with various interlocutors, and the fact that it induces a questioning of these pre-existing values. This is what makes for us a pertinent image. A good image should be in between two others, a previous one and another to come."

» Ein Bild ist nie an sich schon interessant. Seine Relevanz beruht darauf, dass es das Resultat vorhergegangener Gespräche, Geschichten und Erfahrungen verschiedener Menschen ist und es Fragen zu den in ihm ausgedrückten Werten provoziert. Das ergibt dann für uns ein treffendes Bild. Ein gutes Bild sollte zwischen zwei anderen stehen: einem früheren und einem späteren.«

« Une image en elle-même ne nous intéresse pas. Sa pertinence réside dans le fait qu'elle contienne la somme des dialogues, d'histoires et d'expériences antérieures avec divers interlocuteurs et qu'elle induise un questionnement des valeurs pré-existantes. C'est ce qui nous la rend pertinente. Une bonne image devrait se situer entre deux autres, une précédente et une à venir. »

M/M (Paris)
5–7, rue des Récollets
75010 Paris
France

T +33 1 4036 1746
F +33 1 4036 1726

E anyone@mmparis.com

www.mmparis.com

Design group history
1992 Co-founded by Michael Amzalag and Mathias Augustyniak in Paris

Founders' biographies
Michael Amzalag
1968 Born in Paris
1990 École Nationale Supérieure des Arts Décoratifs, Paris
Mathias Augustyniak
1967 Born in Cavaillon, France
1991 MA Graphic Design and Art Direction, Royal College of Art, London

Recent exhibitions
1998 "Museum in Progress, Signs of Trouble", Der Standard, Vienna; "La Table", Air de Paris, Paris; "Festival international d'affiches de Chaumont", Maison du Livre et de l'Affiche, Chaumont; "Silver Space: Allegrette Script", Air de Paris, Paris; "Festival 98", Reading Electric Power Station, Tel Aviv
1999 "M/M", Y-1, Stockholm; "About", with Pierre Huyghe, Philippe Parreno and Dominique Gonzalez-Foerster, D'Apertutto, Venice Biennale; "Souviens toi l'été dernier", Air de Paris, Paris; "Fastforward: mode in den medien der 90er jahre", Künstlerhaus, Vienna
2000 "Etat des lieux #2", Museum of Contemporary Art, Tucson; Collection JRP, Fri-Art, Fribourg; "Xn 00", Espace des Arts, Chalon-sur-Saône; "Au delà du spectacle", with Pierre Huyghe, Philippe Parreno, Centre Georges Pompidou, Paris; "Let's Entertain", with Philippe Parreno, Walker Art Center, Minneapolis; "One Thousand Pictures Falling From One Thousand Walls", with Philippe Parreno, Mamco, Geneva; "DGF/PH/PP", with Pierre Huyghe, Philippe Parreno and Dominique Gonzalez-Foerster, Kunstverein, Hamburg; "No Ghost Just A Shell", with Pierre Huyghe, Philippe Parreno,

Air de Paris/Marian Goodman, Paris and Schipper & Krome, Berlin
2001 "In Many Ways The Exhibition Already Happened", with Pierre Huyghe, Philippe Parreno and R&Sie/François Roche, Institute of Contemporary Arts, London; "We Set Off In High Spirit", with Inez van Lamsweerde & Vinoodh Matadin, Matthew Marks Gallery, New York; "Le Chateau de Turing", with Pierre Huyghe, French Pavilion, Venice Biennale; "Milneufcentseptantesix", with Inez van Lamsweerde & Vinoodh Matadin, Elac (Lausanne), Maison Européenne de la Photographie (Paris); "Cosmodrome", with Dominique Gonzalez-Foerster and Jay-Jay Johanson, Le Consortium, Dijon; "Annlee in Anzen Zone", with Dominique Gonzalez-Foerster, Galerie Jennifer Flay, Paris; "Interludes", with Pierre Huyghe, Stedejlik Van Abbemuseum, Eindhoven; "One Thousand Pictures Falling From One Thousand Walls", with Philippe Parreno, Friedrich Petzel Gallery, New York; "Even More Real Than You", with Pierre Huyghe, Marian Goodman, New York
2002 "Restart: Exchange & Transform", Kunstverein, Munich; "Design Now: Graphics", Design Museum, London

Clients
APC
Balenciaga
Berlin Biennale
Café Etienne Marcel
Callaghan
Calvin Klein
CDDB Théâtre de Lorient
Centre Georges Pompidou
Frac Champagne Ardenne
Galerie 213
Gingham
Hermès
Jeremy Scott
Jil Sander
Little-i Books
Louis Vuitton
Martine Sitbon
Musée d'art moderne de la ville de Paris
One Little Indian Records
Palais de Tokyo
Patrick Seguin
Pearl Union
Pittimagine Discovery
Schirmer/Mosel
Science
Siemens Artsprogram
Source
The Republic of Desire
Villa Medici
Virgin France
Vitra
Vogue Paris
Yohji Yamamoto

Project
A book about muscle cars
and drag racing by
fashion photographer
Craig McDean. Edited &
designed by M/M (Paris)

Title
I Love Fast Cars

Client
Powerhouse books

Year
2000

Project
From "French Landscape
1.0", a visual essay by
M/M (Paris) for the
Guggenheim Magazine.
Re-used as a cover image
for Documents sur l'art #12

Title
Bébé avec Deleuze

Client
Powerhouse books

Year
2000

Opposite page:

Project
Invitation card for
Balenciaga Fall / Winter
2002/03 collection

Title
Balenciaga (Melia)

Client
Balenciaga

Year
2002

Project
Invitation card for
Balenciaga Spring /
Summer 2002 collection

Title
Balenciaga (Christy)

Client
Balenciaga

Year
2002

Project
Theatre poster

Title
Marion de Lorme

Client
CDDB Théâtre de Lorient

Year
1999

Hideki Nakajima

"To find a brand new form that does not currently exist."

Opposite page:

Project
Poster for 'code
exhibition/new village'

Title
S/N

Client
Code

Year
2002

"Just as the invention of the electric guitar and synthesizer gave birth to rock 'n' roll and to techno music, and the invention of the projector gave birth to film, new technology bears new means of expression. In the same way, new technology in graphic design provides new ways of communicating and, perhaps, novel representations. Not only in design but in all fields of expression it is never true to say 'all possible forms of representation have been exhausted.'"

» Die Erfindung der Elektrogitarre und des Synthesizers hat den Rock'n'Roll und die Technomusik hervorgebracht, die Erfindung des Projektors führte zum Film. Jede neue Technologie bringt neue Ausdrucksmittel mit sich. Dementsprechend eröffnen moderne grafische Techniken auch neue Arten der Kommunikation und führen vielleicht zu neuartigen Darstellungsweisen. In keinem schöpferischen Bereich – einschließlich der Gebrauchsgrafik – stimmt die Behauptung, sämtliche möglichen Ausdrucksformen seien ausgeschöpft.«

« Tout comme l'invention de la guitare électrique et du synthétiseur a donné naissance au rock'n'roll et à la musique techno, et celle du projecteur au cinéma, les nouvelles technologies engendrent de nouveaux moyens d'expression. Parallèlement, dans le domaine du graphisme, elles offrent de nouveaux outils de communication et, peut-être, de représentation. En graphisme comme dans tous les autres domaines d'expression, on ne peut jamais dire ‹ on a déjà épuisé toutes les formes possibles de représentations ›. »

Hideki Nakajima
Nakajima Design
Kaiho Bldg-4F
4–11, Uguisudani-cho
Shibuya-ku
Tokyo 150–0032
Japan

T +81 3 5489 1757
F +81 3 5489 1758

E nkjm-d@
kd5.so-net.ne.jp

Biography
1961 Born in Saitama, Japan

Professional experience
1988–1991 Senior Designer, Masami Shimizu Design Office, Tokyo
1992–1995 Art Director, Rockin'on, Tokyo

Recent exhibitions
1994 "Tokyo Visual Groove", Tokyo
1998 "Japan Graphic Design Exhibition", Paris; Art Exhibition for Seiko's Neatnik, Tokyo
2000 "Graphic Wave 5" at ggg, Tokyo
2001 "Takeo Paper Show 2001", Tokyo; "Graphisme(s)", Paris; "Typo-Janchi", Seoul; 032c's "The Searching Stays with You", Berlin and London
2002 code exhibition [new village], Tokyo, Osaka, Kyoto

Recent awards
1995–2000 Gold Award (x5) and Silver Award (x7), The Art Directors Club, New York
1999 Tokyo ADC Award
2000 Best Book Design, 19th International Biennale of Graphic Design, Brno, Czech Republic
2001 Good Design Award, Chicago Athenaeum

Clients
Issey Miyake
The National Museum of Modern Art, Tokyo
Nestle Japan
PARCO
Rockin'on
Sony Music
Toshiba-EMI
Warner Music Japan
Victor Entertainment

Project
Poster for 'code exhibition/new village'

Title
S/N

Client
Code

Year
2002

Project
Art box for Ryuichi
Sakamoto's opera 'LIFE'

Title
Sampled Life

Client
Code

Year
1999

Project
Artwork for 'IDEA'
magazine

Title
re-cycling

Client
IDEA

Year
2002

Matt Owens

"An ongoing examination/conversation between the dynamics and interrelationships of personal exploration and professional practice."

Opposite page:

Project
CD Rom cover and poster

Title
CODEX SERIES 1 and 2

Client
Self-published

Year
1999/2000

1 the**Codex**series
narrative exploration beyond the book
Josh Ulm. Tree Axis. Orangeflux. Volumeone.

Persistence
of Vision
Josh Ulm.

Fantasy Island
Tree Axis.

Love Horse
Orangeflux.

Heterotopia
Volumeone.

the **Codex** series is a quarterly
document of new projects by
four different talents working
in the digital medium, exploring
the interrelation of narrative,
design and the interactive.

"The definition of where graphic design ends and begins is becoming more and more blurred as technology and functional constraints begin to further determine visual constraints. As a result, I think that 'design' will become more clearly divided along visual and technological lines. I really enjoy the space between the visual and the technological and feel that designers who can negotiate the space between technology and aesthetics will be the most successful in the future. The interrelationship between print and interactive and motion graphics is an interesting space that will become more and more important in the future. Visual language exists all around us and this will not change. How visual language interacts with popular culture, technology and media/mediums will remain at the heart of what makes graphic design as a discipline so interesting and ever-evolving."

» Die Bestimmung der Punkte, an denen die Gebrauchsgrafik beginnt und endet, wird mit den durch Technik und funktionale Zwänge immer enger gezogenen optisch-bildlichen Grenzen zunehmend schwieriger. Meiner Meinung nach wird man ›Design‹ deshalb künftig noch klarer nach visuellen und technischen Kriterien kategorisieren. Mir macht das Spannungsfeld zwischen den visuellen Aspekten und der Technik Spaß und ich glaube, dass diejenigen Grafiker, denen die Verbindung von Technik und Ästhetik gelingt, in Zukunft am erfolgreichsten sein werden. Die Wechselbeziehung zwischen Druck-grafik und interaktiver Grafik mit bewegten Bildern stellt ein interes-santes Feld dar, das in Zukunft an Bedeutung gewinnen wird. Wir sind auf allen Seiten von Bildsprachen umgeben und das wird auch so bleiben. Wie sie mit Popkultur, Technik und verschiedenen Medien interagieren, wird auch weiterhin den Kern des Grafikdesigns aus-machen, der es so interessant und entwicklungsfähig erhält.«

« La technologie et les restrictions fonctionnelles déterminent chaque fois plus les contraintes visuelles, on a de plus en plus de mal à définir où commence le graphisme et où il finit. Par conséquent, je pense que la ‹création› sera plus clairement divi-sée par des frontières visuelles et technologiques. Je me plais bien dans l'espace contenu entre le visuel et le technologique et pense que les graphistes qui s'en sortiront le mieux seront ceux capables de négocier l'aire située entre la technologie et l'esthétique. Les interactions entre l'impression et le graphisme interactif et animé forment un domaine inté-ressant qui prendra de plus en plus d'importance. Le langage visuel est partout autour de nous et cela ne devrait pas changer. La manière dont il interagit avec la culture populaire, la technologie et les médias restera au cœur de ce qui fait du graphisme une discipline intéressante et en évolution constante. »

Matt Owens
Volumeone
Suite 607
54 West 21st Street
New York
NY 10010
USA

T +1 212 929 7828

E matt@volumeone.com

www.one9ine.com
www.volumeone.com

Biography
1971 Born in Dallas, Texas
1993 Graduated from the University of Texas
1994 MFA Graphic Design, Cranbrook Academy of Arts, Michigan

Professional experience
1995–1997 Creative Director, MethodFive, New York
1997 Founded Volume-one in New York
1999 Co-founded the design company one9ine with Warren Corbitt

Recent exhibitions
1999 "Young Guns 2", Art Directors Club, New York; "The Remedi Project", www.theremediproject.com
2001 "Young Guns 3", Art Directors Club, New York; "VidelLisboa", Lisbon; RMX TWO, "Extended Play", Sydney Fresh Conference

Recent awards
1999 Shockwave Site of the Day
2000 Shockwave Site of the Day; Flash Film Festival finalist – flashforward.com
2001 Flash Film Festival finalist – flashforward.com

Clients
Bartle Bogle Hegarty
Cooper-Hewitt, National Design Museum
National Geographic
The Museum of Modern Art, New York
United Nations
Wieden+Kennedy

Project
Postcards

Title
Arrival/Departure

Client
Self-published

Year
1999

Project
IdN magazine cover

Title
IdN magazine, vol. 6 no. 3
cover

Client
IdN

Year
1999

Project
Website

Title
Volumeone, Spring 2001
(volumeone.com)

Client
Self-published

Year
1997–2001

Opposite page:

Project
Emigre magazine spreads

Title
Deep End

Client
Emigre Magazine 51

Year
1999

sink or

Learning the parameters. Acquiring the fundamentals.
There is a physics behind the phenomenon.
Complex equations. suffocated.

A sense of hesitant regret clouds the previous ascent. A scrambling
effort to find footing merges with an acute sense of mortal terror. [5:35:24pm. quick shower]

deep end, by Matt Owens

Weighing the consequences. assessing the variables.
Precipitate caution. suspended.
Familiar safeguards. dismantled.

Preliminary steps having been taken, the process is initiated.
[09:23:47am. Metropolitan Ave.]

Mirco Pasqualini

"I like design work because I can express my ideas and my thoughts. I can share my mind…"

Opposite page:

Project
Personal Book

Title
Graphic Design
Experiment 5

Client
Self-published

Year
2002

"I'd like to create and build an entire city – I have been drawing buildings for a long time, I project streets, bridges, plazas; I'd like to create fashion; I'd like to create music; I'd like to cover the Chrysler Building in New York with images; I'd like to open a sunshine bar on a Caribbean beach; I'd like to follow important and creative projects for Human Interface research; I'd like to make drums, taking the wood and working it into an instrument; I'd like to travel for my business more weeks in a year; I'd like to live in Rovigo, in Paris, in New York, in Los Angeles, in Sydney and Tokyo; I'd like to learn every single creative technique; I'd like to have a son; I'd like all that means creativity. I'd like to dream forever ;-)"

» Ich würde gerne eine ganze Stadt entwerfen und bauen. Seit langem schon zeichne ich Gebäude, plane Straßen, Brücken und Plätze. Ich würde gerne Mode machen und Musik komponieren. Ich würde gerne das Chrysler Building in New York mit Bildern bedecken. Ich würde gerne eine Bar an einem Strand in der Karibik eröffnen. Ich würde gerne wichtige kreative Projekte im Bereich der Human Interface Forschung entwickeln. Ich würde gerne Trommeln herstellen, Holz nehmen und daraus ein Instrument bauen. Ich würde gerne jedes Jahr längere Geschäftsreisen als bisher machen. Ich würde gerne in Rovigo, in Paris, New York, Los Angeles, Sydney und Tokio leben. Ich würde gerne jede einzige kreative Technik erlernen. Ich hätte gerne einen Sohn. Ich hätte gerne alles, was Kreativität ausmacht. Ich würde gerne für immer und ewig träumen ;-)«

«J'aimerais créer et construire une ville entière. Je dessine des bâtiments depuis longtemps. J'imagine des rues, des ponts, des places. J'aimerais dessiner des vêtements. J'aimerais composer de la musique. J'aimerais recouvrir d'images le Chrysler Building à New York. J'aimerais ouvrir un bar paillote sur une plage des Caraïbes. J'aimerais suivre des projets importants et créatifs pour la recherche sur les interfaces ergonomiques. J'aimerais fabriquer des tambours, façonnant l'instrument à partir du bois brut. J'aimerais voyager plus souvent pour mon travail. J'aimerais vivre à Rovigo, à Paris, à New York, à Los Angeles, à Sydney et à Tokyo. J'aimerais apprendre toutes les techniques créatives. J'aimerais avoir un fils. J'aime tout ce qui signifie créativité. J'aimerais rêver toujours ;-)»

Mirco Pasqualini
Ootworld Srl
Piazza Serenissima, 40
31033 Castelfranco
Veneto (TV)
Italy

T +39 042 342 5311
F +39 042 342 5312

E mirco.pasqualini@ ootworld.com

www.mircopasqualini.com

Biography
1975 Born in Lendinara, Italy
1994 Graduated from technical commercial college

Professional experience
1999 Multimedia art director, Seven, Treviso, Italy
2000+ Co-founder and creative director, Ootworld, Italy

Recent exhibitions
2001 "Flashforum IBTS", Milan, Italy; "Flashforum", Perugia, Italy
2002 "Opera Totale", Mestre, Italy

Recent awards
1998 Macromedia Site of the Day (x2), USA
1999 Site of the Week, Communication Arts for Giglio project
2000 New Media Talent 2000, AKQA and Creative Review
2001 Mediastar and Bardi awards, Italy; Silver Lions, Cannes Festival

Clients
Expanets
FILA skates
Giglio
ItaliaOnLine Spa
King's markets
SAI Assicurazioni
Savannah International Trade Center
Sebastian International Hairstyling
Sillary Mayer & Partners
Teatro Massimo di Palermo
Wall Street Journal

Project
Website Teatro Massimo of Palermo

Title
Teatro Massimo

Client
Foundation Teatro Massimo

Year
2000

Opposite page:

Project
Personal book

Title
Japanese Web Design Annual 1999

Client
Self-published

Year
2000

JAPANESE
WEBDESIGN
ANNUAL
1999

TheWebDesignAnnual1999

コンピュータの世界でよく言われる「For every difficult thing that become easy, two impossible things
become difficult」というアイロニーは、Webの世界にも十二分にあてはまるようで、ページ作りに必要な基礎知
識の増え方といったら半端じゃないに説いて歩く身にもなってみろってんだ)。必要とされる素養も単なるHTML
のコーディングから、ページレイアウト的なデザイン、さらには動的要素を含んだAUI(Animated User Interface)
にいたる感覚まで必要とされるようになってきた。DTPに近いというより、CM作りとかに近いんじゃないかな。この
世界に身を投じる若者もその素養を示すべく、名刺代わりにいろんなテクニカルなサイトを作って楽しませてくれる。
このサイトはそんな中でよくできる(パターンのひとつとも言える。すべてFLASHで作ったサイト。アメリカ人の知人に
教えてもらったイタリアの青年は結構面白い感覚を見せてくれる。[木島英寺]

Opposite page, top:

Opposite page, bottom:

Project
Personal book

Title
No words

Client
Self-published

Year
2000

Project
Personal book

Title
Teatro Massimo vision
remix

Client
Self-published

Year
2001

Project
Personal book

Title
FILA Skates vision remix

Client
FILA

Year
2001

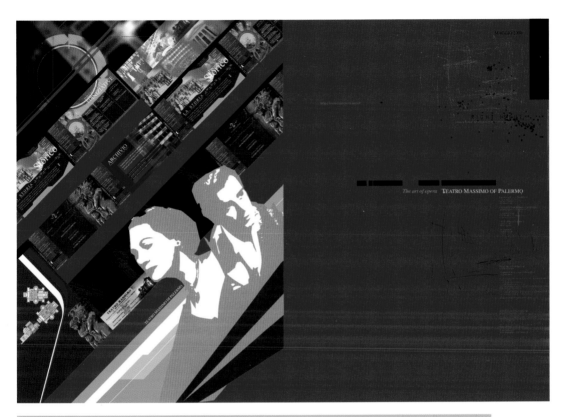

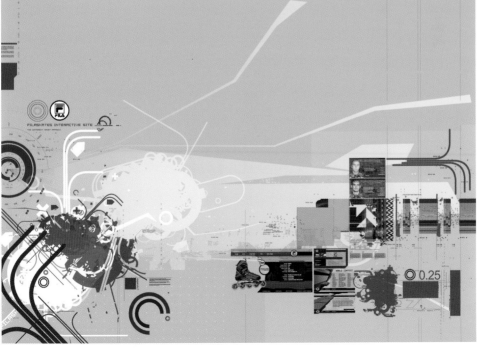

Katrin Petursdottir

"We are all just bobbing around."

Project
Illustration

Title
Angel

Client
M.Y. Studio

Year
2002

"I like to tell and produce stories in my work, in a kind of visual comfort which I hope can speak to and entertain others as well. In a more detailed way these images spring out of a desire to explore and expand imaginary worlds and to cultivate them in computer-generated environments. With computer technology the possibilities for expressing this has become so detailed and expansive that these worlds have developed their own kinetic momentum within the structures that I have created for them. In modern society we breathe the air of visual communications. It envelops us, inside and outside, and we accept it, under the illusion of making a choice. This is our reality and with the multitude of choices all around us we have become very trained at analysing, making connections and drawing conclusions about the messages and codes we are forced to absorb. I think that it's possible to intertwine different creative languages without making a sticky mixture, and that design in the future will be practised in a much more 'interfused,' fluid way, resulting in a freer mental environment. It definitely won't be just logos."

» Mit meinen Arbeiten erzähle ich gern Geschichten als eine Art visueller Trost, der auch andere Menschen anspricht. Wenn man es genauer betrachtet, entspringen diese Bilder dem Wunsch, imaginäre Welten zu erkunden und zu erweitern und sie in computersimulierten Umgebungen zu kultivieren. Mit der Computertechnik sind die Ausdrucksmöglichkeiten dafür so detailliert und weitreichend geworden, dass diese Welten innerhalb der Strukturen, die ich für sie geschaffen habe, eine Eigendynamik entwickelt haben. In der modernen Gesellschaft atmen wir die Luft der visuellen Kommunikation. Das ist unsere Realität und bei der allgegenwärtigen Fülle von Angeboten haben wir es inzwischen gelernt, in all den uns aufgezwungenen Botschaften und Zeichen Zusammenhänge zu erkennen und daraus Schlüsse zu ziehen. Ich halte es für möglich, verschiedene kreative Sprachen zu mischen, ohne dass dabei etwas Klebriges herauskommt. Ich halte es auch für möglich, dass Design in Zukunft viel übergreifender und fließender sein wird und mehr geistigen Freiraum schafft. Auf keinen Fall wird es sich nur mit Firmenlogos befassen.«

« Dans mon travail, j'aimerais raconter et produire des histoires, trouver une forme de confort visuel qui, je l'espère, parvienne à toucher et divertir les autres. Mes images naissent d'un désir d'explorer et d'élargir des mondes imaginaires et de les cultiver dans des environnements générés par ordinateur. Grâce à l'informatique, les possibilités d'expression sont si détaillées et expansives que ces mondes ont développé leur propre élan cinétique au sein des structures que je leur ai créés. Dans la société moderne, nous respirons l'air des communications visuelles. Il nous enveloppe, et nous l'acceptons, croyant faire un choix. Du fait de la multitude des choix, nous sommes très bien entraînés à analyser, à établir des liens et à tirer des conclusions sur les messages et les codes que nous sommes contraints d'absorber. Je crois qu'il est possible d'entremêler différents langages créatifs sans en faire une mixture poisseuse, et que le graphisme sera pratiqué à l'avenir d'une manière beaucoup plus fluide, débouchant sur un environnement psychologique plus libre. Une chose est sûre, il ne s'agira pas uniquement de logos. »

Katrin Petursdottir
M.Y. Studio Ltd.
Box 498
Reykjavík 121
Iceland

T/F +354 561 2327

E katrin@simnet.is
E katrin.petursd@lhi.is

Biography
1967 Born in Akureyi, Iceland
1990 Foundation Course, Polycrea, Paris; Design Diploma, Industrial Design, E.S.D.I., Paris

Professional experience
1996 Product Development, Philippe Starck office, Paris
1997 Product Development, Ross Lovegrove studio, London
1998–2001 Product Development, Michael Young – M.Y. Studio Ltd., Reykjavík
2000 Curated Design in Iceland exhibition, Reykjavík
2000–2001 Director of Studies, Iceland Academy of Art, Reykjavík

Recent exhibitions
2000 "Art Is.", Interactive art piece designed in collaboration with an Icelandic artist and Michael Young, National Art Museum, Reykjavik
2001 "Drew", Designers Block, Osaka, Japan; 100% Design, London

Clients
66 N
Casa Brutus
Channel 2 Iceland
Corian
ERES
Iceland Spring
Idée
Ritzenhoff
Rosenthal
S.M.A.K.

Project
Illustration

Title
Flags

Client
Self-published

Year
2001

Project
Illustration

Title
flowers&bugs

Client
Self-published

Year
2000

左のオブジェは「マジックワゴン」というス
トレージテーブル。右は、ヴァイキング・ベ
ースボールの現代版で、もちろん、骨はプラ
スチックで作ってあります。ともに4月に行
われるミラノ・サローネで発表！

マイケル・ヤング＆キャトリン・ピータース
ドッター：マイケルは仕事でノルウェーに行
ったり、サローネの準備などで、相変わらず
アイスランドをお留守のよう。キャトリンも、
洋服のデザインに乗り出してパリまで出張。

✣ パフィン通信
フェロー諸島上空
38,000フィートからのリポート
インターナショナルな犬とは。

マイケルとキャトリンは本当に動物好き。中でも犬がお気に入り。
で、今回は世界の犬の性格判断をしてみました（飛行機の中で）。
つーか、とどのつまりは人間の国別性格判断か？

text_Michael Young illustration_Katrin Petursdottir
translation_Chise Taguchi

マッドだから。
別な条件があるというよりは、ただ単に
アイスランドの人たちって、何か特
ランドの犬たちも例外じゃない。なぜな
見てくれれば分かると思うから。アイス
それから上のスプレープードルの絵を
君だよ」とかって話しかけるくらいだ。
のいちばん好きなのは毛深い男、それは
エンは、彼のウェルシュ・ラブラドール
のゲイバーみたいなんだ。友達のオーウ
ウェールズのパブはロンドンのソーホー
って、羊が好きで女嫌い、これ、ホント。
僕らのほとんどが考えるウェールズ人
らは歌うじゃないか！
が悪い」？そう思ったよ。すべて……彼
だった。しかし、デブのイタリアンで何
の大きさはある犬、それがロッキー！
イナーがでかいのなんの。想像できる範囲の倍
の友達、イタリア生まれのロッキーのデ
ムス・アーヴィンからクライドの外国
なんだよね、同じくらいのブリティッシュ
これってすごく、典型的なブリティッシュ
る。クライドは、足を使ってスタジオの
彼はいつまでもドアを押しつづけてる。
中に入ってるとき、同じ方法でドアの
ど、部屋を出る時は、同じ方法でドア
は開かないということができるんだ。だけ
ドアのノブを回し、さらにドアを押して、
類のボクサー犬で、何につけ、とても頭
ライドは、イギリス産のとても珍しい種
ロンドンのMY オフィスの上に住むク
クリアになるはずだ。
みを発見した大人なら、この結果はもっと
各国の犬を通して友達を作ることに楽し
というこどた。最近の僕はこれに反映される
性には、犬科王国のメンバー反映される
ういうことかというと、ほとんどの国民
ついているんだ。つまりだ、これは、ど
頭がいいということにおそらく気が
メリカの犬はドイツの犬に比べてあまり

も
しあなたが「Emergency Vet」
や「Animal Planet TV」という
テレビ番組を見たことがあるならば、ア

Project
Illustration

Title
Puffin Mail, May

Client
Casa Brutus, Japan

Year
2002

Project
Illustration

Title
Puffin Mail, Winter

Client
Casa Brutus, Japan

Year
1999

Project
Illustration

Title
Puffin Mail, June

Client
Casa Brutus, Japan

Year
2001

Research Studios

"Visual communication is soulfood for the mind."

Opposite page:

Project
Main promotional poster

Title
Fuse 18, Secrets

Client
Self-published

Year
2000

FUSE18 : dogdots

FUSE18 : SECRETS FEATURING EXPERIMENTAL TYPEFACES AND POSTERS BY JASON BAILEY, NEVILLE BRODY, MATTHEW CARTER, BRUCE MAU, JAKE TILSON

"Research Studios is a dynamic, experienced and innovative visual communications and design studio with offices in London, Paris, Berlin, San Francisco and New York, operating across a broad range of commissions and media, from one-off creative projects to complete visual communication strategies. A small team infrastructure maintains a strong human aspect. For each project we work by creating solid systems and constructions over a well researched and rooted foundation or DNA. Over this solidity we then improvise, so as to explore new possibilities while remaining rooted in clear structure and code – a basic language model. Our approach to design is one of an exploratory process leading wherever we can to constantly evolving solutions focused on a criteria of revealing, not concealing, the underlying control mechanisms evident at the root level of visual communication. We attempt to actively engage the viewer emotionally and intellectually by confronting them with ambiguous and often incomplete or abstracted images, usually underpinned by a formal typography, which create a dialogue that by necessity can only be completed by the viewer's own interpretation, ensuring a fluidity of communication. This can help highlight directly the insubstantiality of consumer culture through a kind of experiential shift, and can often create a vital place of quiet, peace and oxygen."

» Research Studios ist eine dynamische, erfahrene und innovative Agentur für visuelle Kommunikation mit Niederlassungen in London, Paris, Berlin, San Francisco und New York. Wir bearbeiten eine breite Palette von Aufträgen und Medien, von kreativen Sonderlösungen bis hin zu kompletten visuellen Kommunikationsprogrammen. Aufgrund unserer Arbeitsweise in kleinen Teams bewahren unsere Entwürfe einen ausgeprägt menschlichen Aspekt. Jedes Projekt wird als ein stabiles System auf dem Fundament einer gründlich recherchierten Grundlage oder DNA entwickelt. Unser Gestaltungsansatz ist ein Erkundungsprozess, der uns zu sich stets entwickelnden Lösungen führt und sich darauf konzentriert, die Steuerungsmechanismen der visuellen Kommunikation aufzudecken statt zu verbergen. Wir bemühen uns, die Gefühle und den Verstand der Betrachter anzusprechen, indem wir ihnen zweideutige, vielfach auch unvollständige oder abstrahierte Bilder zeigen, begleitet von einer entsprechenden Typografie. Diese führt zu einem Dialog mit den Bildern, der nur von der Interpretation durch den Betrachter vervollständigt werden kann und so für eine fließende, unvorhersehbare Kommunikation sorgt. Das streicht – mithilfe einer Art Erfahrungsverschiebung – die Substanzlosigkeit der Konsumkultur heraus und ist oft dazu angetan, einen lebenswichtigen Ort der Stille, des Friedens und Luft zum Atmen zu schaffen.«

« Research Studios est un bureau de graphisme et de communication visuelle dynamique, expérimenté et innovateur avec des agences à Londres, Paris, Berlin, San Francisco et New York. Il gère une vaste gamme de commandes et de moyens de communications, des projets créatifs isolés et des stratégies de communication visuelle complètes. Notre infrastructure en petites équipes nous permet de conserver un caractère très humain. Pour chaque projet, nous créons des systèmes et des constructions solides s'appuyant sur des fondations bien documentées. A partir de cet appui stable, nous improvisons, nous recherchons de nouvelles possibilités tout en restant enracinés dans un cadre et des codes clairs. Notre approche du graphisme repose sur l'exploration, sur une quête de solutions en évolution constante. Notre critère est de révéler, non de cacher, les mécanismes de contrôle sous-jacents à la base de la communication visuelle. Nous tentons de faire intervenir les émotions et l'intellect du public en le confrontant à des images ambiguës, souvent incomplètes ou abstraites, généralement encadrées par une typographie formelle, créant un dialogue qui ne peut être complété que par l'interprétation personnelle de notre interlocuteur. Cela contribue parfois à souligner le caractère insaisissable de la culture de consommation et crée souvent un espace vital de tranquillité, de paix et d'oxygène. »

Research Studios
94 Islington High Street
Islington
London N1 8EG
UK

T +44 20 7704 2445
F +44 20 7704 2447

E info@
 researchstudios.com

www.research-
 studios.com

Design group history
1994 Founded by Neville Brody in London

Founder's biography
1957 Born in London
1976–1979 BA (Hons) Graphic Design, London College of Printing
1981–1986 Art Director, The Face magazine
1983–1987 Designer, City Limits, New Socialist and Touch magazines
1986–1990 Art Director, Arena magazine
1994 Founded Research Studios, London, and Research Arts, London, and Research Publishing, London
2000 Established Research Studios in Paris and San Francisco

Exhibitions
1988 "The Graphic Language of Neville Brody" (Retrospective exhibition), Victoria & Albert Museum, London

Clients
AGFA
Allied Dunbar
Amdocs
Armand Basi
Armani
BMW
Body Shop
British Council
British Airways
Calman & King
Camper
Channel Four
Citadium
Dentsu
Deutsche Bank
Domus Magazine
Electrolux
Fiorucci
Guardian Newspaper Group
Haus der Kulturen der Welt
Jean-Paul Gaultier Parfums
Katherine Hamnett
Kenzo
Leopold Hoesch Museum
Maceo
Macromedia
Martell
Max Magazine
Men's Bigi
The Museum of Modern Art, New York
N.B.C.
The National Theatre
Nike
NMEC
ORF
Parco
Pathé
Premiere Television
Reuters
Ricoh
Salomon
Scitex
Sony
Swatch
Thames & Hudson
Turner Network Television
United Artists
Vauxhall
Vitsoe
Yedioth Ahronoth
Young & Rubican
Zumtobel

Project
Box edition of 'The
Graphic Language of
Neville Brody', Books 1
and 2

Title
Special Poster Insert

Client
Thames and Hudson,
London

Year
1994

Project
Cover of Typography
Issue

Title
MacUser

Client
Dennis Publishing,
London

Year
2001

Project
Main promotional poster

Title
Fuse 14, Cyber

Client
FSI, Berlin

Year
1995

Project
Main promotional poster

Title
Fuse 15, Cities

Client
FSI, Berlin

Year
1996

Rinzen

"A post-ironic, post-pastoral, post-humorist approach to graphic design, championing the expression of the very minutiae of human experience through the mathematics of magnitude and direction (with the occasional bitmap)."

Project
RMX (no. 2) book

Title
RINZEN PRESENTS RMX
EXTENDED PLAY
Featuring 30 Contributors
from around the World

Client
Die Gestalten Verlag

Year
2001

"In the future there will be increasingly visually-literate and style-conscious communities, personal graphical representation in real or virtual spaces will become all-pervasive by calm necessity, as omnipresent and invisible as clothing and complexion. The ultimate statement of graphic authorship – 'I am'. Trends will drift, coalesce and divide like pixel clouds as geographical-space will become subservient to idea-space; dreamers, outsiders and heretics will shine like beacons, quickly to be extinguished or exalted … Elsewhere, laws will be passed banning the use of Gill Sans."

» In Zukunft wird es zunehmend visuell bewanderte und stilbewusste Gruppen geben. Die persönliche grafische Darstellung in realen oder virtuellen Räumen wird sich infolge der allgemein stillschweigend anerkannten Notwendigkeit überall verbreiten und ebenso allgegenwärtig und unsichtbar sein wie Kleidung und Teint. Die ultimativen Worte des grafischen Urhebers: ›Ich bin.‹ Trends werden dahintreiben, sich bündeln und wieder zerteilen wie Pixelwolken, wenn der geografische Raum sich dem Ideenraum unterordnet. Träumer, Außenseiter und Häretiker werden wie Leuchtfeuer strahlen, die entweder rasch gelöscht oder aber in den Himmel gehoben werden … Anderswo wird man die Verwendung der Gill Sans gesetzlich verbieten.«

« A l'avenir, il y aura de plus en plus de communautés possédant une grande culture visuelle et une conscience de style. La représentation graphique personnelle s'imposera tranquillement dans tous les espaces réels ou virtuels par nécessité, aussi omniprésente et invisible que les vêtements ou le teint, affirmation même de la qualité d'auteur graphique – ‹Je suis›. Les tendances passeront, fusionneront, se diviseront telles des nuages de pixels tandis que l'espace géographique deviendra subordonné à l'espace idée. Les rêveurs, les marginaux et les hérétiques brilleront comme des balises, rapidement éteintes ou exaltées… Ailleurs, on adoptera des lois pour interdire l'utilisation du Gill Sans. »

Rinzen
PO Box 1729
New Farm 4005
Queensland
Australia

E they@rinzen.com

www.rinzen.com

Biography
Rinzen is an Australian collective, working on a range of client and personal projects – in print and web design, illustration, fonts, characters, animation and music. Published in magazines such as The Face, Wired, Zoo, Creative Review and Nylon, Rinzen's work has also been exhibited in Australia, Asia and Europe, broadcast on German Music Television station, Viva Plus and included in the Diesel Friendship Gallery. Rinzen is also extremely active in self-initiated and contributor-based projects, participating in a number of online and print-based graphic works, as well as directing the RMX series of projects. RMX Extended Play, the second RMX project, was published in book-form in September 2001. It features the visual remixing talents of around 30 designers from Australia, the US, the UK, Switzerland, Japan and Germany.

Recent exhibitions
2000 "We are the World", Brisbane; "RMX//A Visual Remix Project", Brisbane and Berlin
2001 "Rinzen Presents RMX Extended Play", Sydney, Brisbane and Berlin; "All about Bec", Sydney; "Kitten", Melbourne

Clients
Black + White
Blue
Brisbane Marketing
Family/Empire/Pressclub
Kitten
Mushroom
The Face
Warner
Wink Media
Wired

Project
Promotional material
(flyers, stickers, passes)

Title
Family

Client
Family (Nightclub)

Year
2001

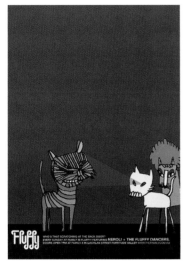

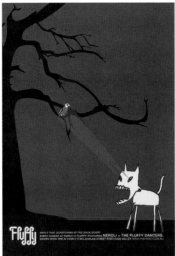

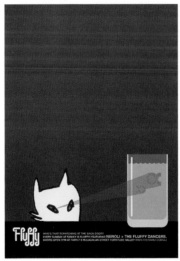

Project
Flyers

Title
Who's that Scratching at
the Back Door?

Client
Family (Nightclub)

Year
2001

Project
Spreads from RMX (No. 2)
Various contributing
designers

Title
RINZEN PRESENTS RMX
EXTENDED PLAY

Client
Die Gestalten Verlag

Year
2001

Stefan Sagmeister

"STYLE = FART"

Opposite page:

Project
Lecture poster

Client
Cranbrook Academy of
Art and AIGA Detroit

Year
1999

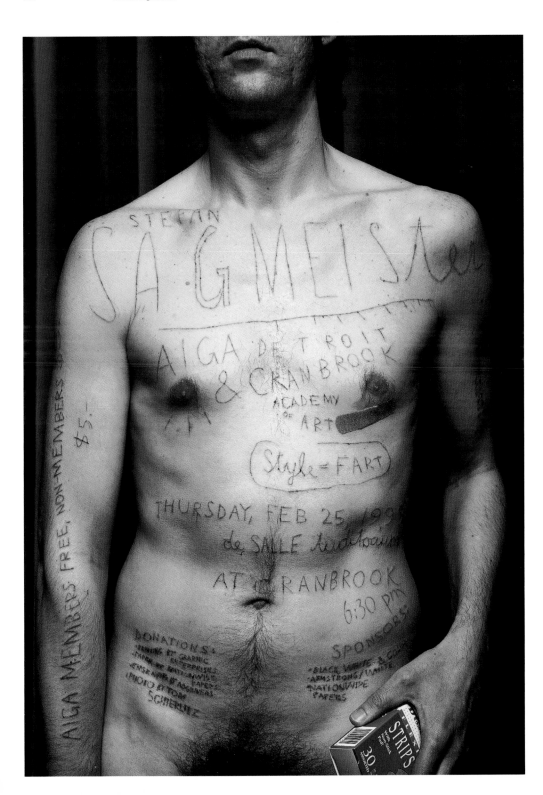

"I am mostly concerned with design that has the ability to touch the viewer's heart. We see so much professionally done and well executed graphic design around us, beautifully illustrated and masterfully photographed, nevertheless, almost all of it leaves me (and I suspect many other viewers) cold. There is just so much fluff: well produced, tongue-in-cheek, pretty fluff. Nothing that moves you, nothing to think about, some is informing, but still all fluff. I think the main reason for all this fluff is that most designers don't believe in anything. We are not much into politics, or into religion, have no stand on any important issue. When your conscience is so flexible, how can you do strong design? I've seen movies that moved me, read books that changed my outlook on things and listened to numerous pieces of music that influenced my mood. Our goal for the future will be to touch somebody's heart with design."

» Mir geht es vor allem um Design, das dem Betrachter zu Herzen gehen kann. Wir sehen überall so viele professionelle Grafikarbeiten, die mich (und ich vermute auch viele andere Betrachter) kalt lassen. Es gibt so viele Schaumschläger, die technisch perfekten, hübschen Schaum produzieren. Nichts, das rührt oder zum Nachdenken anregt. Der Grund für all diese Schaumschlägerei ist, dass die Designer an nichts mehr glauben. Wir haben mit Politik nichts am Hut, mit Religion nicht, haben zu keiner wichtigen Frage einen eigenen Standpunkt. Wenn das Gewissen so wenig ausgeprägt ist, wie kann man dann überzeugendes Design schaffen? Ich habe Filme gesehen, die mich bewegt haben, Bücher gelesen, die meine Sicht der Dinge verändert, und Musikstücke gehört, die meine Stimmung beeinflusst haben. Unser Ziel muss es werden, mit unserem Design die Herzen zu berühren.«

«Je m'intéresse à un graphisme capable de toucher le cœur des gens. Nous voyons partout tant de créations graphiques bien réalisées, joliment illustrées, photographiées de main de maître. Pourtant, la plupart d'entre elles me laissent froid. C'est bien produit, ironique, agréable à regarder, mais ce n'est que du vent. Il n'y a rien qui vous émeuve, rien qui vous fasse réfléchir. Certaines vous informent, mais ça reste du vent. La plupart des créateurs ne croient en rien. Nous nous occupons peu de politique et de religion, nous ne prenons position sur aucune question importante. Avec une conscience aussi flexible, comment réaliser un graphisme fort ? J'ai vu des films bouleversants, lu des livres qui ont changé ma vision des choses et écouté des morceaux de musique qui ont influencé mon humeur. A l'avenir, notre objectif sera de toucher le cœur d'un être humain avec notre graphisme. »

Stefan Sagmeister
Sagmeister Inc.
222 West 14th Street
New York
NY 10011
USA

T +1 212 647 1789
F +1 212 647 1788

E Stefan@
 Sagmeister.com

www.sagmeister.com

Biography
1962 Born in Bregenz, Austria
1982–1986 MFA Graphic Design, University of Applied Arts, Vienna
1986–1988 MSc Communication Design, Pratt Institute, New York (as a Fulbright Scholar)

Professional experience
1983–1984 Designer, ETC. magazine, Vienna
1984–1987 Designer, Schauspielhaus, Vienna
1987–1988 Designer, Parham Santana, New York
1988–1989 Designer, Muir Cornelius Moore, New York
1989 Art Director, Sagmeister Graphics, New York
1989–1990 Art Director, Sagmeister Graphics, Vienna
1991–1993 Creative Director, Leo Burnett (Hong Kong Office)
1993 Creative Director, M&Co, New York
1993+ Principal of Sagmeister Inc. in New York

Recent exhibitions
2000 "Design Biannual", Cooper Hewitt National Design Museum, New York
2001 "Stealing Eyeballs", Künstlerhaus, Vienna; Solo exhibition, Gallery Frederic Sanchez, Paris
2002 Solo exhibition – MAK, Vienna

Recent awards
Has won over 200 design awards, including four Grammy nominations and gold medals from The New York Art Directors Club and the D&AD plus: 2000 Gold Medal, poster biannual Brno; Gold Medal, Warsaw poster exhibit
2001 Chrysler Design Award
2002 Grand Prize, TDC Tokyo

Clients
Aiga Detroit
Amilus
Anni Kuan Design
Booth Clibborn Editions
Business Leaders for Sensible Priorities
Capitol Records
Gotham
Warner Bros.
Warner Jazz

Project
AIGA national conference poster, New Orleans

Title
Jambalaya

Client
American Institute for Graphic Arts

Year
1997

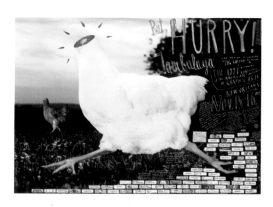

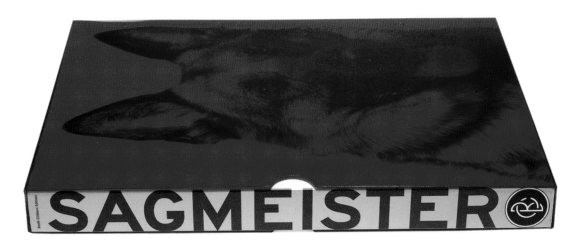

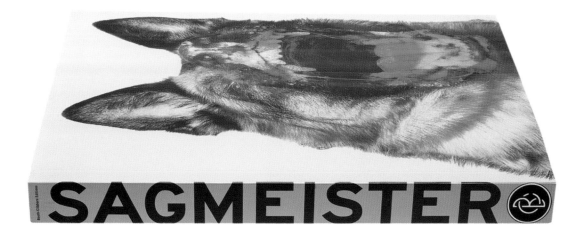

Project
Design monograph

Title
Made You Look

Client
Self-published

Year
2001

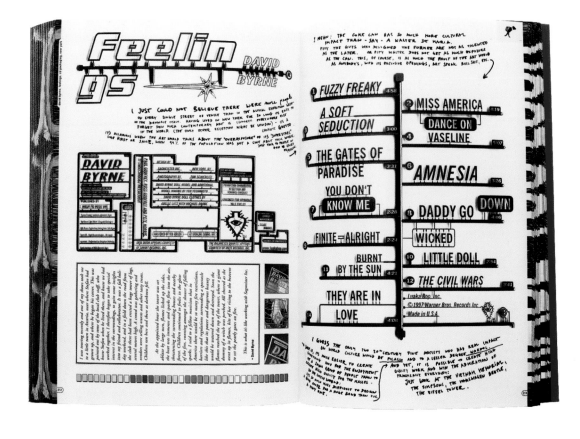

Opposite page:

Project
Design monograph

Title
Made You Look

Client
Self-published

Year
2001

Project
Poster

Title
Set the Twilight Reeling

Client
Warner Bros.

Year
1996

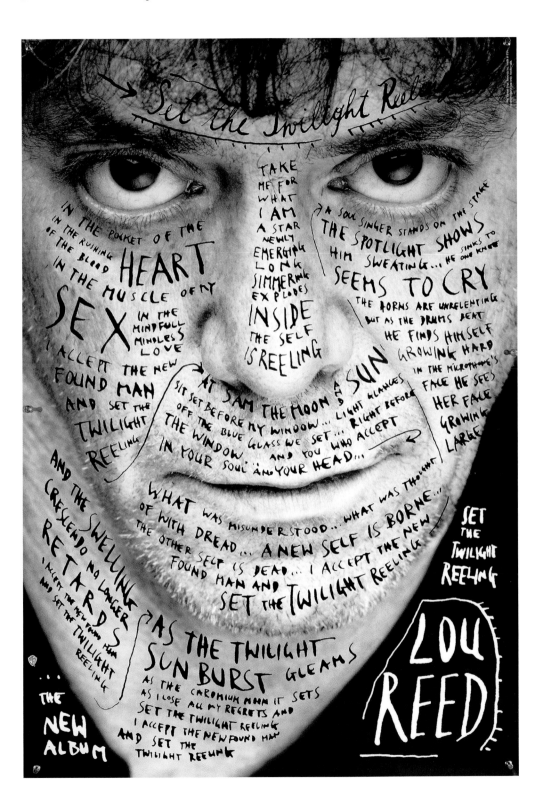

Peter Saville

"Do your best."

Opposite page:

Project
Illustration

Title
Waste Painting #3

Client
Graphic art Howard
Wakefield, Peter Saville &
Paul Hetherington

Year
2001

"As the interface of today's social and cultural change, graphic design will continue to evolve as a reflection of the needs and values of its audience and its practitioners."

»Als Schnittstelle des derzeitigen sozialen und kulturellen Wandels wird das Grafikdesign sich als Reflexion der Bedürfnisse und Werte seines Publikums und seiner Schöpfer weiterentwickeln.«

«En tant qu'interface des changements sociaux et culturels contemporains, le graphisme continuera d'évoluer, reflet des besoins et des valeurs de son public et de ses exécutants.»

Peter Saville
Saville Associates
Expert House
25–31 Ironmongers Row
London EC 1V 3QN
UK

T +44 20 7253 4334
F +44 20 7253 4366

E sarah@
 saville-associates.com

Biography
1955 Born in Manchester, England
1978 BA (Hons) Graphic Design, Manchester Polytechnic

Professional Experience
1979–1991 Founding Partner and Art Director, Factory Records, Manchester
1981–1983 Art Director, Dindisc (Virgin Records), London
1983–1990 Established his own studio, Peter Saville Associates, London
1990–1993 Partner, Pentagram Design, London
1993–1994 Creative Director, Frankfurt Balkind, Los Angeles
1995–1998 Established London office for German communications agency, Meire und Meire
1999 Co-founded multidisciplinary new media project, SHOWstudio, with photographer Nick Knight
2000–2001 Co-curater, SHOWstudio with Nick Knight, London

Clients
ABC Television
Balenciaga
Brian Eno / David Byrne
Centre Georges Pompidou / La Villette
Channel One
China Crisis
Christian Dior
Chrysalis
Depeche Mode
Digital Entertainment Network
Electronic
Estée Lauder
Factory Communications
Fine Young Cannibals
Fruitmarket Gallery
Gay Dad
Gagosian Gallery
George Michael
Givenchy
Goldie
Gucci / Sapient
Holland & Holland
Institute of Contemporary Arts
Jil Sander
John Cooper Clarke
Joy Division
King Crimson
London Records
Lounge Lizards
Mandarina Duck
Marconi / Pres.co
Martha & The Muffins
Martine Sitbon
Mercedes Benz / Smart Car
Midge Ure
Ministry of Culture
Museum Boijmans Van Beuningen
Natural History Museum
New Order
OMD
Paul McCartney
Peter Gabriel
Pringle of Scotland
Pulp
Richard James
Roxy Music
Selfridges
Sergio Rossi
Stella McCartney
Suede
The Hacienda
Ultravox
Visage
Wham!
Whitechapel Art Gallery
White Cube
Yohji Yamamoto
Y's Company

Project
Illustration. Graphic art
Paul Hetherington &
Howard Wakefield

Title
Sister Honey

Client
Dazed & Confused

Year
1999

Project
CD cover
Art Direction: Peter Saville
Concept: Paul Barnes

Title
Gay Dad "Leisure Noise"

Client
London Records

Year
1999

Project
CD artwork
Photography: Jürgen
Teller
Design: Howard
Wakefield

Title
New Order "Get Ready"

Client
London Records

Year
2001

Pierre di Sciullo

"Graphic design: see forms and meanings/ forms: see sign (cf. signification) and de-sign/design: see graphic. 'I was walking in the forest when suddenly this graphic design totally modified my life'."

Automne — Poumon / Peine — Sécheresse

Été — Cœur / Joie — Feu

Été tardif — Rate / Anxiété — Humidité

Printemps — Foie / Colère — Vent

Hiver — Reins / Peur — Froid

Le corps, ses émotions
et son environnement
climatique

Project
Exhibition "médecines
chinoises"

Title
Hierarchy of organs and
their relations with
feelings and weather

Client
Grande Halle de la Villette,
Paris

Year
2001

"Most of the independent graphic designers will be employed by big agencies to clean the windows. The survivors will be the one's who don't ask silly questions such as 'Is it something else other than business?', 'Why is the world of fashion so empty?', 'Am I only a servant of the enterprise?'. If you take the money and run, no problem. But sometimes it's hard to be a citizen of a rich country – you have misgivings. Your way will be the graphic design of nice sentiments, which I call 'Gradenice': war, poverty, Aids, what a shame … In the future I hope the use of media will become more efficient again, so the question of the inner value of the work will appear more and more indecent: my work is good because it is visible – of course it is visible because it is good. But to save this situation commissioners will have to study at art and design schools. This next generation will begin making strong, open, intelligent projects and the sun will shine on a pacified world."

» Die meisten freischaffenden Grafiker werden von den großen Agenturen als Fensterputzer beschäftigt. Überleben werden diejenigen, die keine dummen Fragen stellen wie etwa: ›Geht es außer ums Geschäft noch um etwas anderes?‹ – ›Warum ist die Modewelt so leer?‹ – ›Bin ich nur ein Diener des Unternehmens?‹ Wenn man das Geld nimmt und denkt: ›Nach mir die Sintflut‹, ist das in Ordnung. Manchmal aber ist es gar nicht so leicht, Bürger eines reichen Landes zu sein – man ahnt Böses. Der Weg wird das Grafikdesign angenehmer Gefühle sein: Krieg, Armut, Aids, bedauerlich, aber … In Zukunft, so hoffe ich, wird das Medium wieder wirksamer werden, so dass die Frage nach dem inneren Wert einer Grafik zunehmend als unangebracht gelten wird. Meine Arbeit ist gut, weil sie auffällt – und natürlich fällt sie auf, weil sie gut ist. Die nächste Generation wird starke, offene, intelligente Projekte in Angriff nehmen und die Sonne wird über einer befriedeten Welt aufgehen.«

« La plupart des graphistes indépendants seront engagés dans les grandes agences pour nettoyer les vitres. Les survivants seront ceux qui ne poseront pas de questions bêtes comme : ‹ Y a-t-il autre chose que le commerce ? Pourquoi le monde de la mode est-il si vide ? Suis-je au bout du compte le serviteur des entreprises ? › Prends l'argent et tire-toi, ça ne pose pas de problème. Mais quelquefois c'est dur d'être le citoyen d'un pays riche, on a des états d'âme ; solution : pratiquer le GRABS, le GRAphisme des Bons Sentiments, à propos de la guerre, du Sida, de la pauvreté, quel dommage… L'usage des médias sera encore plus efficace afin que la question de la valeur même d'un travail semble indécente. ‹ Mon travail est bon car il est visible, bien sûr il est visible parce qu'il est formidable en vérité. › Pour sauver la situation les commanditaires feront leur apprentissage dans les écoles d'art et de design. Cette nouvelle génération lancera des projets intelligents, forts et ouverts et le soleil brillera sur un monde pacifié. »

Pierre di Sciullo
12, avenue du Château
77220 Gretz Armainvilliers
France

T +33 1 64 07 24 32

E atelier@quiresiste.com

www.quiresiste.com

Biography
1961 Born in Paris
Self-taught

Professional experience
1983+ Published "Qui? Résiste" (10 issues).
1994+ Workshops and lectures in the art schools of Strasbourg, Orléans, Amiens, Saint-Étienne, Nancy, Besançon, Pau, Valence, Lyon, Cergy–Pontoise, Nevers, Cambrai, Paris, Lausanne, Basle and Tel Aviv

Recent exhibitions
1997 "Aquarelles", La Chaufferie, Strasbourg
1996–1997 "Approche", touring exhibition, Barcelona, Seville, Madrid, Buenos Aires, Chaumont, Paris, Sofia, Warsaw and Prague

Recent awards
1995 Grants from the French Ministry of Culture
1995 Charles Nypel Prize, The Netherlands

Clients
AFAA (Ministry of Foreign Relations)
City of Nantes
Collège de Pataphysique
Éditions Brøndum
Grande Halle de la Villette
Ministry of Culture
Reporters Sans Frontières
Wines Nicolas

Project
Visual identity of
PrimalineaFactory.com

Title
Intro of the Website. This site sells online original creations of graphic artists and designers

Client
Primalinea agency, Paris

Year
2001

Project
Two typefaces designed
specially for glass, easy to
cut in this medium

Title
Minimum overlap
Blocs

Client
Self-published

Year
2001

Project
Exhibition "Médecines
chinoises"

Title
Médecines chinoises

Client
Grande Halle de la Villette,
Paris

Year
2001

Opposite page:

Project
Exhibition "Médecines
chinoises"

Title
Acupuncture: the body as
an irrigation system

Client
Grande Halle de la Villette,
Paris

Year
2001

Angle externe de l'œil
Angle interne de l'œil
Région sous l'œil
Nez
Région devant l'oreille
Région derrière l'oreille

Région sous l'aisselle
Péricarde
Clavicule / sternum
Cœur

Majeur
Auriculaire
Pouce
Index
Annulaire
Auriculaire

Région interne du thorax
Région latérale de l'abdomen

4ᵉ orteil
Gros orteil
Petit orteil
Petit orteil
2ᵉ orteil
Gros orteil

Les voies de passage des 12 conduits majeurs : le corps en tant que système d'irrigation

1. Conduit du poumon : de la région interne du thorax au pouce
2. Conduit du gros intestin : de l'index au nez
3. Conduit de l'estomac : de la région sous l'œil au 2ᵉ orteil
4. Conduit de la rate : du gros orteil à la région sous l'aisselle
5. Conduit du cœur : du cœur à l'auriculaire
6. Conduit de l'intestin grêle : de l'auriculaire à la région devant l'oreille
7. Conduit de la vessie : de l'angle interne de l'œil au petit orteil
8. Conduit du rein : du petit orteil à la clavicule / sternum
9. Conduit du péricarde : du péricarde au majeur
10. Conduit du triple réchauffeur : de l'annulaire à la région derrière l'oreille
11. Conduit de la vésicule biliaire : de l'angle externe de l'œil au 4ᵉ orteil
12. Conduit du foie : du gros orteil à la région latérale de l'abdomen

Carlos Segura

"Communication that doesn't take a chance, doesn't stand a chance"

Opposite page:

Project
Poster

Title
Faces

Client
[T-26] Digital Type
Foundry

Year
1997

"No clue" » Keine Ahnung« « Aucune idée »

Carlos Segura
Segura Inc.
1110 North Milwaukee
Avenue
Chicago
IL 60622.4017
USA

T +1 773 862 5667
F +1 773 862 1214

E info@segura-inc.com

www.segura-inc.com
www.segurainteractive.com
www.5inch.com
www.t26.com

Biography
1957 Born in Santiago,
Cuba
1965 Moved to Miami
1980 Moved to Chicago
1980–1991 Worked for
advertising agencies
Marsteller, Foote Cone &
Belding, Young &
Rubicam, Ketchum, DDB
Needham
1991 Founded Segura
Inc. in Chicago
1994 Founded [T-26]
Digital Type Foundry
in Chicago
2000 Founded Segura
Interactive
2001 Launched 5inch.com

Recent exhibitions
2002 "US Design:
1975–2000", Denver Art
Museum

Recent awards
1998 Silver and Certificate
of Merit (x2), Chicago
Show; Certificate of Merit,
100 Show, American
Center for Design; Certifi-
cates of Merit (x3), Ameri-
can Corporate Identity,
14th Edition; Certificates
of Merit (x2), NY Type
Directors Club, TDC44
1999 Certificates of Merit
(x2), Logo 2000 Annual
2000 Certificates of Merit
(x3), NY Art Directors
Club; Certificates of Merit
(x4), Tokyo Type Directors
Club, 2000 Annual; Certifi-
cates of Merit (x2), NY
Type Directors Club,
TDC46
2001 Bronze, Certificates
of Merit (x9) and Special
Section in annual, Tokyo
Type Directors Club, 2001
Annual; Best of Category
(x2) (won a car) and Best
of Show, Eyewire Awards
2002 Certificates of Merit
(x2), Tokyo Type Directors
Club, 2002 Annual

Clients
American Crew
Computer Café
DC Comics
Elevation
Emmis Communications
FTD
Kicksology
Mongoose Bikes
Motorola
MRSA Architects
Plungees
Q101 Radio (Chicago)
Rockwell
Sioux Printing
Swatch
The Syndicate
Tiaxa
TNN

One of a series of Digipak CD sets for Lesley Spencer. This one is *Authentic Flavors* with t-shirts. **AUTHENTIC FLAVORS** LESLEY SPENCER® AND THE LATIN CHAMBER POP ENSEMBLE

Project
CD and T-shirts

Title
Authentic Flavors

Client
Lesley Spencer

Year
2002

Project
Quicktime movie
campaign

Title
Twisted 7

Client
Q101 Radio

Year
2001

Project
Conference material

Title
TYPY2K

Client
New York Type Directors
Club

Year
1999

Suburbia

"We are reaching for a perfect synergy of information, image, design and parties."

Project
Magazine cover
Photography by
Phil Poynter

Title
Big Magazine – Horror

Client
Big

Year
2000

"We here at Suburbia are inclined to approach the future sideways – laterally if you like. This way we feel less likely to be caught out by it. Thinking about the future in general was enormously popular in pre-revolutionary Russia, but not so much nowadays. Cultural determinants you see are not really dictated by designers, and there are pitfalls in thinking so. The sands, you might say, on which the future rests are always shifting (this is an adaptation or bastardisation of an old Chinese proverb about trusting those who you do business with), which is definitely something we're going to pay more attention to in the future."

»Wir von Suburbia tendieren dazu, uns der Zukunft von der Seite zu nähern. So haben wir das Gefühl, dass sie uns nicht so schnell ertappen kann. Im vorrevolutionären Russland war es äußerst populär, sich Gedanken über die Zukunft im Allgemeinen zu machen, das ist heute nicht mehr so. Kulturelle Determinanten werden nicht wirklich von den Designern diktiert. Das zu glauben, birgt Risiken. Der Sand, auf dem die Zukunft steht, wandert immer weiter (so könnte man in Abwandlung eines alten chinesischen Sprichworts über das Vertrauen zu denen sagen, mit denen man Geschäfte macht) und das ist definitiv etwas, dem wir in Zukunft mehr Aufmerksamkeit widmen werden.«

«Ici à Suburbia, on tend à aborder le futur de biais, latéralement si vous préférez. On espère ainsi limiter le risque d'être pris de court. Dans la Russie d'avant la révolution, réfléchir à l'avenir était une activité très prisée. Ça l'est moins aujourd'hui. Il serait dangereux de croire que les déterminants culturels apparents sont en fait dictés par les créateurs. Les ‹bancs de sable› sur lesquels repose le futur sont aussi mouvants (j'adapte, ou plutôt je détourne, un vieux proverbe chinois parlant de la confiance que l'on peut accorder à ses partenaires en affaire), un aspect auquel nous serons certainement plus attentifs à l'avenir. »

Suburbia
74 Rochester Place
London NW1 9JX
UK

T +44 20 7424 0680
F +44 20 7424 0681

E info@
 suburbia-media.com

www.suburbia-
 media.com

Design group history
1998 Co-founded by Lee Swillingham and Stuart Spalding in London

Founders' biographies
Lee Swillingham
1969 Born in Manchester, England
1988–1991 Studied Graphic Design, Central St Martins College of Art and Design, London
1992–1998 Art Director, The Face magazine, London
1998 Creative Director, Suburbia, London
Stuart Spalding
1969 Born in Hawick, Scotland
1987 Foundation Level Art& Design, Manchester Polytechnic
1988–1991 Graphic Design, Newcastle upon Tyne Polytechnic
1992–1998 Art Editor, The Face magazine, London
1998 Creative Director, Suburbia, London

Clients
Alexander McQueen
Anna Molinari
Big
BMG Records
Bottega Veneta
Emap Publishing
Gucci
London Records
Luella
Mercury Records
Patrick Cox
Vision on Publishing
Warner Records

Project
Logo and identity for new fashion magazine

Title
Pop Logo

Client
Emap Publishing

Year
2000

Opposite page:

Project
Creative Review anniversary artwork

Title
Infinity Poster

Client
Creative Review

Year
2001

Project
Magazine cover
Photography by Mert
Allas and Marcus Piggot

Title
Pop, issue 4 – Icons

Client
Emap Publishing

Year
2002

Opposite page:

Project
Magazine spreads
Photography by Mert
Allas and Marcus Piggot

Title
Pop, issue 4 – Icons

Client
Emap Publishing

Year
2002

Stella's *icons*

ons

MRS RITCHIE

Occupation: Whatever

Location: Some shabbly that took forever to get to

Who: your cover What's an icon?

What are you wearing? Some rags

Madonna wears pink satin
shirt and pale pink trousers,
both by Stella McCartney
from her collection for
spring/summer 2001, black
front thigh lace-up boots by
Yves Saint Laurent, stylist worn
around body from VV
Rouleaux

& INSET: Madonna wears
trousers with lace pockets
detailing by Stella
McCartney, stylist worn
around body from
VV Rouleaux

Stella McCartney has a famous family and some very
famous friends. She knows an icon when she invites one
over for dinner. But with the first year of Stella's own
label still unfolding, one question remains: >

Sweden Graphics

"Not by making interesting graphic design but by making graphic design interesting"

Opposite page:

Project
Poster

Title
Utopist – Javisst

Client
Formfront

Year
1998

"After all these years of dedicated work and the problems with embracing new media and technology, graphic design is finally starting to achieve what it really needed all along – an audience. Graphic design has always been a kind of sidekick to almost every other kind of cultural platform such as literature, film, art, advertising, music etc – sometimes appreciated but often neglected. At times debated, but only within the design community itself. But in the last ten years or so a massive interest has started to grow among the younger generation in graphic design as an end in itself. It is our guess that it is mainly through the process of making their own web sites that young people of today automatically gain a hands-on knowledge of typefaces, colour and composition, and that these insights make them more capable and interested in seeking out, evaluating and at best appreciating the work of more professional designers. This is the single most important factor which, in the foreseeable future, will turn graphic design into a means of expression in itself, and more so than ever before. A language that is powerful not only because there are competent speakers but because there are competent listeners. Thank you for your attention."

» Nach all den Jahren Arbeit und Schwierigkeiten mit den neuen Medien und ihrer Technik beginnt die Grafikdesignbranche endlich das zu erreichen, was sie die ganze Zeit über schon gebraucht hätte – ein Publikum. Die Gebrauchsgrafik hat andere Kulturbereiche wie Literatur, Film, Kunst, Werbung, Musik usw. immer begleitet und wurde dabei manchmal geschätzt, oft aber vernachlässigt. Mitunter umstritten, aber nur innerhalb der Grafikerzunft selbst. In den letzten zehn Jahren ist jedoch das Interesse am Grafikdesign an sich gestiegen, besonders unter jüngeren Leuten. Sie haben mit ihren eigenen Internetportalen den praktischen Umgang mit Schriftarten, Farben und Bildkomosition geübt, so dass sie sich nun auch für die Arbeiten professioneller Grafiker interessieren, sie bewerten und – im günstigsten Fall – schätzen lernen. Das ist der wichtigste Faktor, der in naher Zukunft aus dem Grafikdesign ein eigenständiges Ausdrucksmedium machen wird, eine Sprache, die nicht nur deshalb wirkungsvoll ist, weil sie von kompetenten Interpreten benutzt wird, sondern weil sie von kompetenten Zuhörern aufgenommen wird. Vielen Dank für Ihre Aufmerksamkeit.«

« Après toutes ces années de travail acharné et de problèmes pour s'adapter aux nouveaux moyens de communication et à la technologie, le graphisme commence enfin à obtenir ce dont il avait vraiment besoin : un public. Il a toujours été une sorte de parent pauvre de presque toutes les autres plates-formes culturelles telles que la littérature, le cinéma, l'art, la publicité, la musique, etc., parfois apprécié mais le plus souvent négligé. Si on en débattait, cela ne sortait pas de la communauté des créateurs. Toutefois, ces dix dernières années, on a observé un intérêt massif de la nouvelle génération pour le graphisme en tant que tel. C'est probablement en réalisant leurs propres pages web que les jeunes ont acquis sur le tas une connaissance des types de caractères, des couleurs et de la composition. Cela les a incités à rechercher, à évaluer et, au mieux, à apprécier le travail de graphistes plus professionnels. C'est sans doute le principal facteur qui, dans un futur proche, transformera le graphisme en un moyen d'expression à part entière. Un langage qui puise sa force non seulement dans la compétence de ceux qui le parlent mais également dans celle de ceux qui l'écoutent. Merci pour votre attention. »

Sweden Graphics
Blekingegatan 46
11664 Stockholm
Sweden

T +46 8 652 0066
F +46 8 652 0033

E hello@
 swedengraphics.com

www.swedengraphics.com

Design group history
1998 Sweden Graphics was founded in Stockholm

Project
CD covers & tour poster

Title
Doktor Kosmos

Client
NONS Records

Year
2000

Project
Illustrations

Title
Islands

Client
Raket

Year
2000

Project
Newspaper illustrations
for music review pages

Title
Newspaper illustrations
for music review pages

Client
DN På Stan

Year
1999–2001

Skala 1:1

En improviserad helaftonsföreställning. Premiär 18 februari

Improvisationsformen i Skala 1:1 är inspirerad av den San Franciscobaserade improvisationsgruppen True Fiction Magazine. Små bitar av historier läggs samman till längre berättelser. Dessa bildar en helhet I full skala som pendlar mellan tid och rum, logik och fantasi, komedi och tragedi. Regina Saisi från True Fiction Magazine inledde med en tre veckor lång workshop varefter Roger Westberg tog över och slutförde repetitionsarbetet. Detta är grunden till en mer fördjupad och variationsrik improvisationsform där publiken lovas en ny händelserik föreställning varje kväll.

 Stockholms Improvisationsteater | Torsdag–Lördag kl.19.00 Sigtunagatan 12, T-Odenplan | Biljetter och information **08-30 62 42** www.impro.a.se

Skala 1:1

En improviserad helaftonsföreställning. Premiär 16 Februari

Med en berättarteknik, lik den i Robert Altmans film "Short Cuts", framförs korta sekvenser av historier som läggs samman till längre berättelser. Dessa bildar en helhet i full skala som pendlar mellan tid och rum, logik och fantasi, komedi och tragedi. I varje föreställning skapas helt nya historier och berättelser, karaktärer och öden – vilket gör varje kväll till en premiär.

 Stockholms Improvisationsteater | Fredag–Lördag kl.19.00 Sigtunagatan 12, T-S:t Eriksplan | Biljetter och information **08-30 62 42** www.impro.a.se

Project
Flyers

Title
Skala 1:1

Client
Stockholms
Improvisationsteater

Year
2000

ten_do_ten

"ten means pixel in Japanese."

Project
ten_do

Title
do you like japan?

Client
Self-published

Year
2001

"ten means pixel in Japanese.
ten may be drawn on anyone.
ten may be drawn on no one.
ten may be understood only
by aliens.
ten may be understood only
by human beings.
ten may be understood only
by Japanese people.
ten may be understood only by you!"

»Pixel heißt auf Japanisch ten.
Mit ten kann man alle bezeichnen.
Mit ten kann man niemanden
bezeichnen.
ten kann nur von Außerirdischen
verstanden werden.
ten kann nur von Menschen
verstanden werden.
ten kann nur von Japanern
verstanden werden.
ten kann nur von dir verstanden
werden!«

«ten signifie pixel en japonais.
ten peut être dessiné sur n'importe
qui.
ten ne peut être dessiné sur
personne.
ten ne peut être compris que par
un extraterrestre.
ten ne peut être compris que par
un être humain.
ten ne peut être compris que par
les Japonais.
ten ne peut être compris que par
vous!»

ten_do_ten
Vira Bianca #504
2–22–12 Jingumae
Shibuya-ku
Tokyo 150–0001
Japan

T/F +81 3 3796 6545

E ten@tententen.net

www.tententen.net

Design group history
2001 Founded by Shinya
Takemura in Tokyo

Biography
1996–2001 Worked with
the group Delaware as a
guitarist who does not
play the guitar, as a lead
vocalist and as a graphic
designer who plays
design. Main perfor-
mances took place at the
Mac World Expo '98 in
Makuhari and at p.s.1/The
Museum of Modern Art
in New York in 2001

Clients
ClubKing
College Chart Japan
Gakken
Magazine House
NTT
NTT-Is
Shift
Tachibana Hajime Design

Project
ten_do

Title
sex pistols

Client
Self-published

Year
2001

Project
ten_do

Title
composition of 2 Ten

Client
Self-published

Year
2001

Project
ten_do

Title
plastics

Client
Self-published

Year
2001

Project
ten_do

Title
hanging scroll

Client
Self-published

Year
2001

Project
ten_do

Title
david bowie's atmosphere

Client
Self-published

Year
2001

Project
ten_do

Title
search and destroy
offered to iggy pop

Client
Self-published

Year
2001

tokyo logo mark 点／テン・ドゥ

Project
ten_do

Title
logo mark of tokyo

Client
Magazine House

Year
2001

Project
ten_do

Title
good morning

Client
Self-published

Year
2001

Project
ten_do

Title
kaneiji

Client
Self-published

Year
2001

adam

busy

cute

deee

evil

fuck

gogo

hope

idol

join

kick

love

make

neat

open

play

quit

rock

sign

time

ugly

vice

wise

xmas

yeah

zero

The Designers Republic

"Design or Die"

Opposite page:

Project
Poster

Title
Mitdarchitec_ure™

Client
Self-published

Year
2001

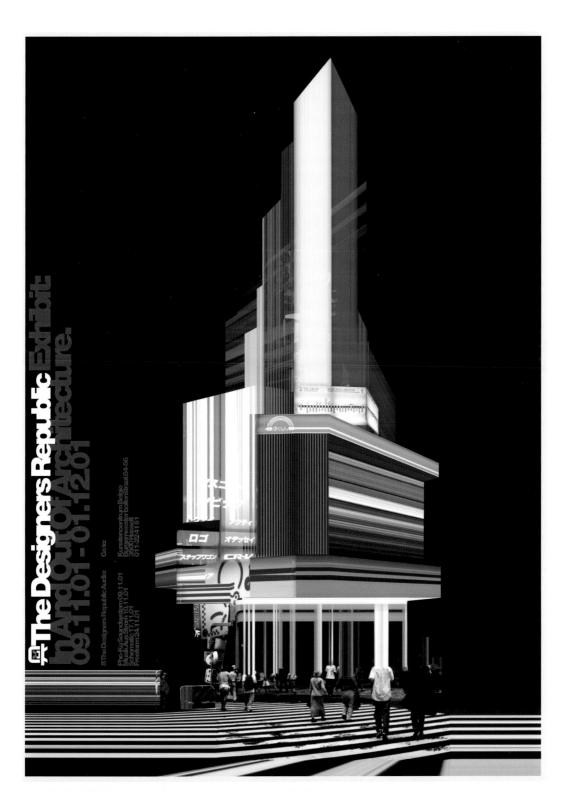

The Designers Republic Exhibit:
In And Out Of Architecture.
09.11.01 - 01.12.01

@The Designers Republic.Audix Go to:

Kunstcentrum Belgie
Bürgemeesters bollenstraat 64-55
3500 Hasselt
011-224161

@The Designers Republic team.09.11.01
Music.Aus Storm 10.11.01
Schematic 17.11.01
Freeform 24.11.01

Pho-Ku Sound system.09.11.01

″Brain Aided Design. Brain Aided Design.″

»Brain Aided Design. Brain Aided Design.«

«Brain Aided Design. Brain Aided Design.»

The Designers Republic
The Workstation
15 Paternoster Row
Sheffield S1 2BX
UK

T +44 114 275 4982
F +44 114 275 9127

E disinfo@
 thedesignersrepublic.com

www.thedesigners
 republic.com
www.thepeoples
 bureau.com
www.pho-ku.com

Biography
1986 Founded by Ian Anderson in Sheffield

Recent exhibitions
1998 "DR Modern Art", Sheffield, Glasgow, Manchester, London, Vienna, Tokyo
1999 "Sound in Motion", Hasselt; EXIT, London
2000 "Sound and Files", Vienna; "Sound Design", Japan, Brunei, Singapore, Hong Kong etc.
2001 "3D>2D>15Y", Magma Clerkenwell, London; "In and Out of Architecture", Hasselt; JAM, Barbican, London, "Brain Aided Design"™, Barcelona.

Clients
!K7/Funkstörung
Adidas
Branson Coates
Architects/Moshi Moshi Sushi
Cartoon Network TV, UK
Emigre Magazine
EMI/Parlophone Records
Gatecrasher
Issey Miyake
KesselsKramer
Moloko
MTV Europe
Nickelodeon
PowerGen/Saatchi&
Saatchi
Pringles/MTV
Psygnosis/Wipeout
PWEI
Sadar Vuga Arhitekti
Satoshi Tomiie
Supergrass
SuperNoodles/Mother Advertising
Swatch
Telia Telecom
Towa Tei
Warp Records

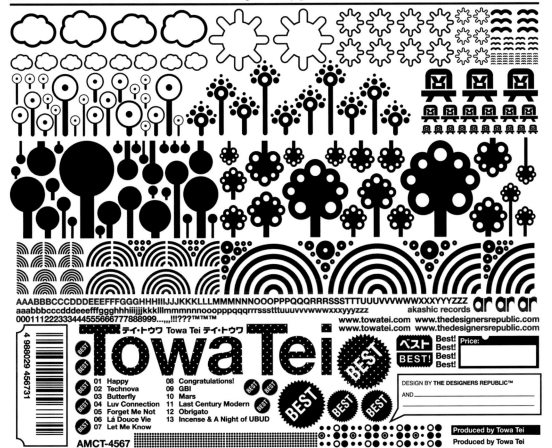

Project
CD packaging

Title
Towa Tei Best

Client
Akashic Records

Year
2001

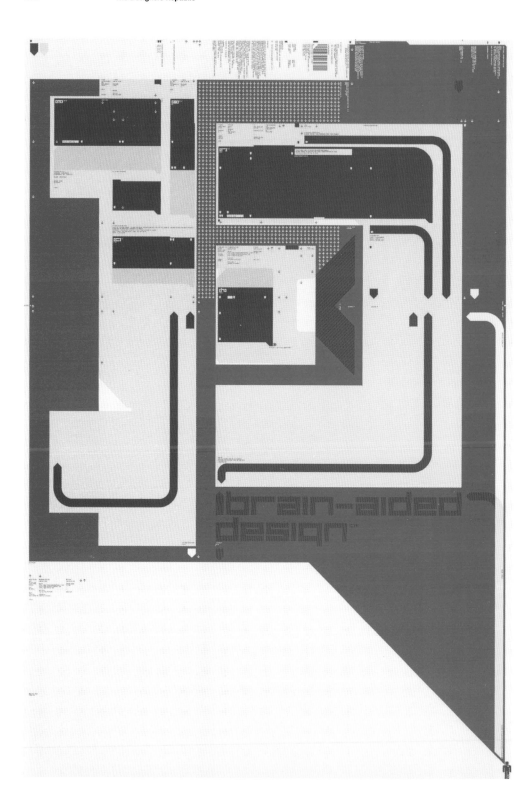

Opposite page:

Project
Poster

Title
Brain Aided Design™

Client
Self-published / The
Peoples Bureau for
Consumer Information

Year
2002

Project
Book

Title
The Designers Republic's
Adventures in and out of
Architecture with Sadar
Vuga Arhitekti and Spela
Mlakar

Client
Laurence King Publishing /
Sadar Vuga Arhitekti

Year
2001

UNA (Amsterdam) designers

"Get to know the client, understand his particular style of language, fathom his questions, and in your own original and unique voice give a lucid response."

Project
Identity/stationery
designed by André
Cremer

Title
D&A

Client
D&A medical group

Year
2001

"The creation of a strong cohesion between impressions expressed through printed and digital media demands of a graphic designer a substantial supply of cultural equipment. It places the designer in the vicarious position of director, conductor and composer. Similarly, the designer must have insight into the possibilities of text, image, sound and production. To be able to survive in a world inundated by consultants, communication experts, marketing specialists, co-ordinators and supervisors – in other words those who deem themselves proficient in a variety of disciplines and are thus qualified to be at the vanguard leading the rest of us – requires a certain degree of authority. Authority is not bestowed upon us as a gift. It is accomplished through education and experience. Education encapsulating a broad spectrum of disciplines. Unfortunately, the length of time necessary for training is shortened and learning to be in command of diverse programmes demands time. The vital question is where the much needed general development and broad orientation eventually lands."

» Das Entstehen der starken Kohäsion zwischen den Eindrücken, die mit Druck- und digitalen Medien vermittelt werden, verlangt vom Grafiker ein umfangreiches kulturelles Rüstzeug. Das versetzt ihn in die Position des stellvertretenden Regisseurs, Dirigenten und Komponisten. In ähnlicher Weise muss der Grafiker ein Gespür für das Potenzial von Text, Bild, Klang und Herstellungsverfahren haben. Um sich in einem von Beratern, Kommunikationsexperten, Marketingspezialisten, Organisatoren und Kontrolleuren wimmelnden Markt durchzusetzen – umgeben von Leuten also, die sich in verschiedenen Fachbereichen für kompetent halten und somit für qualifiziert, die Vorhut zu bilden und uns alle anzuführen –, braucht man ein gewisses Maß an Autorität. Die wird keinem geschenkt. Man erlangt sie durch Bildung, mit einem breiten Wissensspektrum. Leider werden die Ausbildungszeiten immer kürzer, während es doch Zeit erfordert, um die verschiedenen Fächer zu beherrschen. Die Hauptfrage ist, wohin die allgemeine Entwicklung und breite Orientierung führt.«

« Pour pouvoir créer une forte cohésion entre les impressions s'exprimant à travers les médias imprimés et numériques le graphiste a besoin d'un important bagage culturel. Il se trouve indirectement dans la position d'un directeur, d'un chef d'orchestre et d'un compositeur. De même, le créateur doit bien connaître les possibilités de texte, d'image, de son et de production. Pour survivre dans un monde surpeuplé de consultants, d'experts en communication, de spécialistes du marketing, de coordinateurs et superviseurs – en d'autres termes de personnes s'estimant compétentes dans une variété de disciplines et donc qualifiées pour nous conduire tous – il faut une certaine autorité. Celle-ci ne tombe pas du ciel, on l'acquiert par une éducation englobant un large éventail de disciplines. Malheureusement, on nous laisse de moins en moins le temps de nous former alors qu'apprendre à maîtriser les différents programmes en demande de plus en plus. La question cruciale est : où nous mènent le développement et l'orientation générale si nécessaires ? »

UNA (Amsterdam) designers
Korte Papaverweg 7a
1032 KA Amsterdam
The Netherlands

T +31 20 668 62 16
F +31 20 668 55 09

E una@unadesigners.nl

www.unadesigners.nl

Design group history
1987 Co-founded by Hans Bockting and Will de l'Ecluse in Amsterdam

Founders' biographies
Hans Bockting
1945 Born in Bladel, The Netherlands
1963 College of Art & Industry AKI, Enschede, The Netherlands
1967 HVR Advertising, The Hague
1970 Freelance designer, The Hague
1982 Partner, Concepts, Amsterdam
1987 Partner, UNA, Amsterdam
Will de l'Ecluse
1951 Born in Leyden, The Netherlands
1967 Royal College of Art, The Hague
1972 Ruder and Finn, Jerusalem
1975 HDA International, London
1977 Tel Design, The Hague
1979 Freelance designer, Amsterdam
1982 Partner, Concepts, Amsterdam
1987 Partner, UNA, Amsterdam

Recent awards
1991 Best Annual Report Design
1998, 1999, 2000, 2002 Design Week Awards
1998, 2001 ISTD Typographic Awards
2001 Dutch Letterhead Competition, Red Dot Awards
2001, 2002 ADC Awards, Best Calendar Design

Clients
Asko/Schönberg Ensemble
Consumer Safety Insitute
D&A medical group
De Arbeiderspers
Delta Lloyd
Design Zentrum NRW
F. van Lanschot Bankiers
InnoCap
KLM Royal Dutch Airlines
Meervaart Theatre
National Archives
Royal Picture Gallery
Stedelijk Museum
TEFAF
Wolters-Noordhoff

Project
Series of newsletters
designed by Will de
l'Ecluse and Mijke
Wondergem

Title
AskoSchönberg

Client
Asko Ensemble /
Schönberg Ensemble

Year
2000

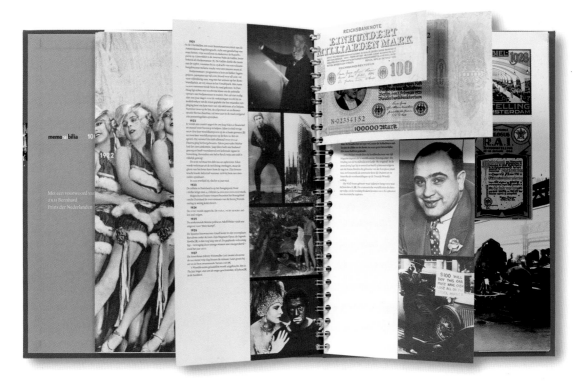

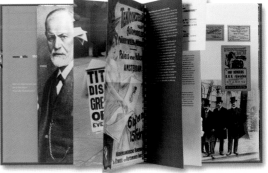

Project
Anniversary publication
designed by André
Cremer

Title
MemoRAIbilia/100 jaar
AutoRAI

Client
Amsterdam RAI
International Exhibition &
Congress Organizers

Year
2000

Opposite page:

Project
Exhibition poster
designed by Hans
Bockting and Sabine
Reinhardt

Title
Baselitz / Reise in die
Niederlande

Client
Stedelijk Museum,
Amsterdam

Year
1999

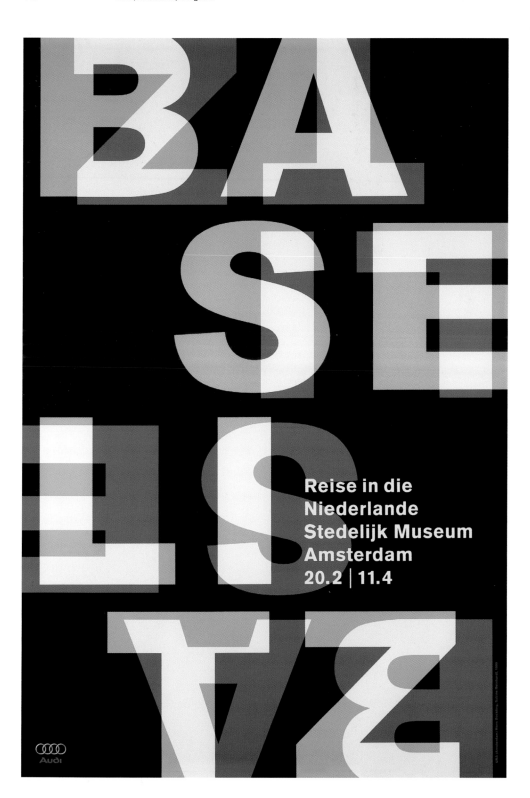

Martin Venezky

"Design doesn't just straighten and clarify the world, it also reflects the world as it ventures beyond problem solving into process, experiment and discovery."

Opposite page:

Project
Magazine

Title
Issue 12

Client
Speak Magazine

Year
1998

SPEAK

filmfiction **conver**music**sation**art

HO-HO

TRADE MARK

november/december $4.50 98
$6.75 Canada

11>

"There is joy in clashing consequence. And there is something to be said in favour of the euphoric, bustling world – for the intense, harmonic, ragged, mysterious, teetering messiness of all things. I take pleasure in making something whole out of unexpected parts. And if that pleasure can be transmitted to others, whether they be clients or viewers, then I feel that I have added something of value to the world. Must all design perform a duty beyond itself, or if it is in service, must its message be transparent? Design doesn't just straighten and clarify the world, it also reflects the world. That doesn't mean that design can't help alleviate suffering, or ease someone's life, or point the way for help and support. But design can also decorate, and in so doing, can add to the beauty and mystery of it all. There is an inherent pleasure in making things that survive even for a short while. And I believe there is a growing body of designers whose disenchantment with the machine may return them to the tool."

» Es macht Spaß, das Zusammentreffen gegensätzlicher Wirkungen zu beobachten. Und die euphorische, geschäftige Welt – die intensive, harmonische, zerrissene, mysteriöse, schwankende Unordentlichkeit aller Dinge – hat etwas für sich. Ich schaffe gerne, aus Teilen, die an der jeweiligen Stelle überraschend wirken, ein neues Ganzes. Wenn sich dieses Vergnügen anderen mitteilt – egal ob Kunden oder Betrachtern –, habe ich das Gefühl, einen wertvollen gesellschaftlichen Beitrag geleistet zu haben. Muss jedes Design einen Zweck erfüllen oder eine einleuchtende Botschaft übermitteln? Design rückt die Welt nicht nur zurecht und erklärt sie, sondern reflektiert sie auch. Zwar kann es auch Leiden mindern, den Menschen das Leben erleichtern oder den Weg zu Unterstützung weisen. Aber Design kann auch dekorativ sein und allem so mehr Schönheit und Geheimnis verleihen. Und ich glaube, die Entzauberung der Maschine könnte viele Grafiker wieder zum Handwerkszeug zurückführen.«

« Les résultats contradictoires peuvent engendrer la joie. Notre monde effervescent et euphorique a du bon : on peut apprécier le chaos intense, harmonique, décousu, mystérieux, vacillant de toutes choses. J'éprouve du plaisir à fabriquer un objet à partir d'éléments insolites. Si ce plaisir peut être transmis aux autres, qu'ils soient commanditaires ou spectateurs, j'ai le sentiment d'avoir ajouté un peu de valeur au monde. Le graphisme doit-il nécessairement apporter quelque chose en plus de sa fonction première, ou son message doit-il être transparent ? Il ne se contente pas de redresser et de clarifier le monde, il le reflète. Cela ne signifie pas qu'il ne puisse contribuer à soulager la souffrance, à faciliter la vie d'autrui, ou à indiquer la voie vers l'aide et le soutien. Mais il peut également être décoratif. Il y a un plaisir intrinsèque à réaliser des choses éphémères. Je crois qu'un nombre croissant de créateurs, déçus par la machine, reviendront à l'outil. »

Martin Venezky
Appetite Engineers
218 Noe Street
San Francisco
CA 94114
USA

T +1 415 252 8122
F +1 415 252 8142

E venezky@
 appetiteengineers.com

www.appetite
 engineers.com

Biography
1957 Born in Miami Beach, Florida
1975–1979 BA Visual Studies (Distinction), Dartmouth College, Hanover, New Hampshire
1991–1993 MFA Design, Cranbrook Academy of Art, Michigan

Professional experience
1993+ Taught at California College of Arts & Crafts, San Francisco
1997 Founded own studio, Appetite Engineers, in San Francisco

Recent exhibitions
2000 "Cooper-Hewitt Design Triennial", Cooper Hewitt National Design Museum, New York
2001 "Martin Venezky: Selections from the Permanent Collection of Architecture and Design", solo exhibition, San Francisco Museum of Modern Art; "Byproduct", Southern Exposure Gallery, San Francisco

Recent awards
1998 100 Show, American Center for Design (ACD), Chicago; Design Achievement Award, I.D. magazine; Book Design Award, 50 Books 50 Covers, American Institute of Graphic Arts (AIGA)
1999 Self Promotion Best of 1999, How magazine; 100 Show, American Center for Design (ACD), Chicago
2000 Museum Publications Design Competition, American Association of Museums (AMM); Regional Design Annual, Print magazine 2000; Design Annual, Communication Arts (CA); Book Design Award, 50 Books 50 Covers, American Institute of Graphic Arts (AIGA); 100 Show, American Center for Design (ACD), Chicago
2002 Honourable Mention, I.D. magazine Design Annual

Clients
American Center for Design
American Institute of Graphic Arts
Blue Note Records
California College of Arts & Crafts
Caroline Herter Studios
CCAC Institute
Chronicle Books
PFAU Architecture
Reebok
Rockport
San Francisco International Gay & Lesbian Film Festival
San Francisco Lesbian, Gay, Bisexual, Transgender Community Center
San Francisco Museum of Modern Art
San Jose Museum of Art
Speak Magazine
Sundance Film Festival

Project
Magazine

Title
Speak, issue 10

Client
Speak magazine

Year
1998

Project
Magazine

Title
Speak, issue 21

Client
Speak magazine

Year
2001

Project
Magazine

Title
Open, issue 3

Client
San Francisco Museum of
Modern Art

Year
2000

Project
Magazine

Title
Open, issue 2

Client
San Francisco Museum of
Modern Art

Year
2000

Opposite page:

Project
Magazine

Title
Open, issue 5

Client
San Francisco Museum of
Modern Art

Year
2001

Why Not Associates

"Trying to enjoy it as much as possible, while getting paid."

Opposite page:

Project
Exhibition poster

Title
Malcolm McLaren's
Casino of Authenticity and
Karaoke

Client
Malcolm McLaren

Year
2001

"God only knows" »Gott allein kennt sie« « Dieu seul le sait »

Why Not Associates
22C Shepherdess Walk
London N1 7LB
UK

T +44 207 253 2244
F +44 207 253 2299

E info@
 whynotassociates.com

www.whynotassociates.com

Design group history
1987 Co-founded by
Andy Altmann, David Ellis
and Howard Greenhalgh
in London

Recent exhibitions
2001 "City/Mesto", The
Czech Centre, London,
Prague

Clients
BBC
Centre Georges
Pompidou
Design Museum
Kobe Fashion Museum
Lincoln Cars
Malcolm McLaren
Nike
Royal Academy of Arts
Royal Mail
Saatchi and Saatchi
The Green Party

Project
Promotional film

Title
Under my skin

Client
Nick Veasey

Year
2001

Project
Exhibition installation &
T-shirt design

Title
Malcolm McLaren's
Casino of Authenticity and
Karaoke

Client
Malcolm McLaren

Year
2001

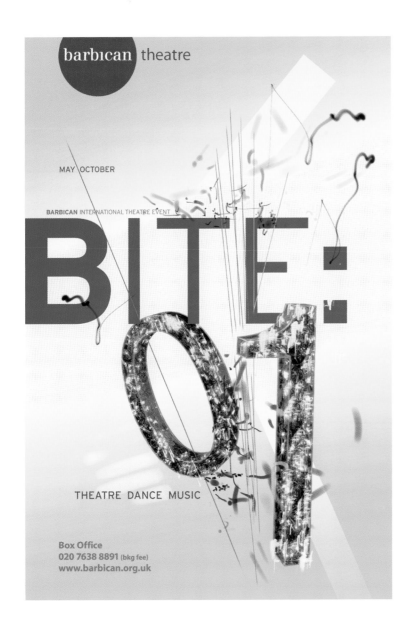

Opposite page:

Project
Television commercial

Title
Forest

Client
Leap Batteries

Year
2001

Project
Exhibition poster

Title
Bite 01

Client
The Barbican

Year
2001

Worthington Design

"There are many correct answers, but they are all smart and sexy."

Opposite page:

Project
Poster

Title
Teatro Amazonas

Client
Sharon Lockhart

Year
2001

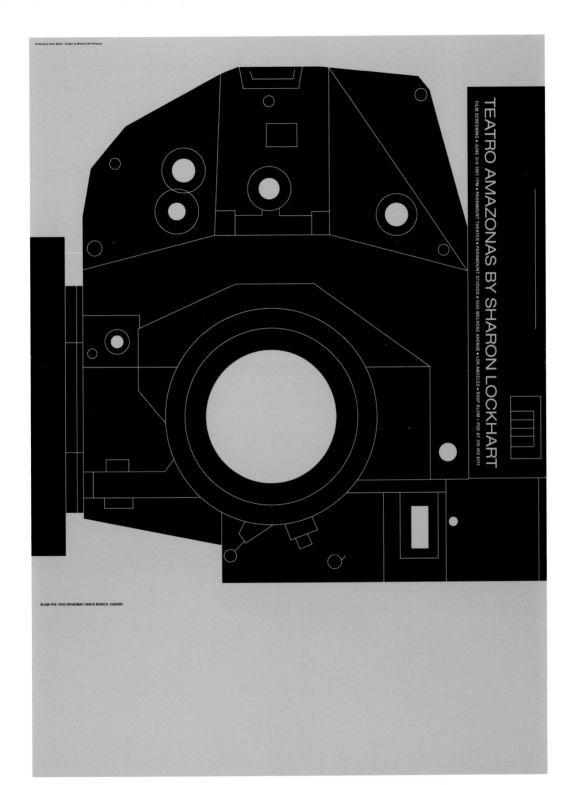

Drawing by Dave Muller Design by Michael Worthington

TEATRO AMAZONAS BY SHARON LOCKHART

FILM SCREENING ● JUNE 3rd 2001 7PM ● PARAMOUNT THEATER ● PARAMOUNT STUDIOS ● 5555 MELROSE AVENUE ● LOS ANGELES ● RSVP BLUM + POE AT 310 453 8311

BLUM+POE / 3942 BROADWAY / SANTA MONICA / CA90404

"The future is rarely true to that which is predicted of it. There will either be massive unexpected changes of an unforeseen nature, or disappointment at the futuristic promises of tomorrow that go unfulfilled. Graphic design could disappear or become the most important cultural practice – there is no point worrying about the future of graphic design – whatever happens designers will adapt and change and always find something and some way to make design."

»Die Zukunft hält sich selten an die Prognosen. Entweder erleben wir gewaltige unerwartete Veränderungen von unvorhersehbarer Art oder aber Enttäuschung über unerfüllte Versprechungen. Das Grafikdesign könnte in Zukunft ganz verschwinden oder zur wichtigsten Form kultureller Praxis werden. Es ist sinnlos, sich über die Zukunft der Gebrauchsgrafik Sorgen zu machen. Was auch immer geschieht, die Grafiker werden sich anpassen, ändern und immer einen Weg und eine Möglichkeit finden, etwas zu gestalten.«

«Le futur correspond rarement à ce qu'on avait prédit. Soit on assistera à des changements massifs et inattendus d'une nature imprévue, soit on sera déçu devant des promesses futuristes non tenues. La création graphique pourrait disparaître ou devenir la pratique culturelle la plus répandue. Il ne sert à rien de s'inquiéter sur son avenir, quoi qu'il arrive, les créateurs s'adapteront, changeront et trouveront toujours quelque chose et un moyen de créer.»

Michael Worthington
California Institute of the Arts
24700 McBean Parkway
Valencia
CA 91355
USA

T +1 323 934 3691

E maxfish@attbi.com

Biography
1966 Born in Cornwall, England
1991 BA (Hons) Graphic Design, Central St Martins College of Art and Design, London
1995 MFA Graphic Design, California Institute of the Arts, Valencia

Professional experience
1996+ Faculty CalArts Design Programme, Valencia, California
1998+ Programme Co-Director, CalArts Design Programme, Valencia, California

Recent exhibitions
2002 "Take It It's Yours" (part of the COLA fellowship show), Japanese American National Museum, Los Angeles

Recent awards
1998 Medal Winner, Art Directors Club 77th Annual; 100 Show, American Center for Design
1999 100 Show, American Center for Design
2000 50 books, 50 covers, AIGA
2001 Recipient of COLA Individual Artist Fellowship 2001–2002, Los Angeles; I.D. magazine 47th Annual Design Review

Clients
CalArts
Henry Art Gallery, Seattle
LaEyeworks
MAK Center for Art and Architecture
MOCA Los Angeles
Sci-Arc
The Broad Foundation
Violette Editions

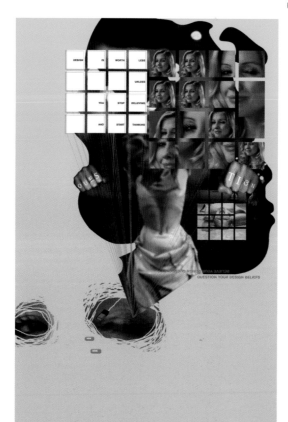

Project
Poster

Title
Adversary poster

Client
Ken Fitzgerald

Year
2001

Opposite page:

Project
Book

Title
Creative Impulse 6

Client
TBP

Year
2002

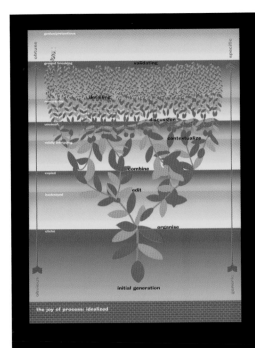

Opposite page:

Project
Book

Title
Restart: New systems in
Graphic Design, spreads

Client
Self-published

Year
2001

Project
Plastic inflatable poster

Title
Plastic inflatable poster

Client
Sci-Arc

Year
2000

Yacht

"To learn and be better"

Opposite page:

Project
12" Vinyl sleeve

Title
TLM Electrastars 77

Client
Hydrogen Dukebox

Year
2001

TLM
ELECTRASTARS

77

"To learn and be better." » Dazulernen und besser werden.« « Apprendre et s'améliorer. »

Yacht Associates
Unit 7
Stephendale Yard
Stephendale Road
Fulham
London SW6 2LR
UK

T +44 20 7371 8788
F +44 20 7371 8766

E info@
 yachtassociates.com

Design group history
1996 Co-founded
by Richard Bull and
Christopher Steven
Thomson in Kensington,
London

Founders' biographies
Richard Bull
1968 Born in London
1987–1989 BTEC Art &
Design, Chelsea School
of Art, London
1989–1992 BA (Hons)
Graphic Design, Chelsea
School of Art, London
Christopher Steven
Thomson
1969 Born in Bury St
Edmunds, England
1987–1989 HND Graphic
Design, Salford College
of Technology

Recent exhibitions
1998 Opening Installation,
Urban Outfitters, London
1999 "Furniture Design
Exhibition", sponsored
by Sony, Haus, London
2001 "Five Year Retro-
spective", Waterstones
Piccadilly, London

Recent awards
2000 Best Album Design,
Music Week Awards
2001 Best Photography,
Music Week Awards;
Editorial & Book Design,
D&AD

Clients
GettyStone
Millennium Images
Next Level Magazine
Parlophone Records
Penguin Books
Sony
Toshiba EMI
United Business Media
Urban Outfitters
Warwick Worldwide

Project
Magazine commission

Title
2lb's of Pix'n'Mix

Client
Selfish Magazine, Japan

Year
2001

Project
Album sleeve

Title
Mover

Client
A&M Records

Year
1998

Project
Book

Title
Yacht

Client
Yacht Associates / DGV

Year
2000

Tadanori Yokoo

"It is just produced from inside of me."

Opposite page:

Project
Poster for the PERUSONA
exhibition

Title
A Ballad Dedicated to the
Small Finger Cutting
Ceremony

Client
Yakuza Shobo

Year
1966

"Graphic design was the main aspect of my work until 1980. Around this time, however, I expanded my agenda to include painting. Although I see some differences between fine art and graphic work, it is hard to draw a boundary. After all, they are both created by one individual – me – and drawn from the same aesthetic reservoir. I intend to keep producing work that crosses these genres."

» Bis 1980 war ich vor allem als Grafik-designerin tätig. Etwa um die Zeit fing ich auch mit dem Malen an. Obwohl ich sehr wohl Unterschiede zwischen bildender und angewandter Kunst erkenne, ist es schwer, sie von-einander abzugrenzen. Schließlich werden beide von ein und der selben Person geschaffen – nämlich von mir – und werden aus der gleichen ästhetischen Quelle gespeist. Ich habe vor, auch weiterhin fachüber-greifende Werke zu schaffen.«

«Jusqu'en 1980, le graphisme consti-tuait l'aspect principal de mon travail. Vers cette époque, j'ai élargi mes activités à la peinture. Bien que je constate des différences entre les beaux-arts et le graphisme, j'ai du mal à délimiter une frontière. Après tout, tous deux sont créés par un individu (moi) puisant dans un même réservoir esthétique. Je compte continuer à travailler en allant et venant entre ces genres. »

Tadanori Yokoo
4–19–7 Seijyo
Setagaya-ku
Tokyo157–0066
Japan

T +81 3 3482 2826
F +81 3 3482 2451

E k-yokoo@s2.ocv.ne.jp

www.tadanoriyokoo.com

Biography
1936 Born in Nishiwaki City, Hyogo Prefecture, Japan
1955 Nishiwaki Hyogo Prefecture high school
Self-taught

Recent exhibitions
1999 Solo exhibition, The Museum of Modern Art, Wakayama; Poster Design of New Japan, Chicago Public Library, Chicago; solo exhibition, Telecommunications Museum, Tokyo; "Ground Zero Japan", Contempo-rary Art Gallery, Art Tower Mito, Japan
2000 "Seven Banzais: Followers of Taro Oka-moto Who Don't Pursue His Path", Taro Okamoto Museum of Art, Kawasa-ki; solo exhibition, Station Art Museum, Kyoto and other venues; "MOMA Highlights", The Museum of Modern Art, New York; "Modern Contemporary", The Museum of Modern Art, New York
2001 Solo exhibition, Loyola University, New Orleans; "Century City: Fine Arts and Culture of Contemporary Cities", Tate Modern, London; solo exhibition, Hara Museum of Contempo-rary Art, Tokyo
2002 "The International Posters Exhibition 2002", Museum of Huis ten Bosch, Nagasaki; "Pop Pop Pop", Museum of Modern Art, Ibaraki; "Screen Memories", Contemporary Art Gallery, Art Tower Mito, Japan; solo exhibition, Museum of Contemporary Art, Tokyo; solo exhibition, Museum of Contempo-rary Art, Hiroshima

Recent awards
1999 Silver Award, New York Art Directors Club
2000 Elected to the Hall of Fame, New York Art Directors Club
2001 Medal with Purple Ribbon, the Japanese Government
2002 Merit Award, New York Art Directors Club; Icograda Award, 20th Brno International Biennial of Graphic Design

Opposite page:

Project
Poster

Title
The 750 Year Anniversary of Nichirenn shu Buddhism.2002.4.28

Client
Nichirenn shu Newspaper Company

Year
2001

Project
Magazine

Title
Brutus

Client
Magazine House Ltd.

Year
1999

Opposite page:

Project
Poster

Title
Koshimaki-Osen

Client
Gekidan Jokyo Gekijo

Year
1966

TASC

25th ann

FASHION NOW
i-D SELECTS THE WORLD'S
150 MOST IMPORTANT DESIGNERS
ED. TERRY JONES & AVRIL MAIR

1000 CHAIRS
CHARLOTTE & PETER FIELL

Gilles Néret
erotica universalis
From Pompeii to Picasso

Design
of the 20th Century
CHARLOTTE & PETER FIELL

1000 Record Covers
MICHAEL OCHS

1000 Tattoos
ED. HENK SCHIFFMACHER

The Male Nude
David Leddick

RAINER ZERBST
GAUDÍ
THE COMPLETE BUILDING

Karl Ruhrberg
Manfred Schneckenburger
Christiane Fricke
Klaus Honnef
Edited by
Ingo F. Walther

Karl Ruhrberg
Manfred Schneckenburger
Christiane Fricke
Klaus Honnef
Edited by
Ingo F. Walther

ART
of the
20th
Century

ART
of the
20th
Century

Peter Gössel and Gabriele Leuthäuser
ARCHITECTURE IN THE 20TH CENTURY

I

II

20TH CENTURY
PHOTOGRAPHY